Beautiful in Black and White

January to July 2016
Photographic Memories

Author Photographer
Publisher

Ian McKenzie

ISBN-13: 978-1539356998
ISBN-10: 153935699X

BISAC: Photography /
Collections, Catalogues,
Exhibitions / General

Copyright 2016 Ian McKenzie

www.IansBooks.com

Powerhouse Park New Farm

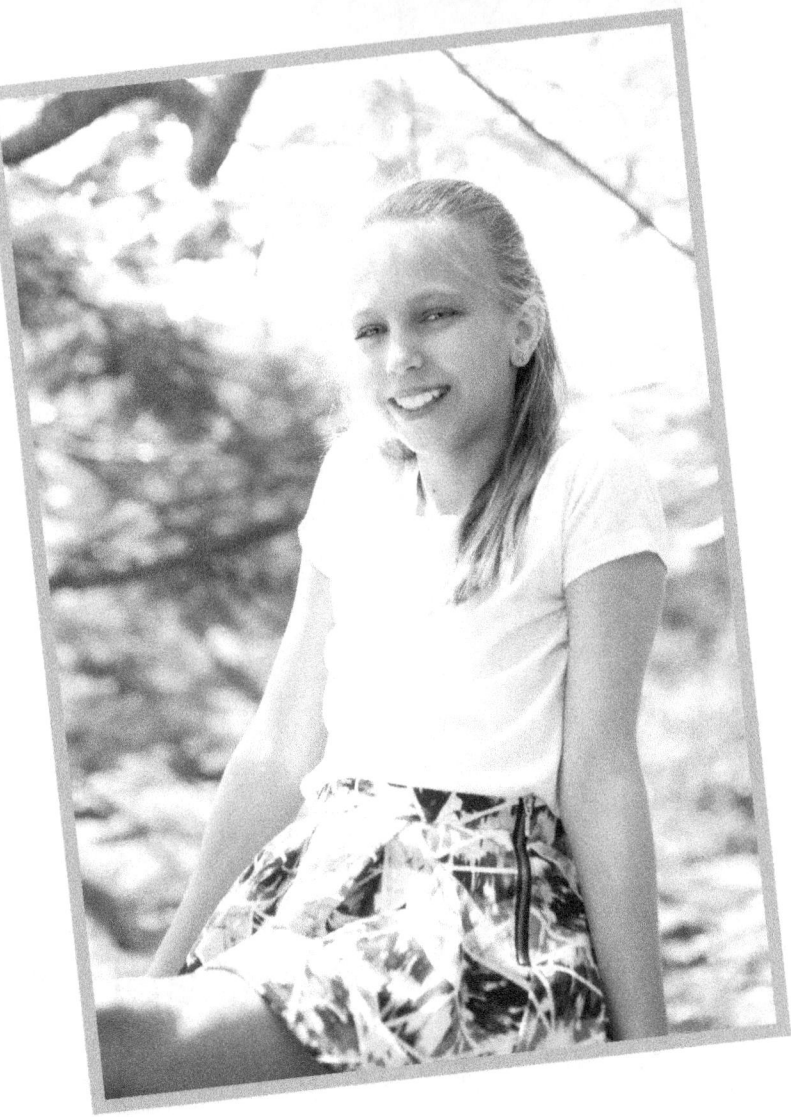

page 1

The Powerhouse on the banks of the Brisbane River at New Farm began life as power station. It has been converted into a trendy theatre with both indoor and outdoor dining areas. On one side of the theatre is Brisbane's well known New Farm Park. On the other side is the Powerhouse Park.

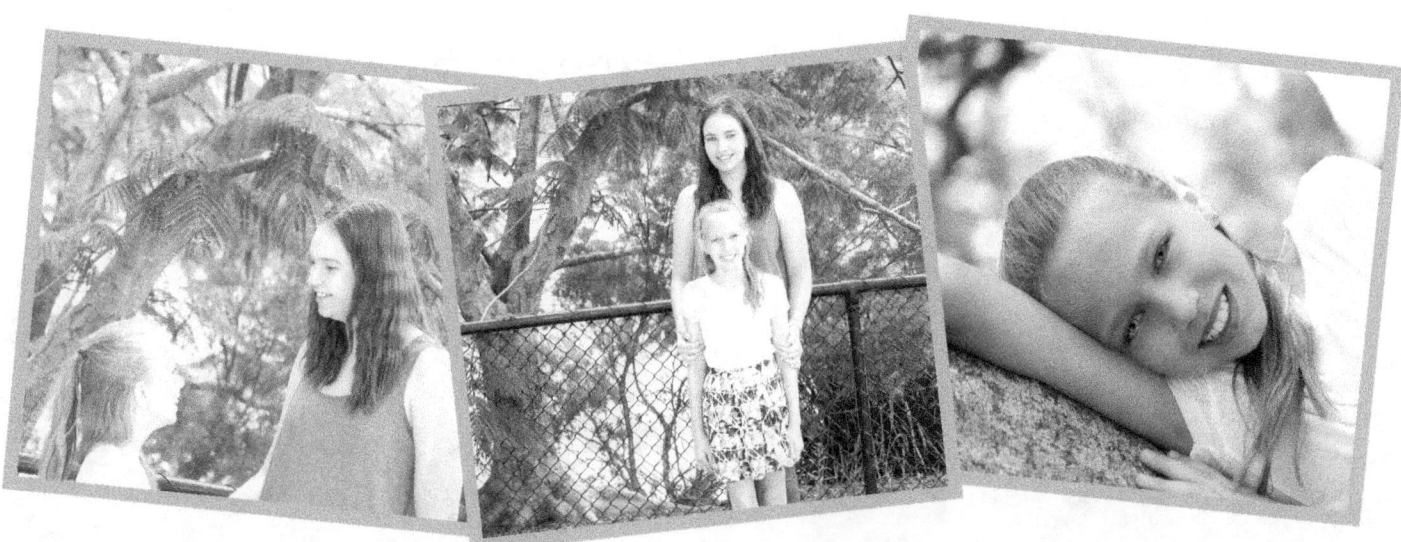

The big old poinciana tree (delonix regia), is a favourite tree to climb, and it's not just for kids.

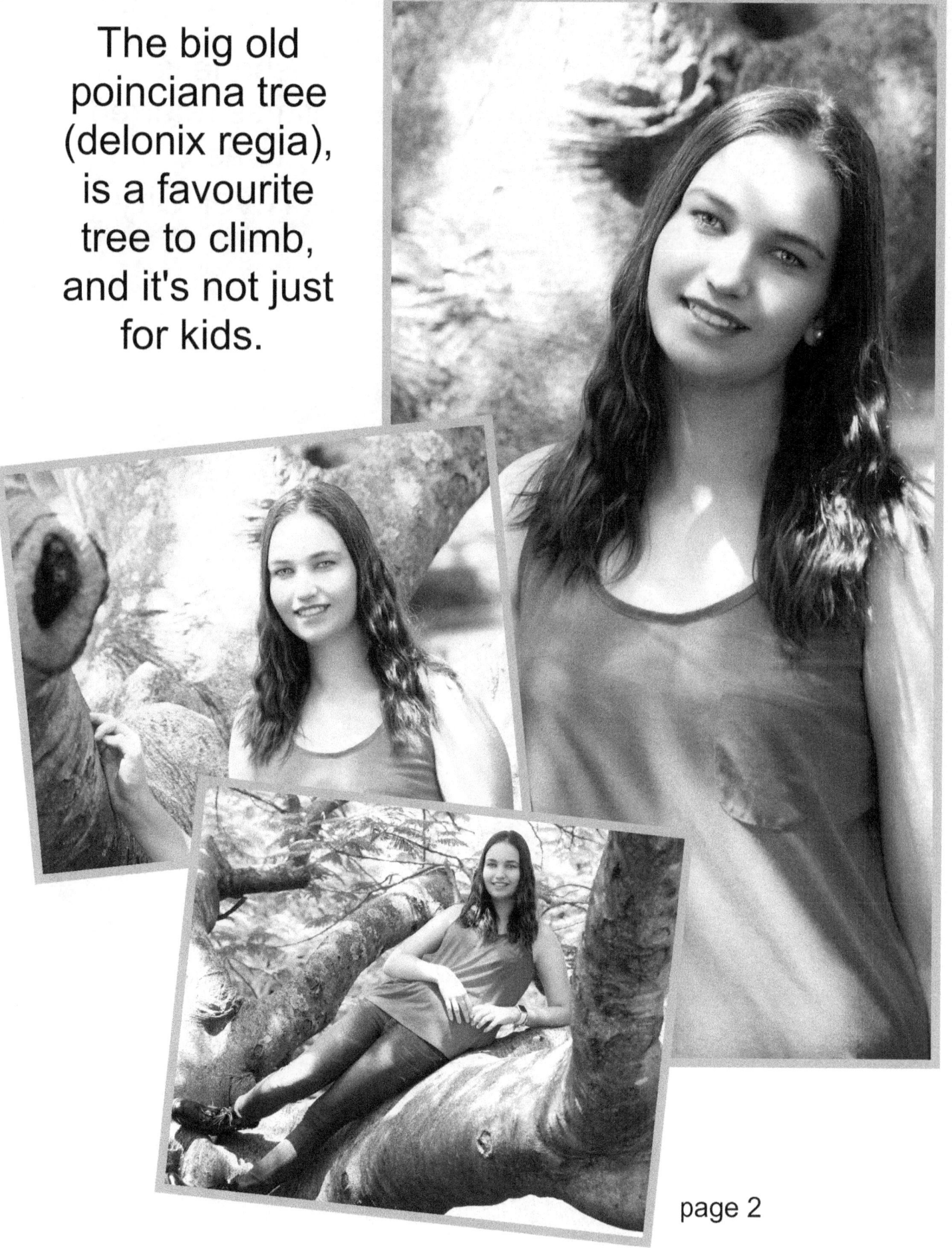

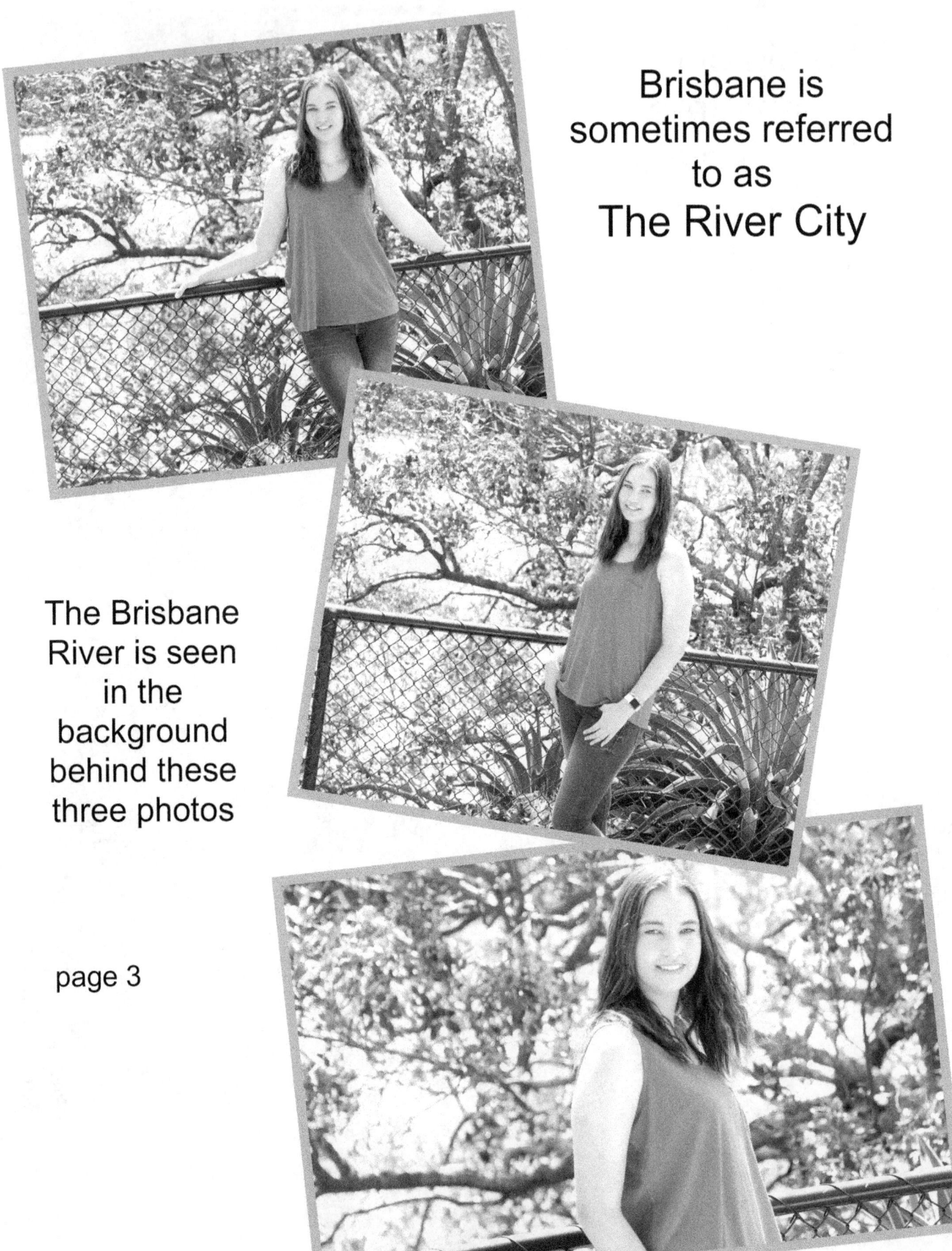

Brisbane is sometimes referred to as The River City

The Brisbane River is seen in the background behind these three photos

page 3

Fitness equipment in the park

page 4

Dancing in the park

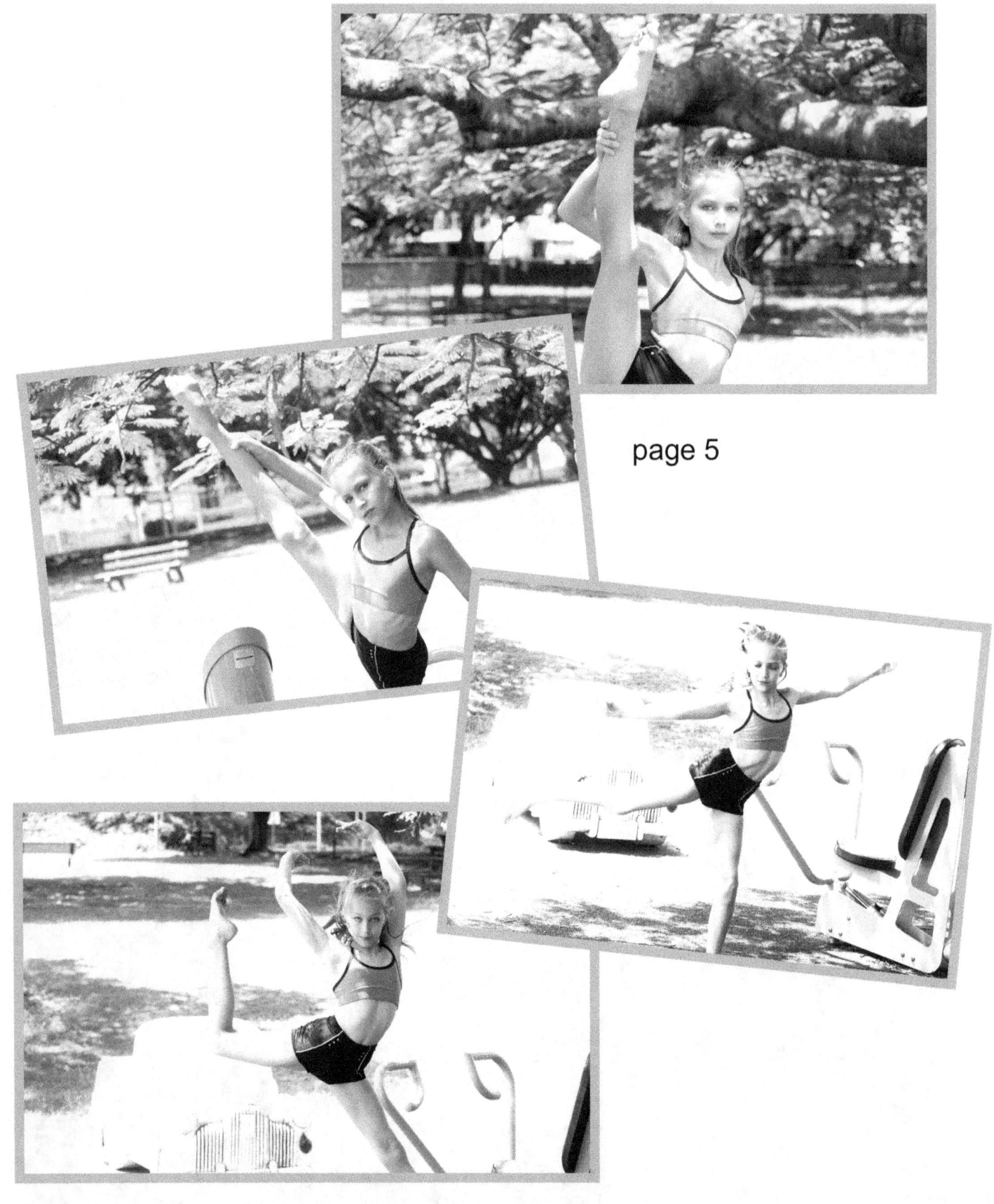

page 5

A great place to exercise or just relax

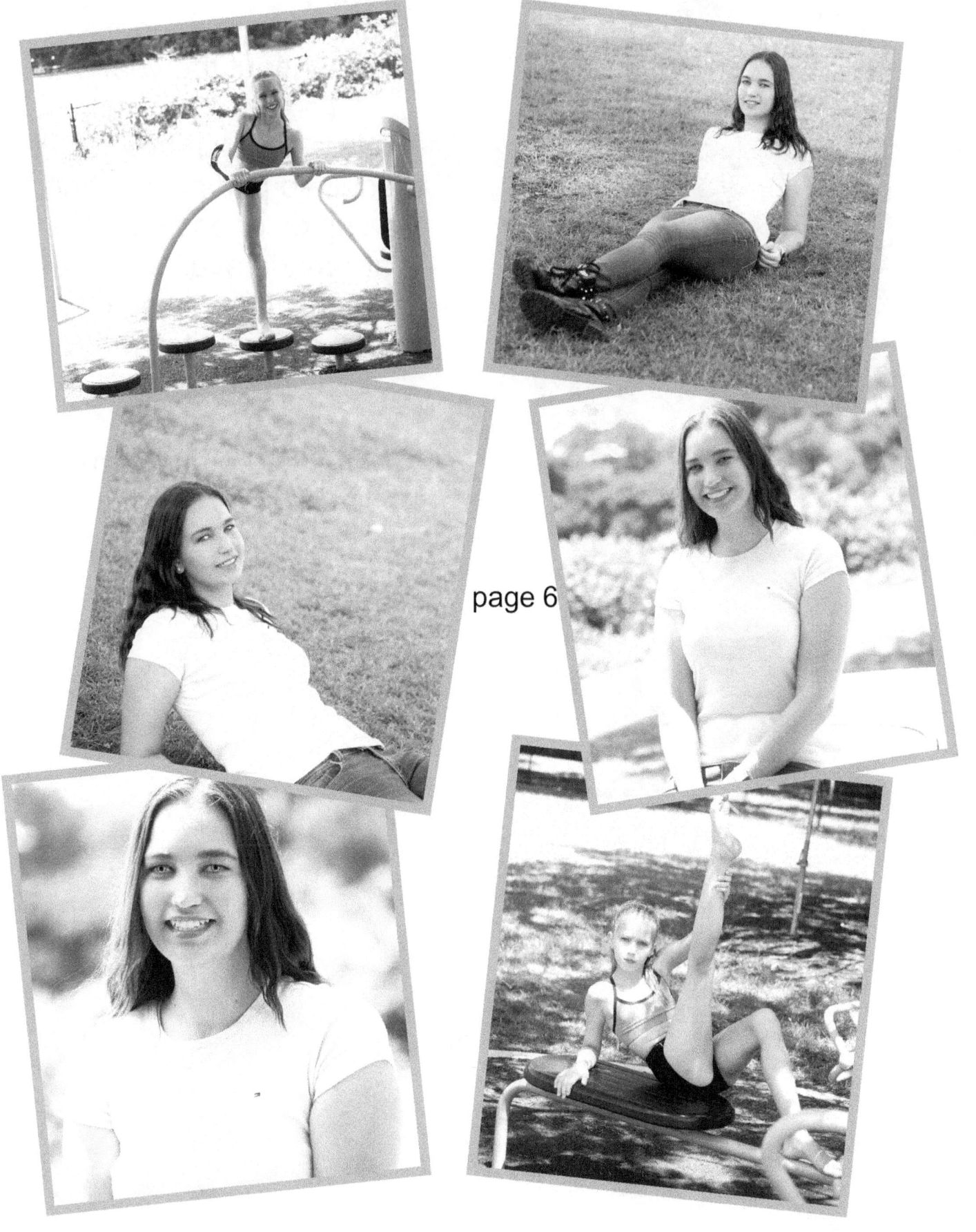

page 6

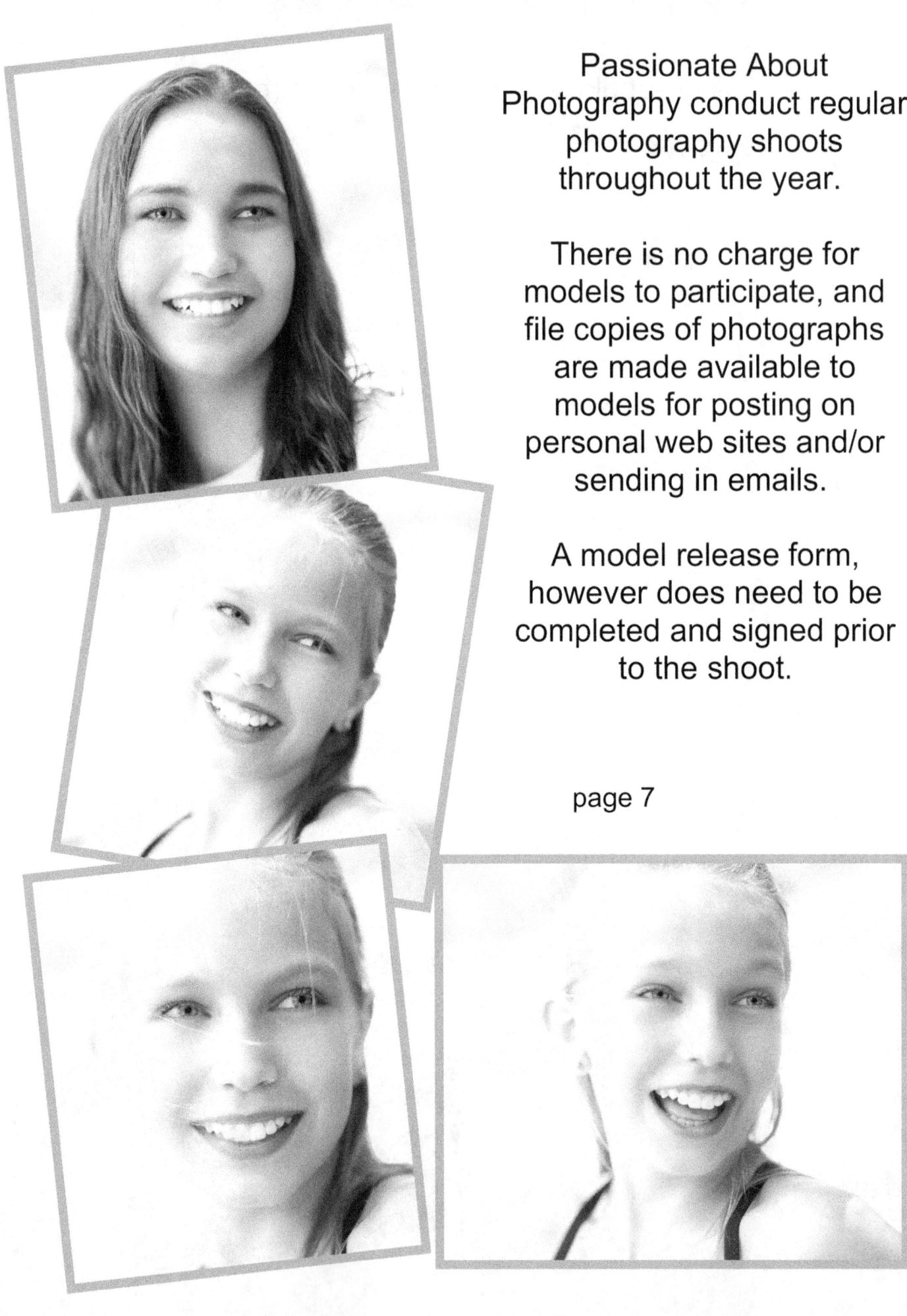

Passionate About Photography conduct regular photography shoots throughout the year.

There is no charge for models to participate, and file copies of photographs are made available to models for posting on personal web sites and/or sending in emails.

A model release form, however does need to be completed and signed prior to the shoot.

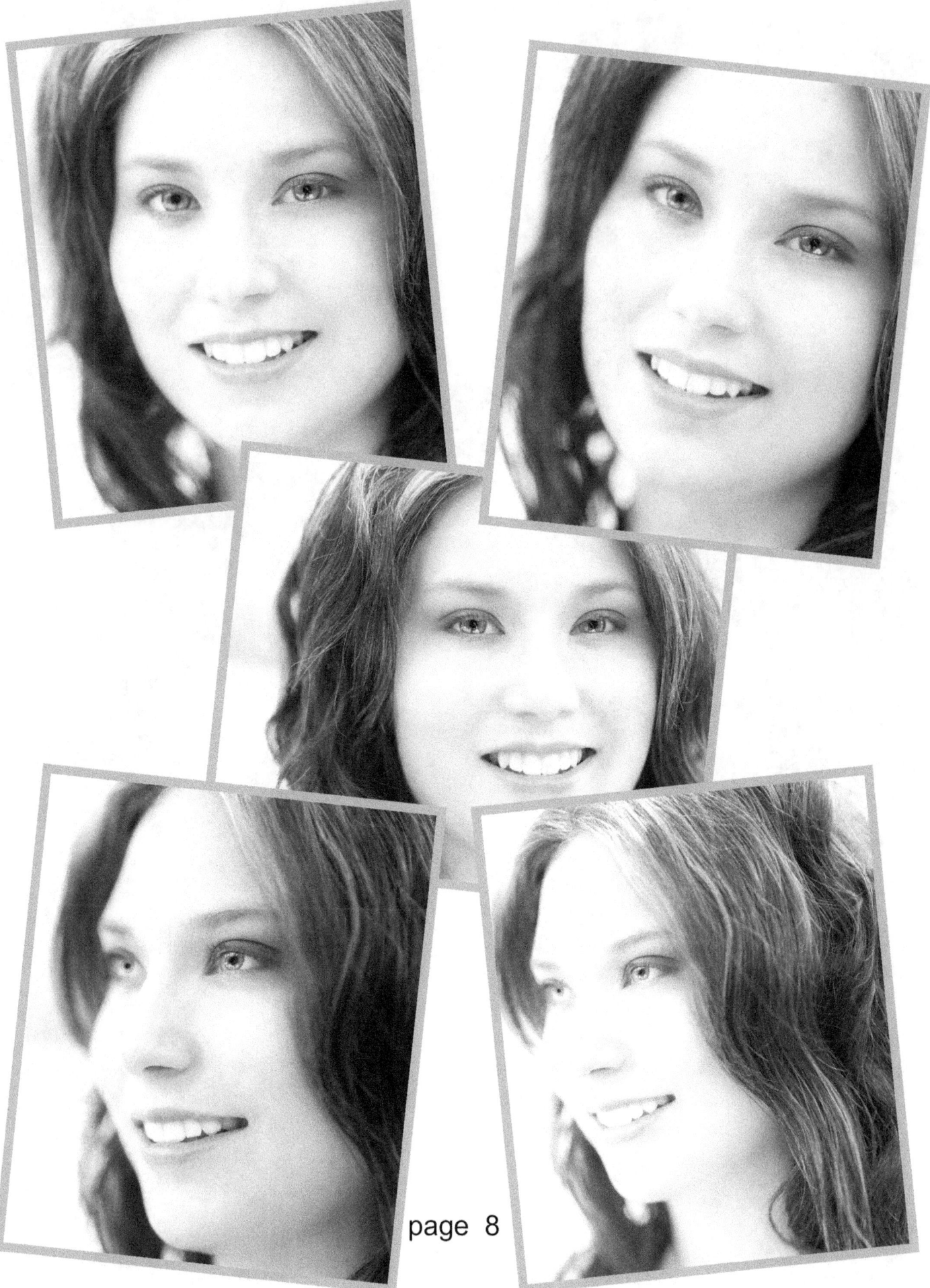

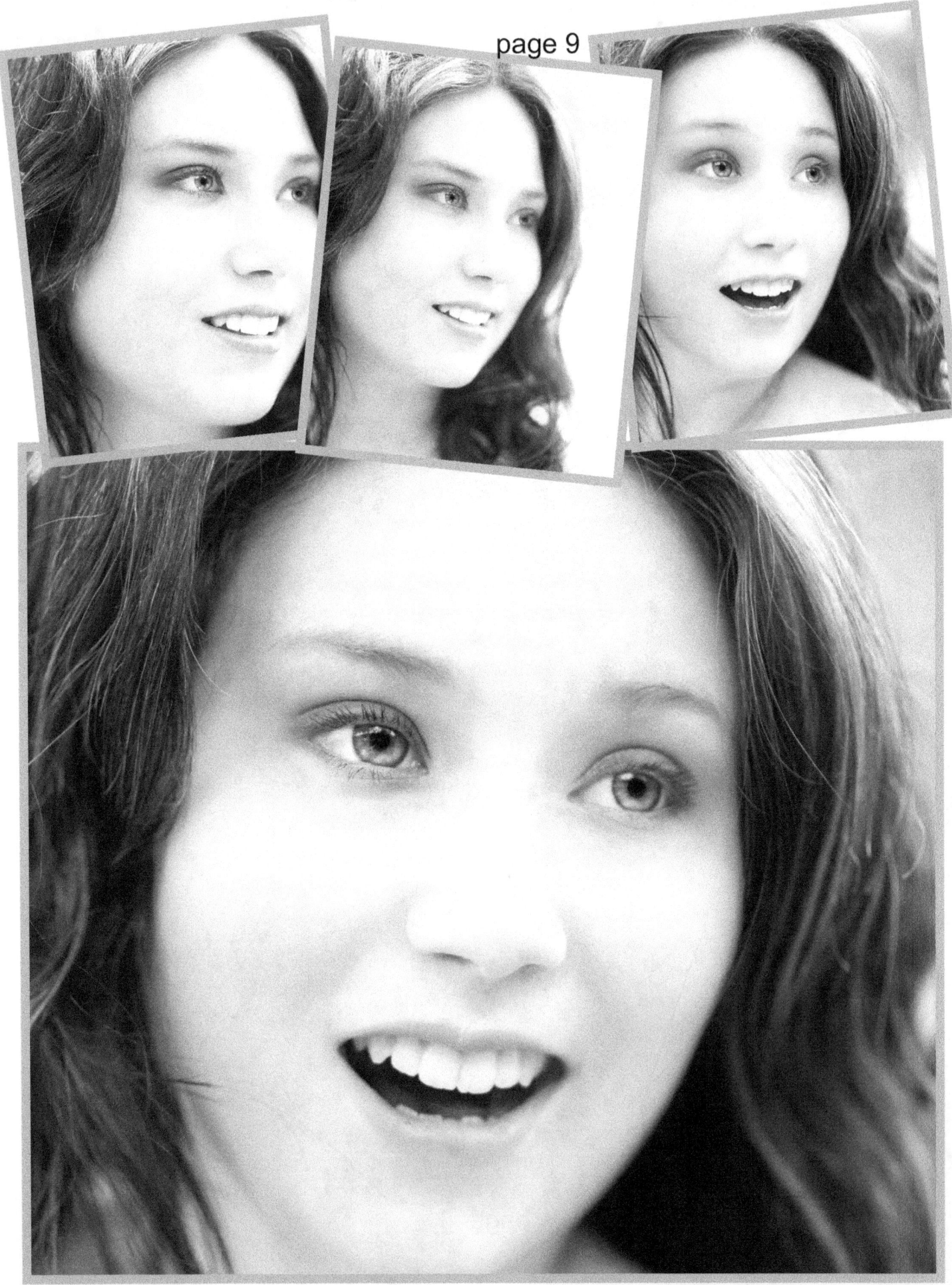

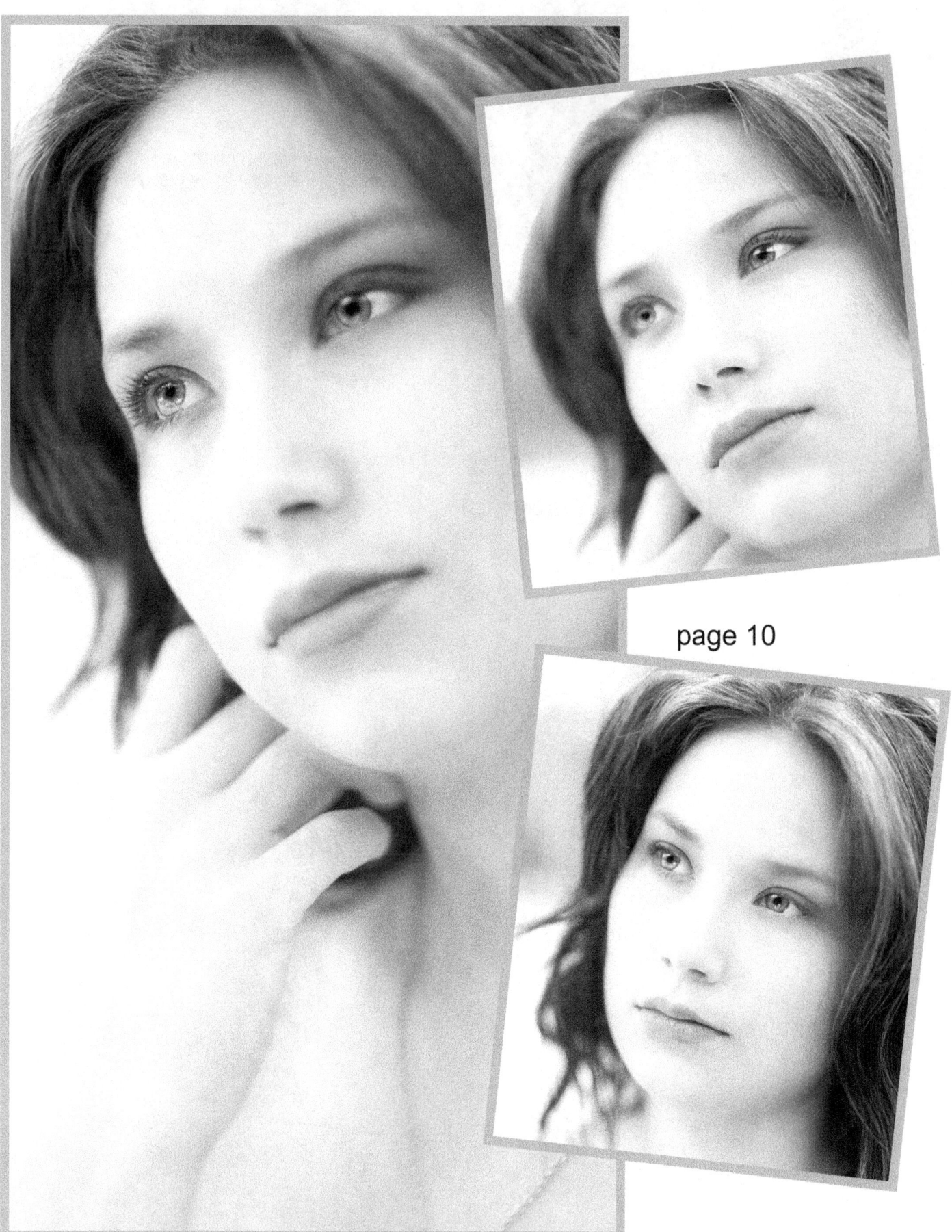

page 10

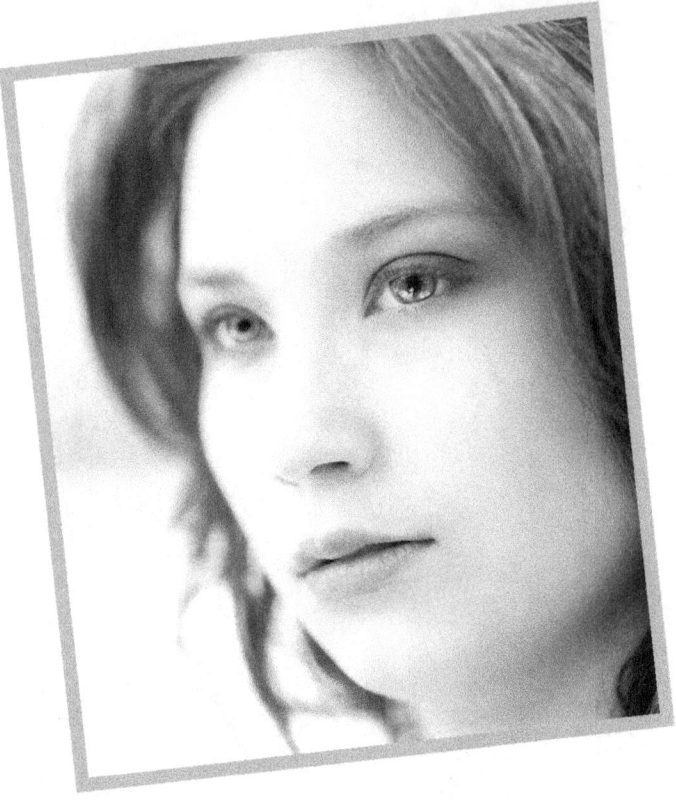
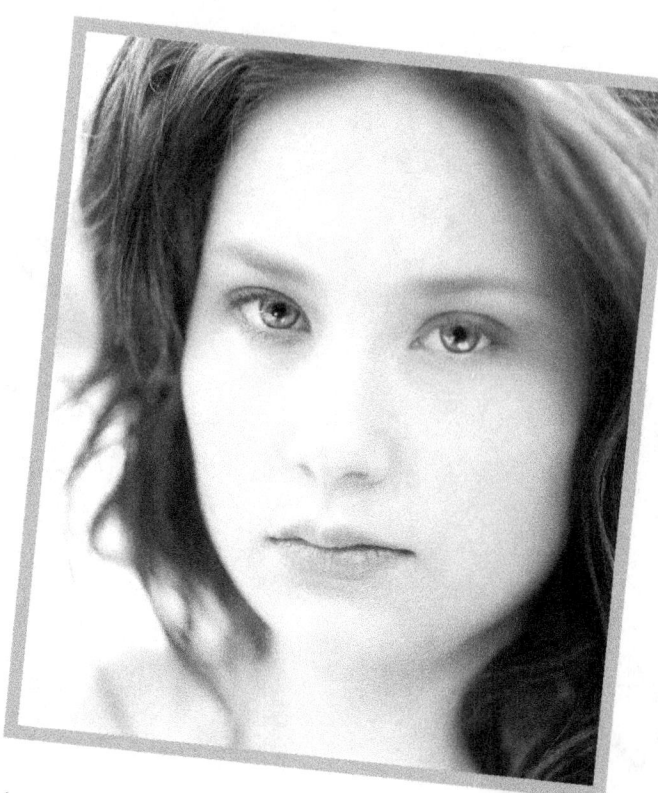

page 11

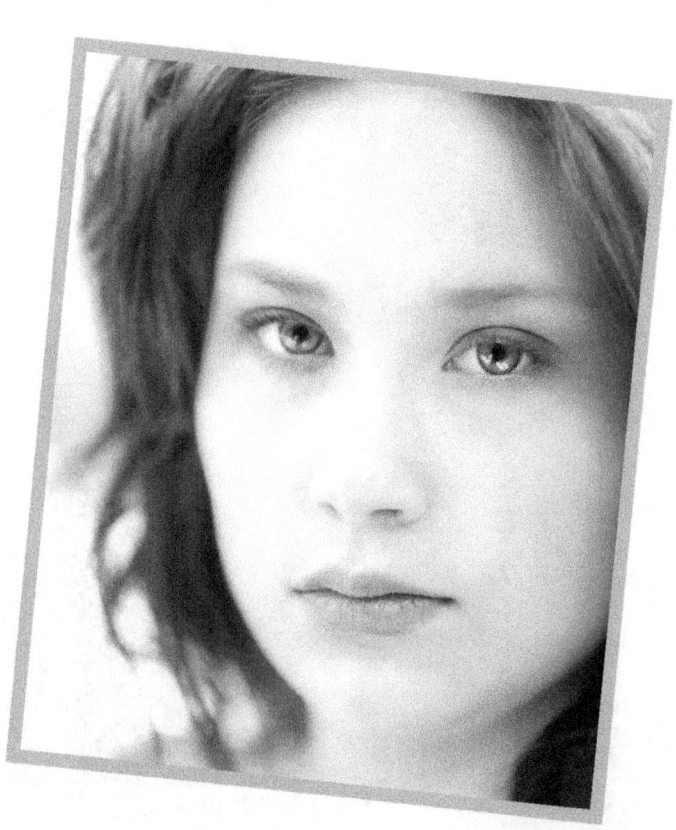
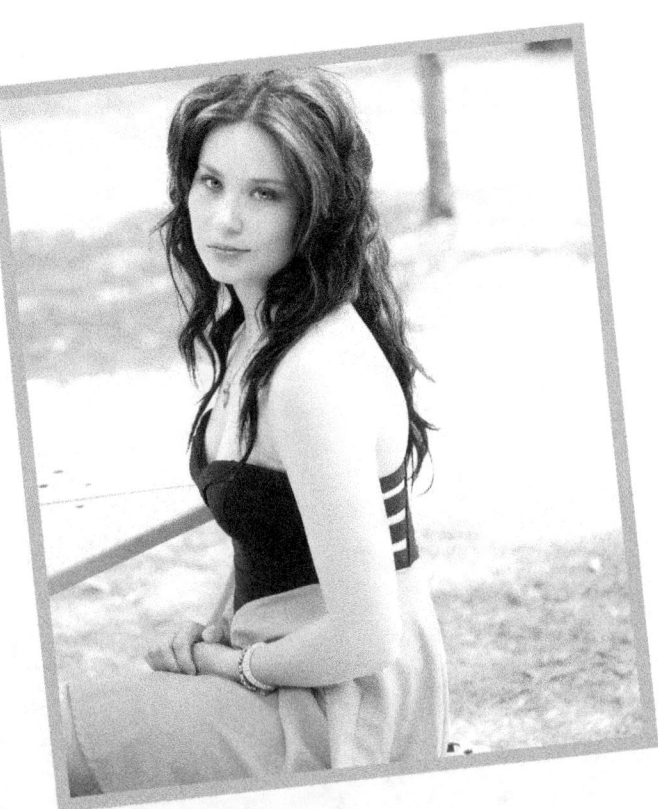

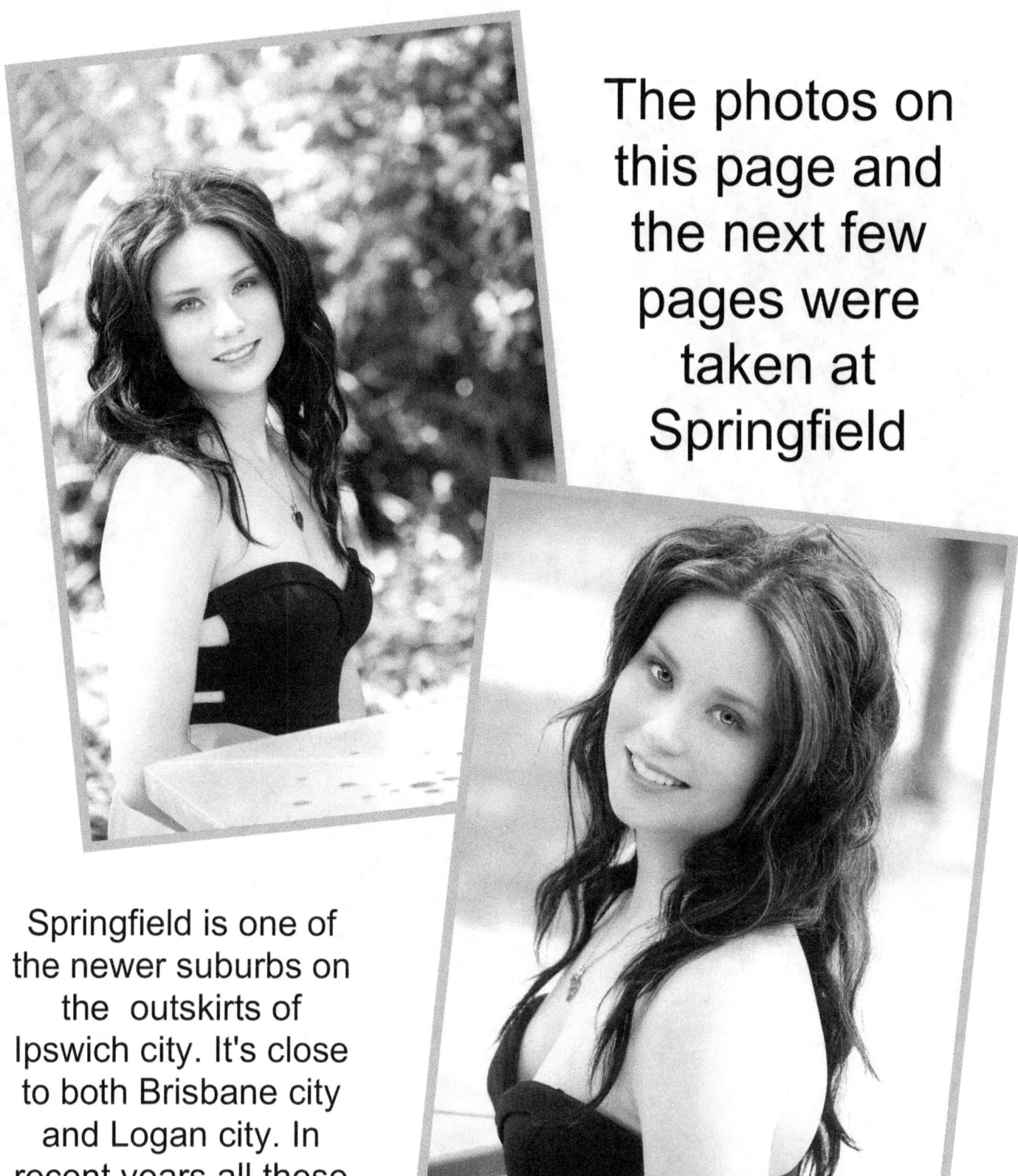

The photos on this page and the next few pages were taken at Springfield

Springfield is one of the newer suburbs on the outskirts of Ipswich city. It's close to both Brisbane city and Logan city. In recent years all these cities have merged together into one large metropolis.

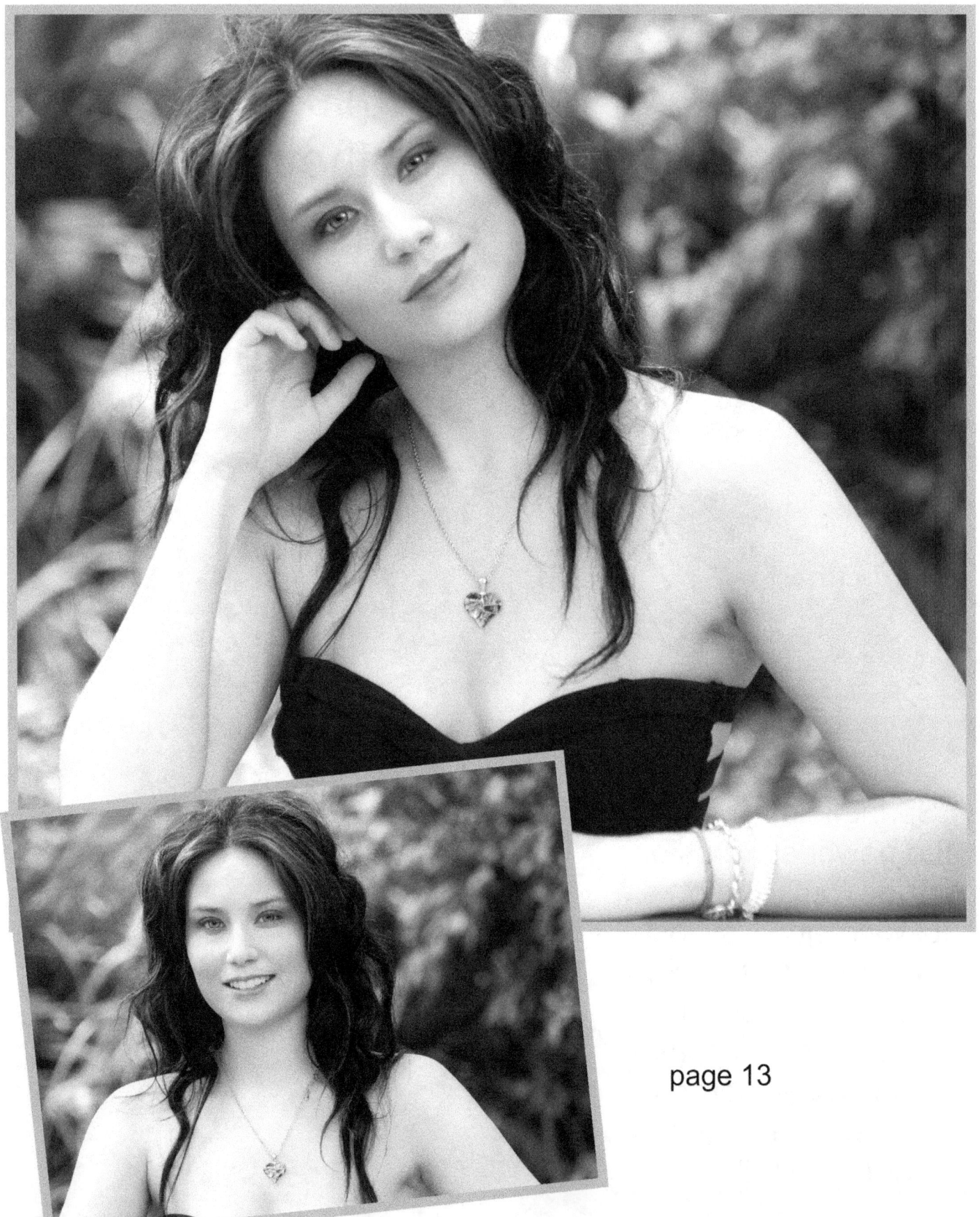

page 13

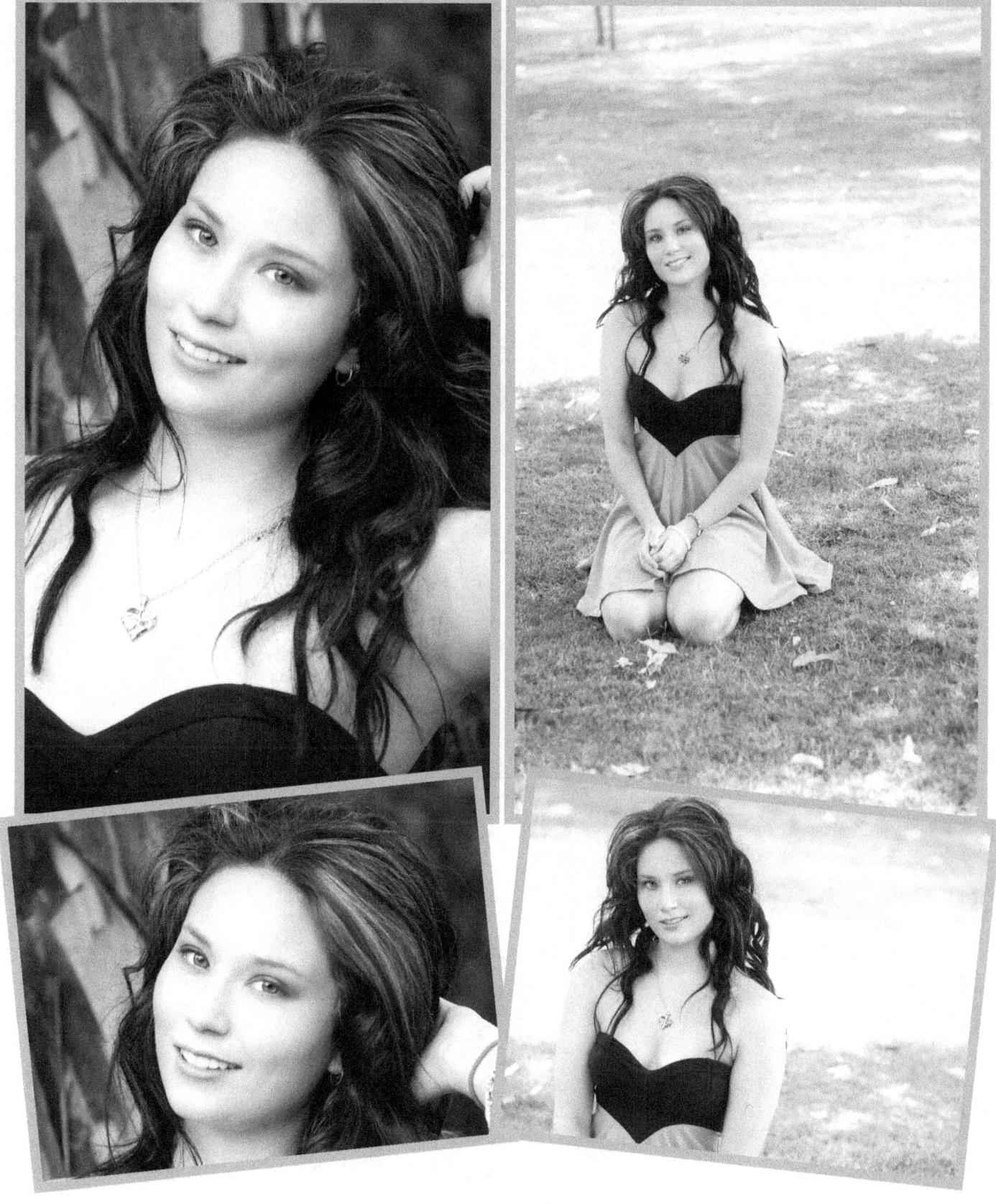

page 15

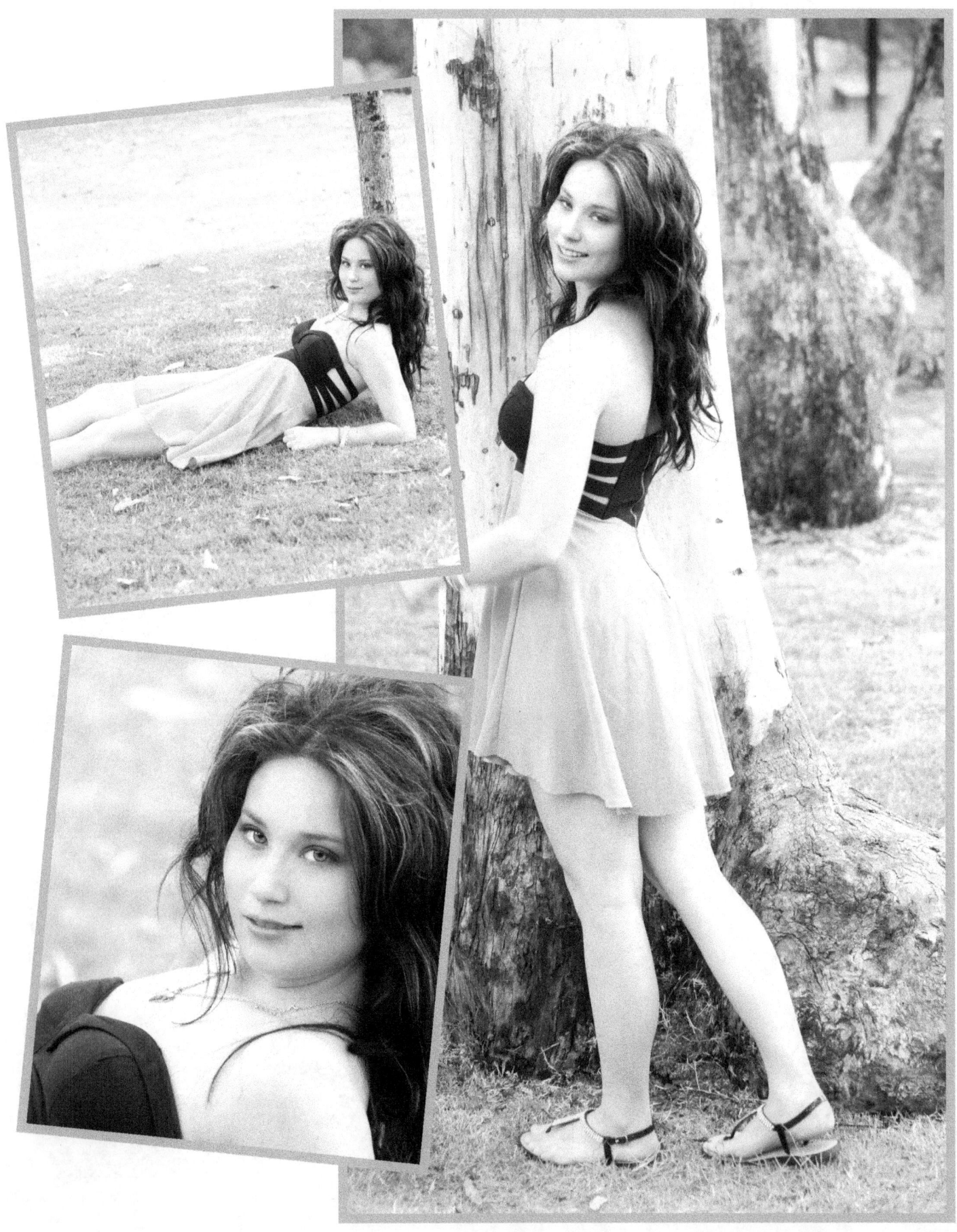

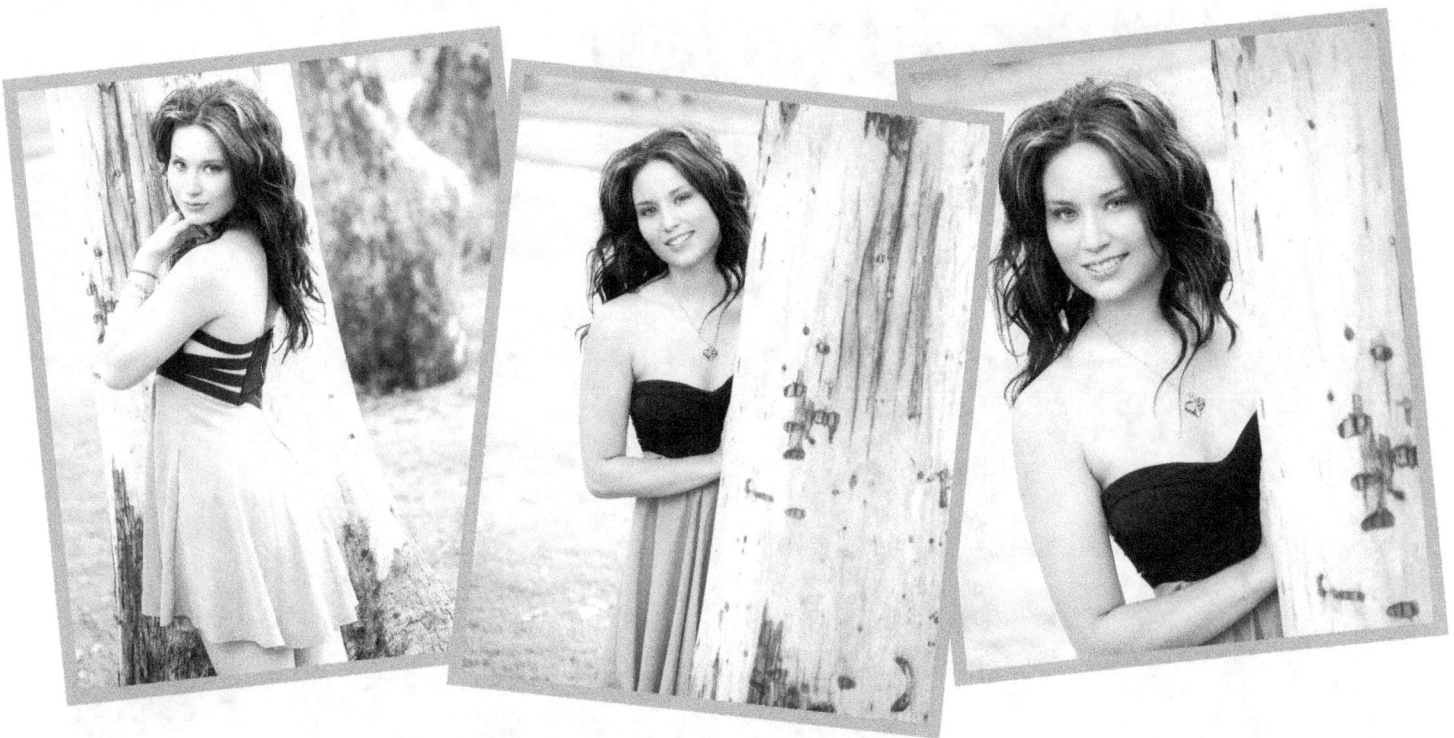

If you live in or near Brisbane and have an interest in being involved in Passionate About Photography shoots, you can obtain further information from the following web site and Facebook page:

www.passionateaboutphotography.net
www.Facebook.com/passionateaphotography

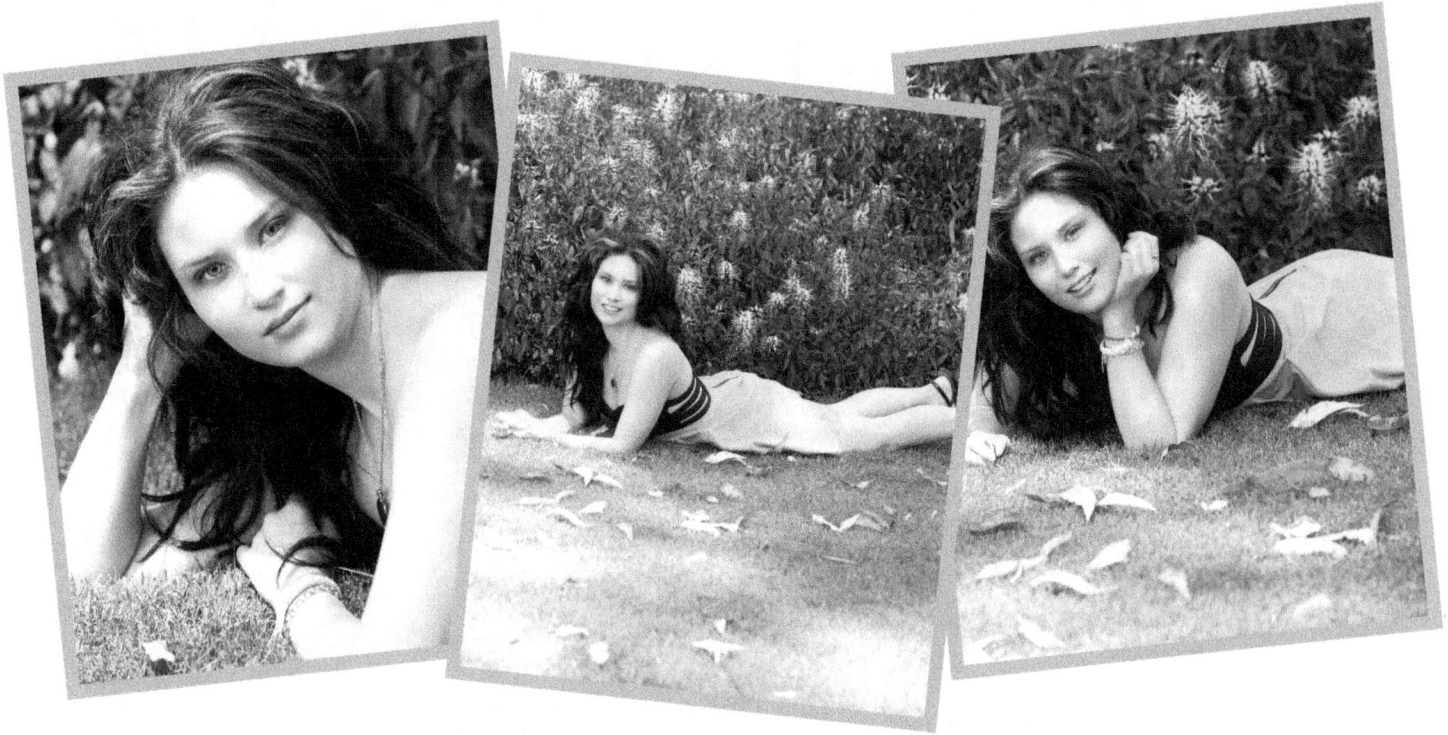

page 17

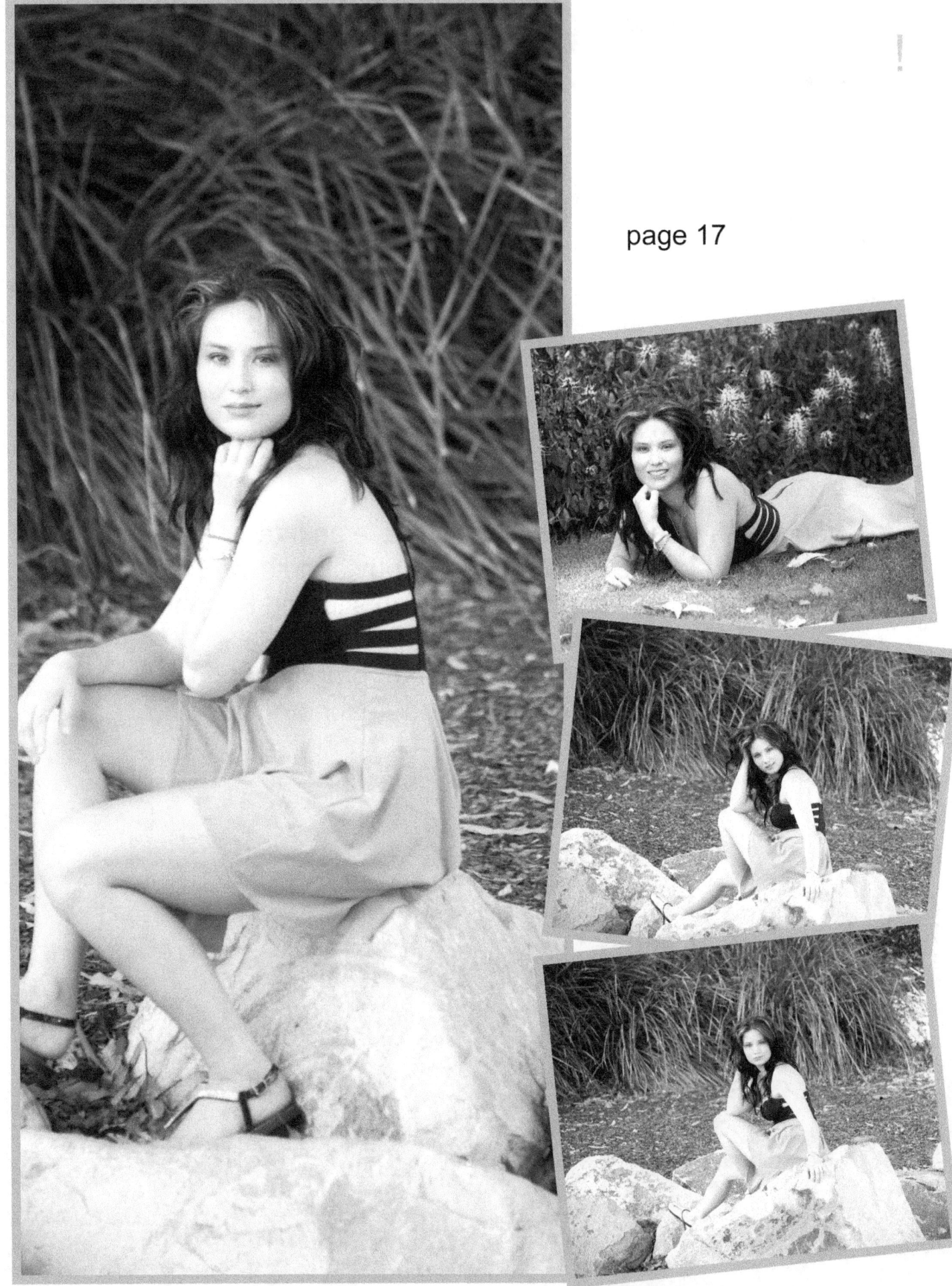

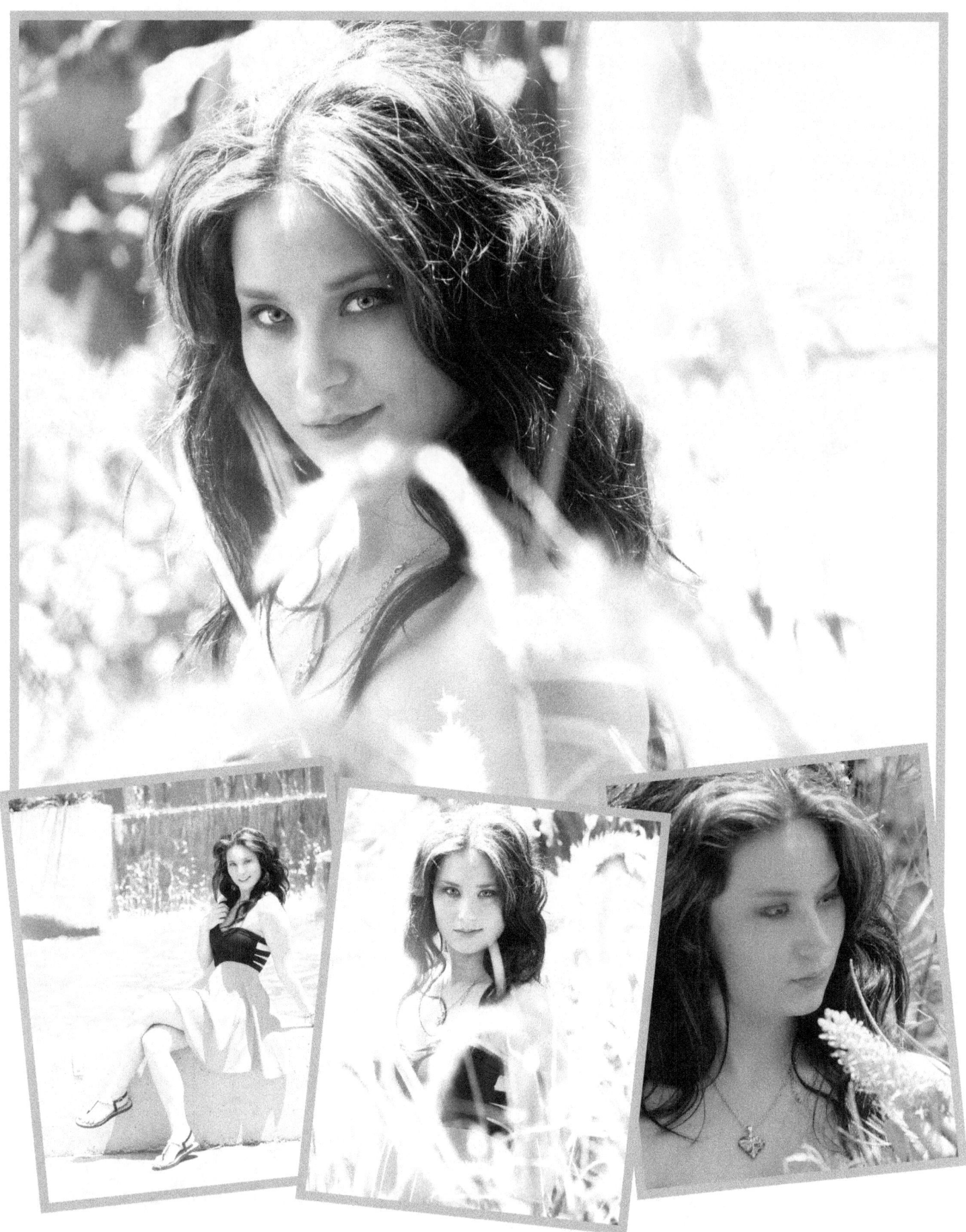

page 19

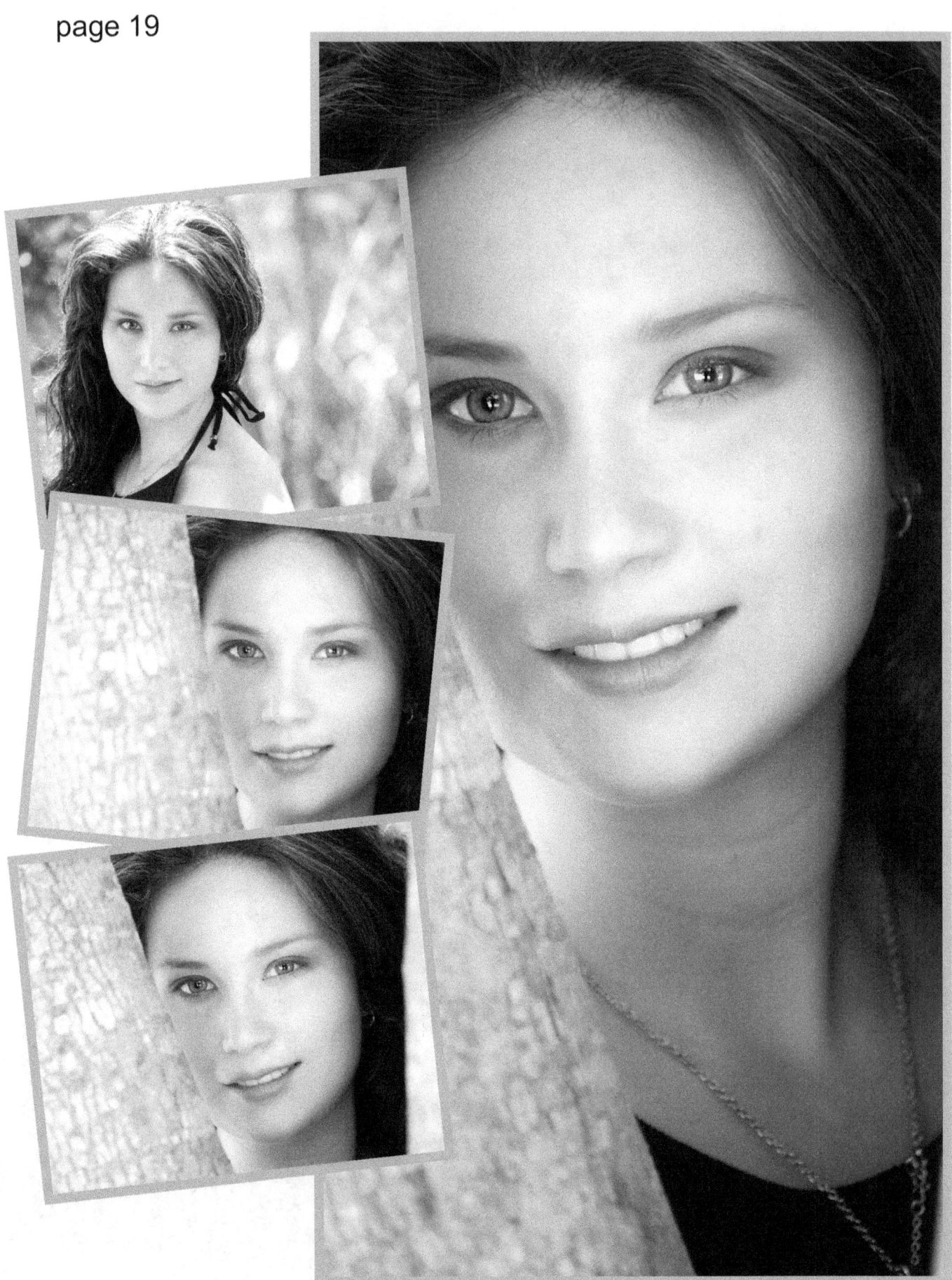

Australia Day - 26 January, 2016

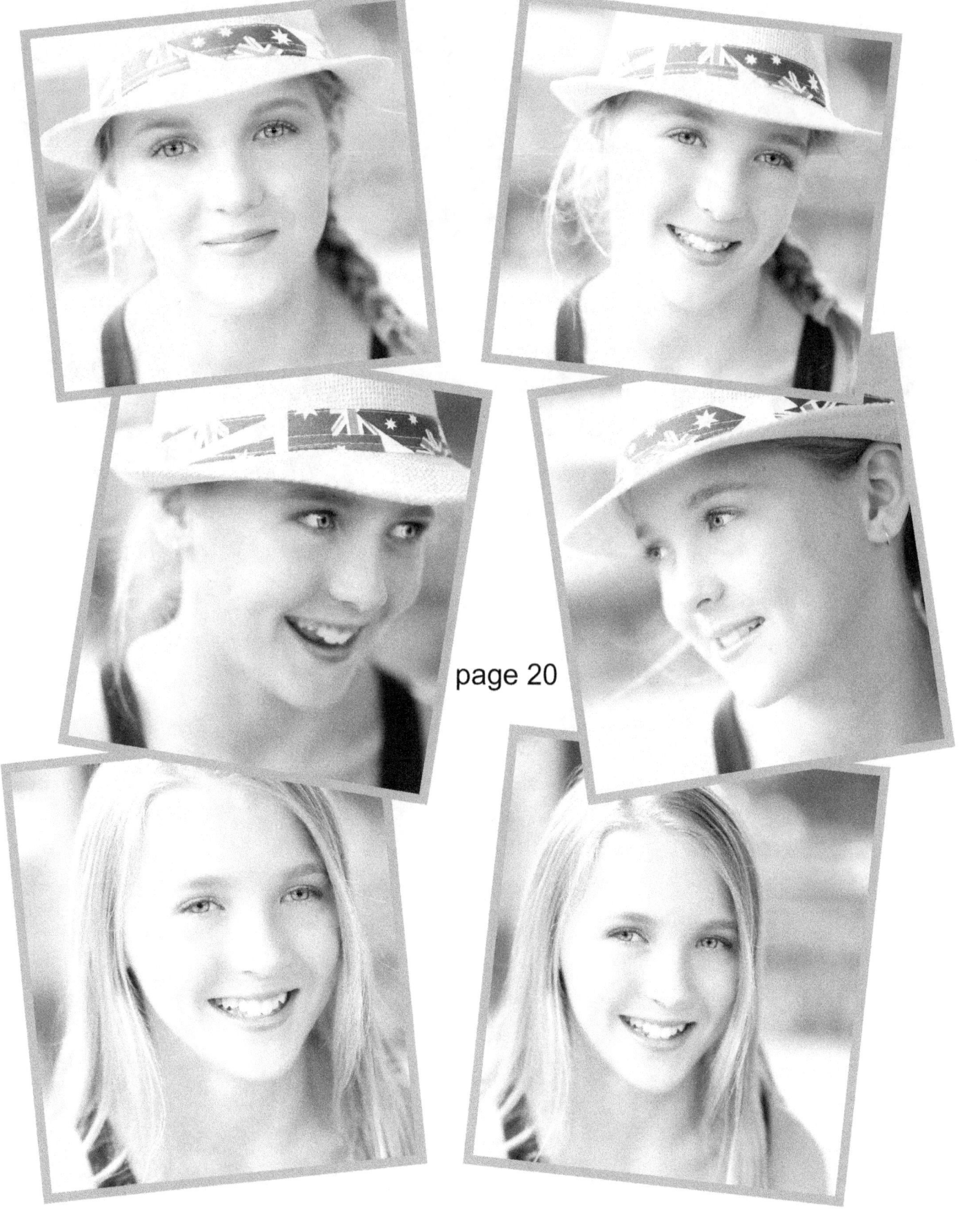

page 20

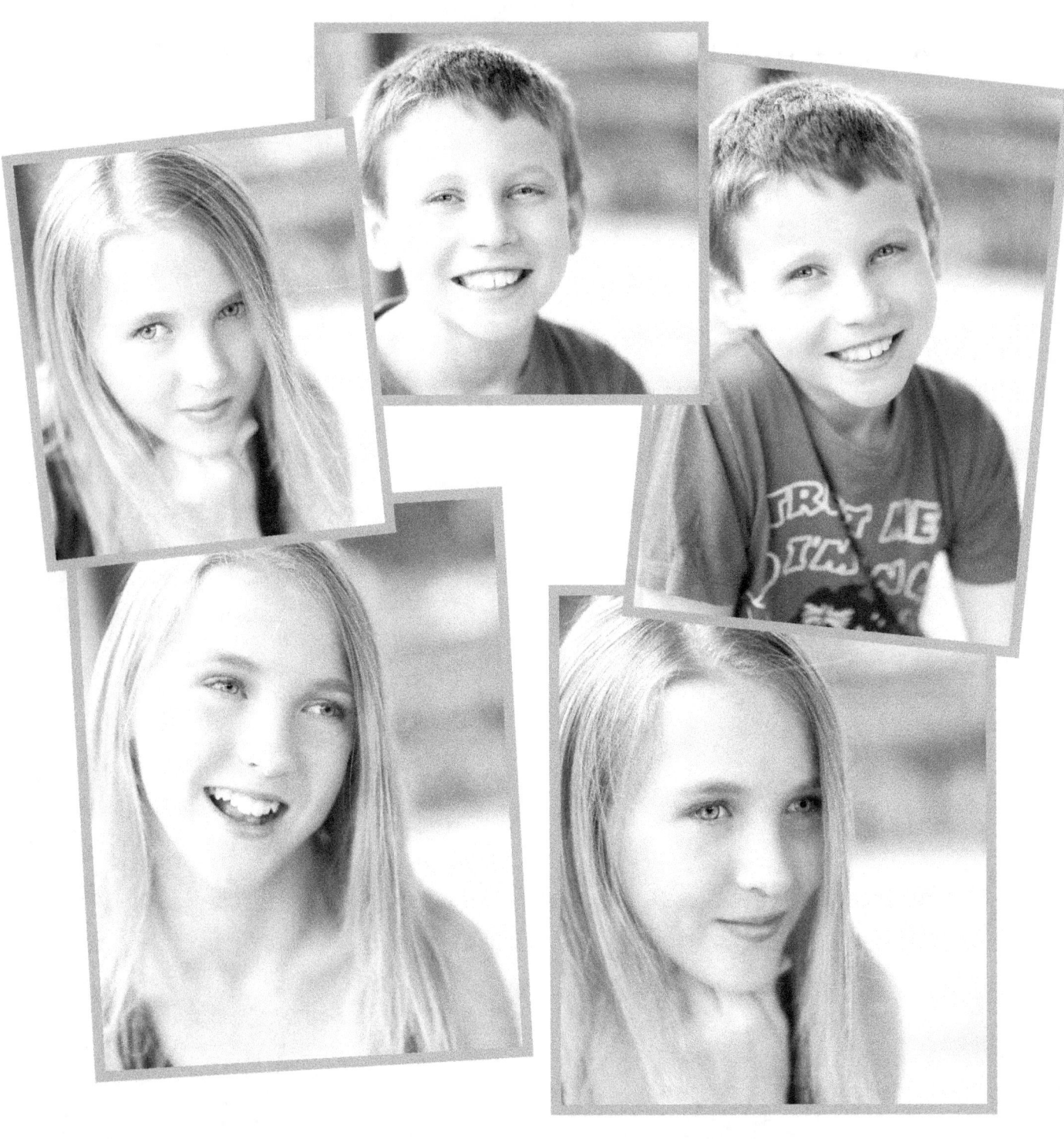

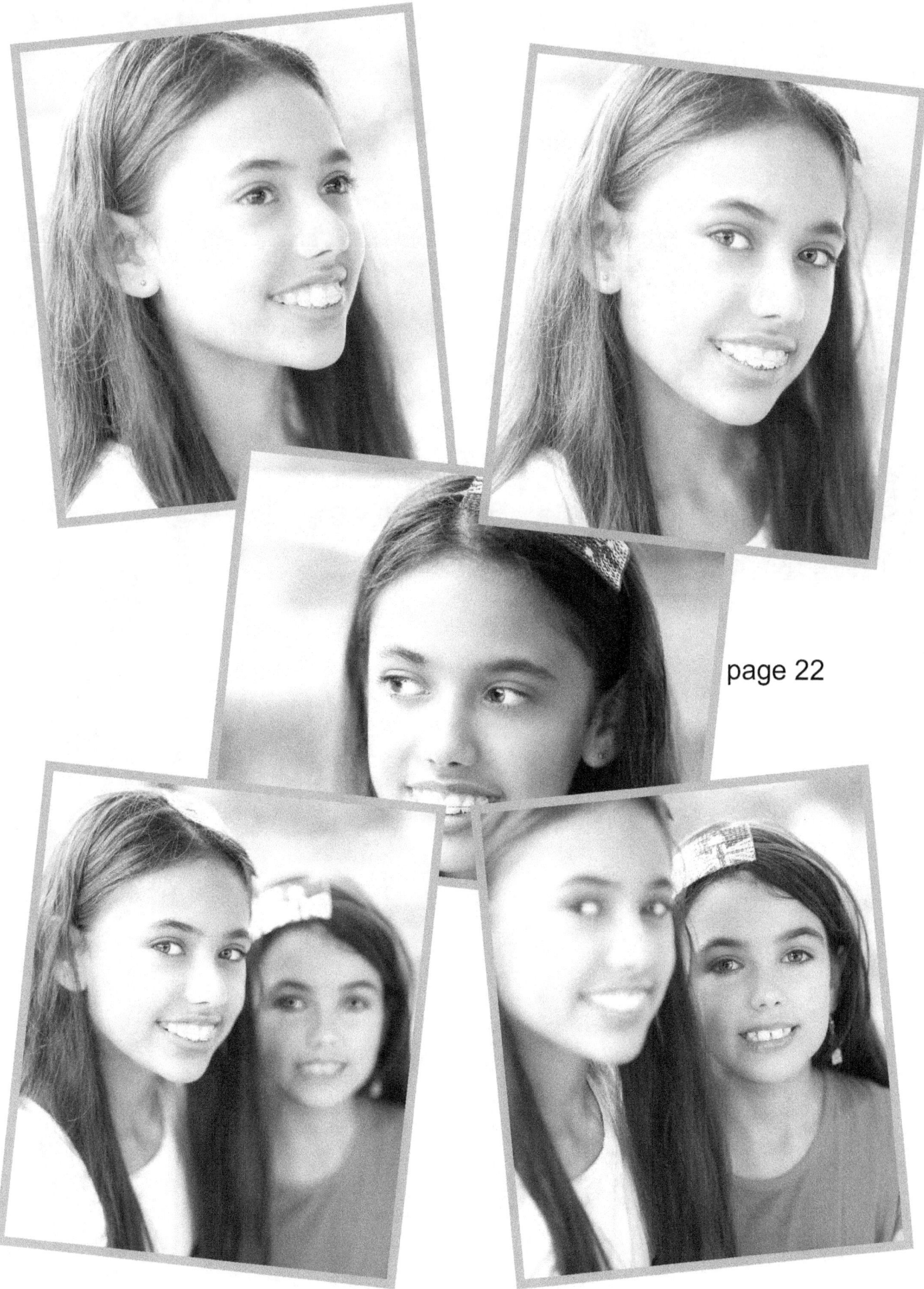

page 22

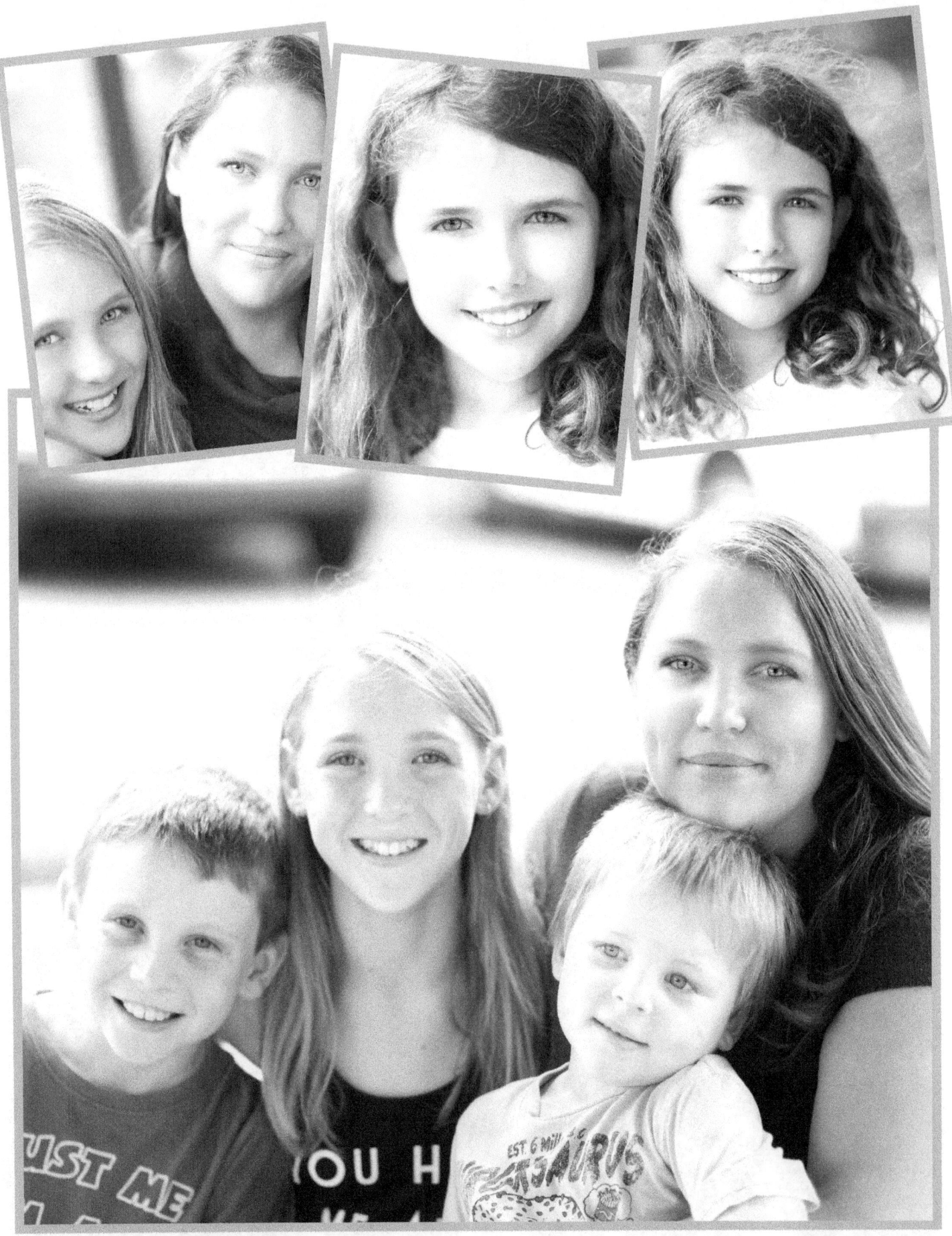

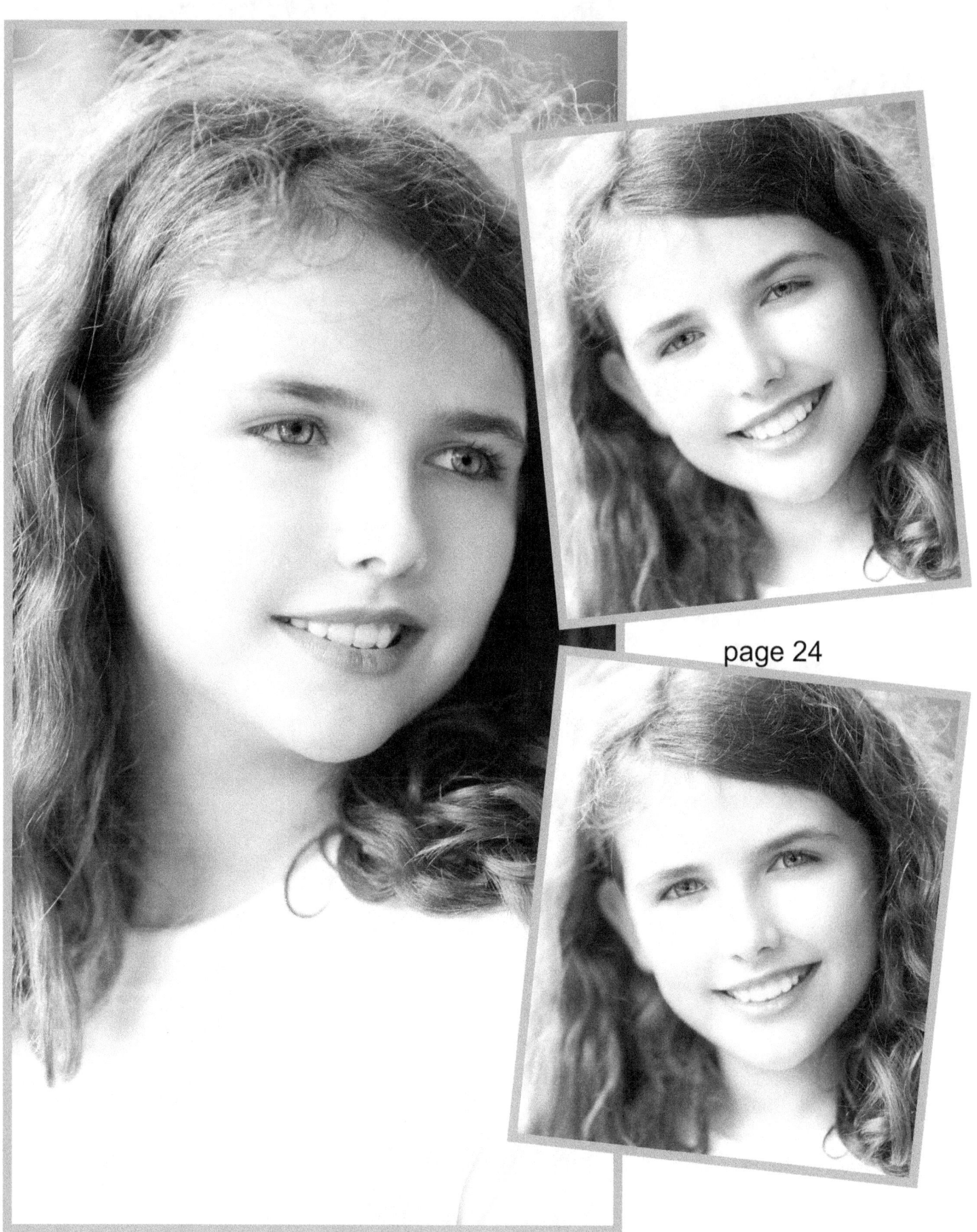

page 24

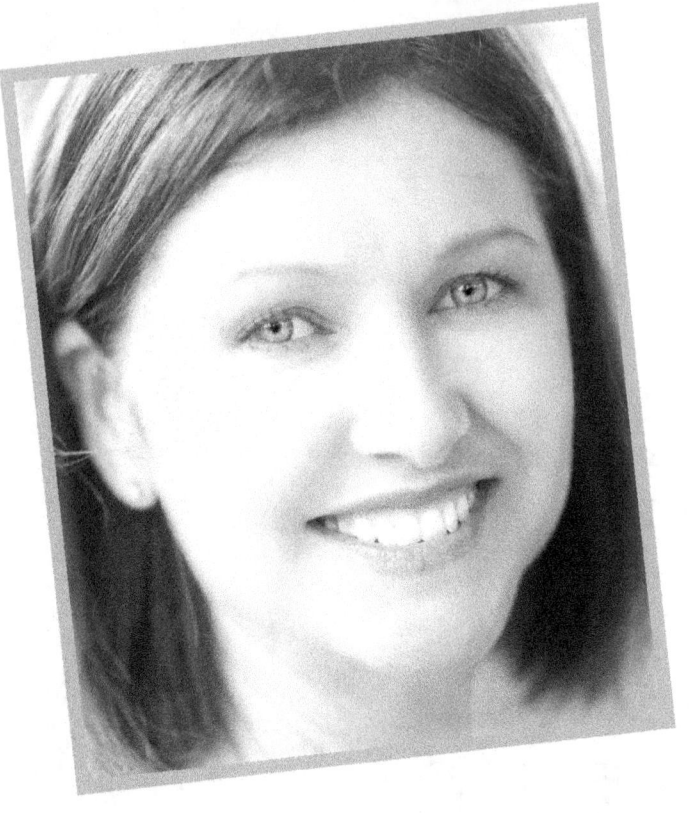
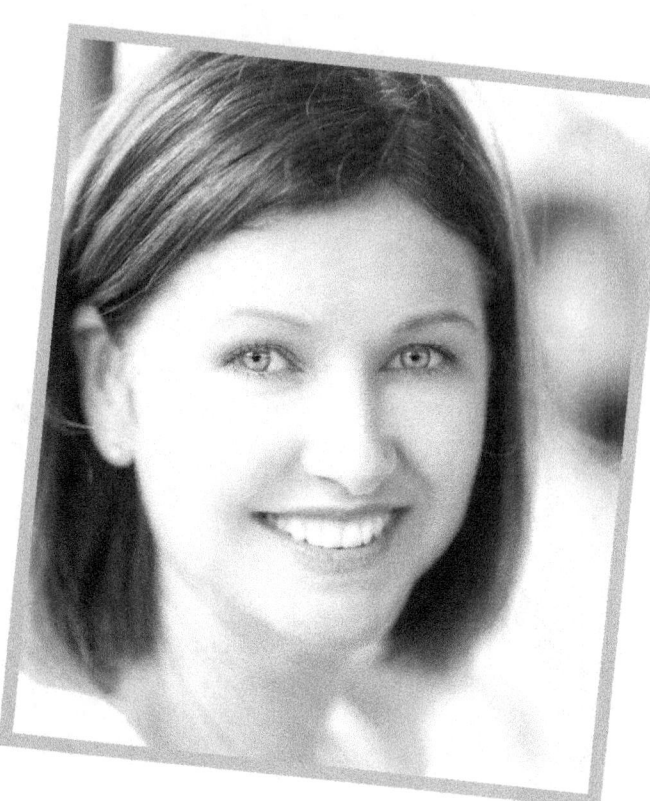

page 25

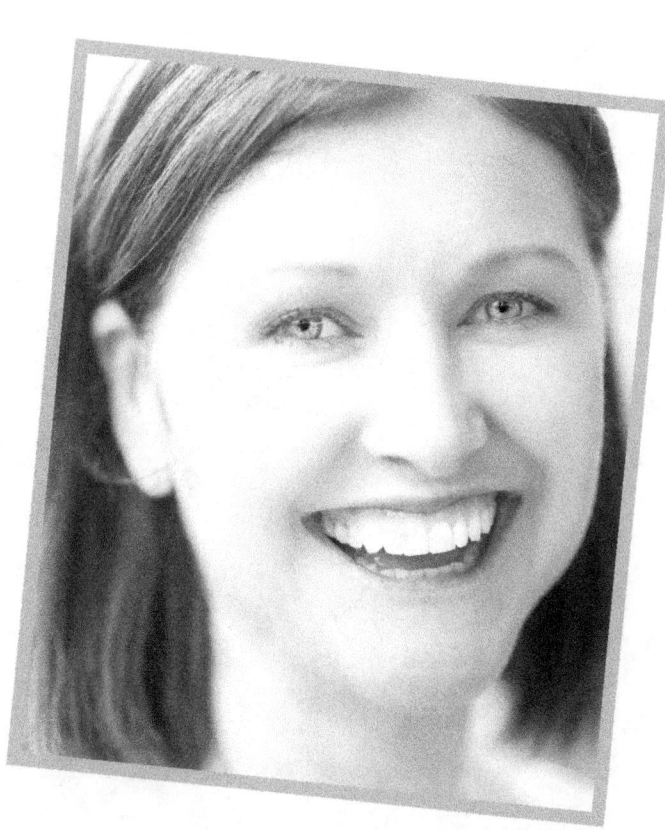
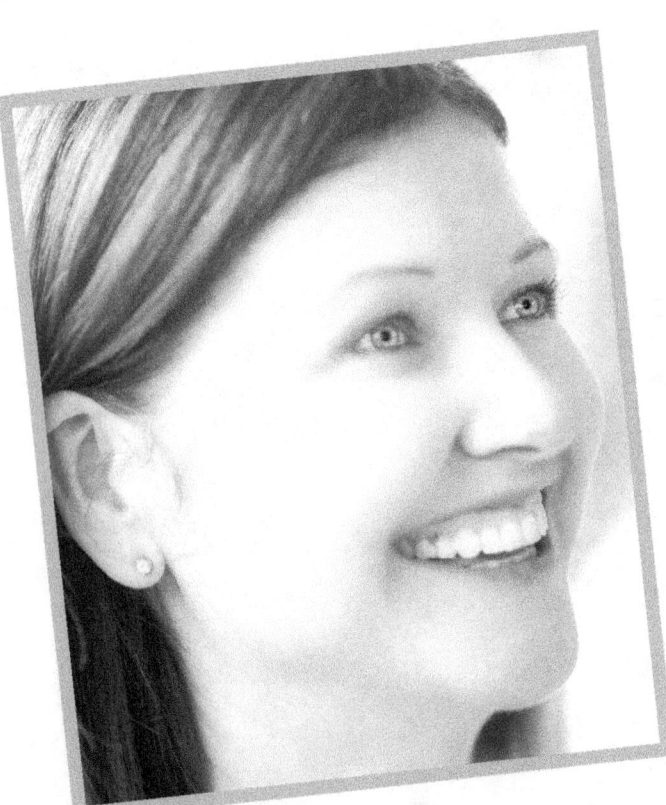

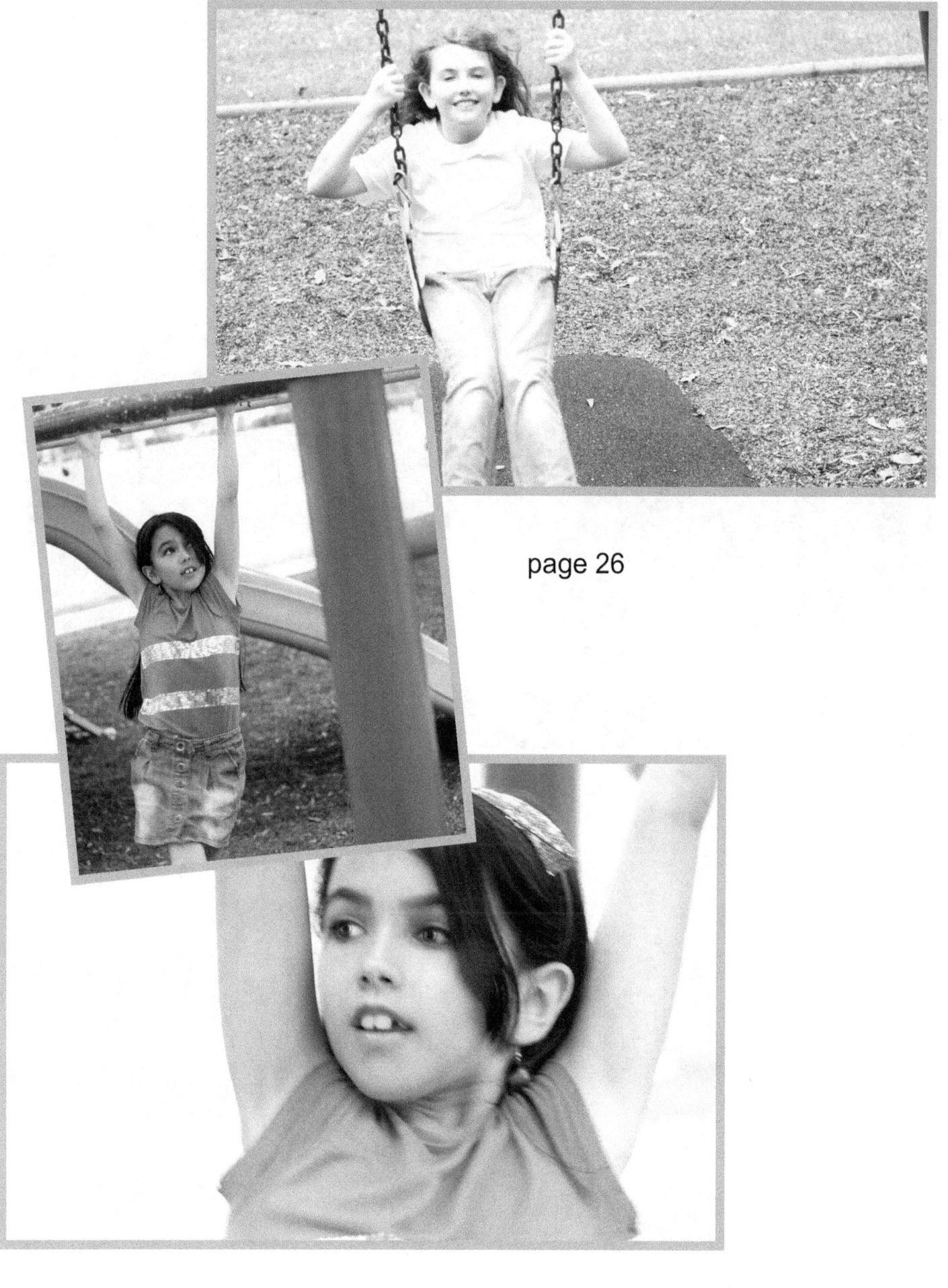

page 26

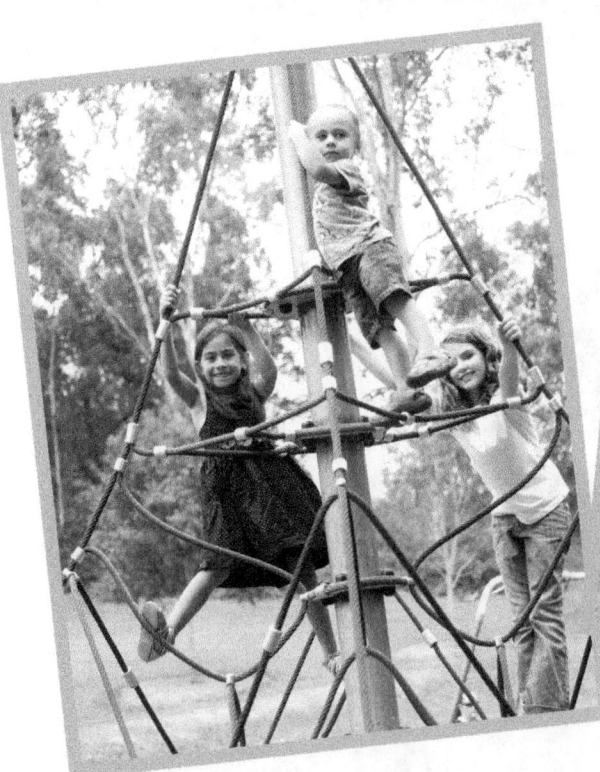
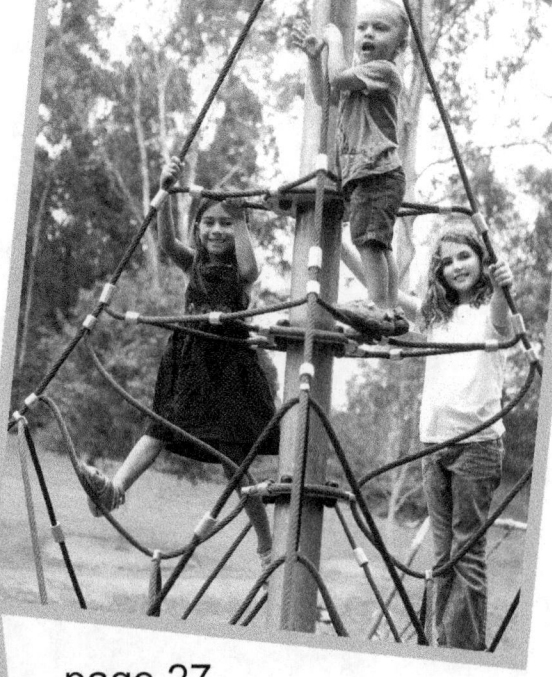

page 27

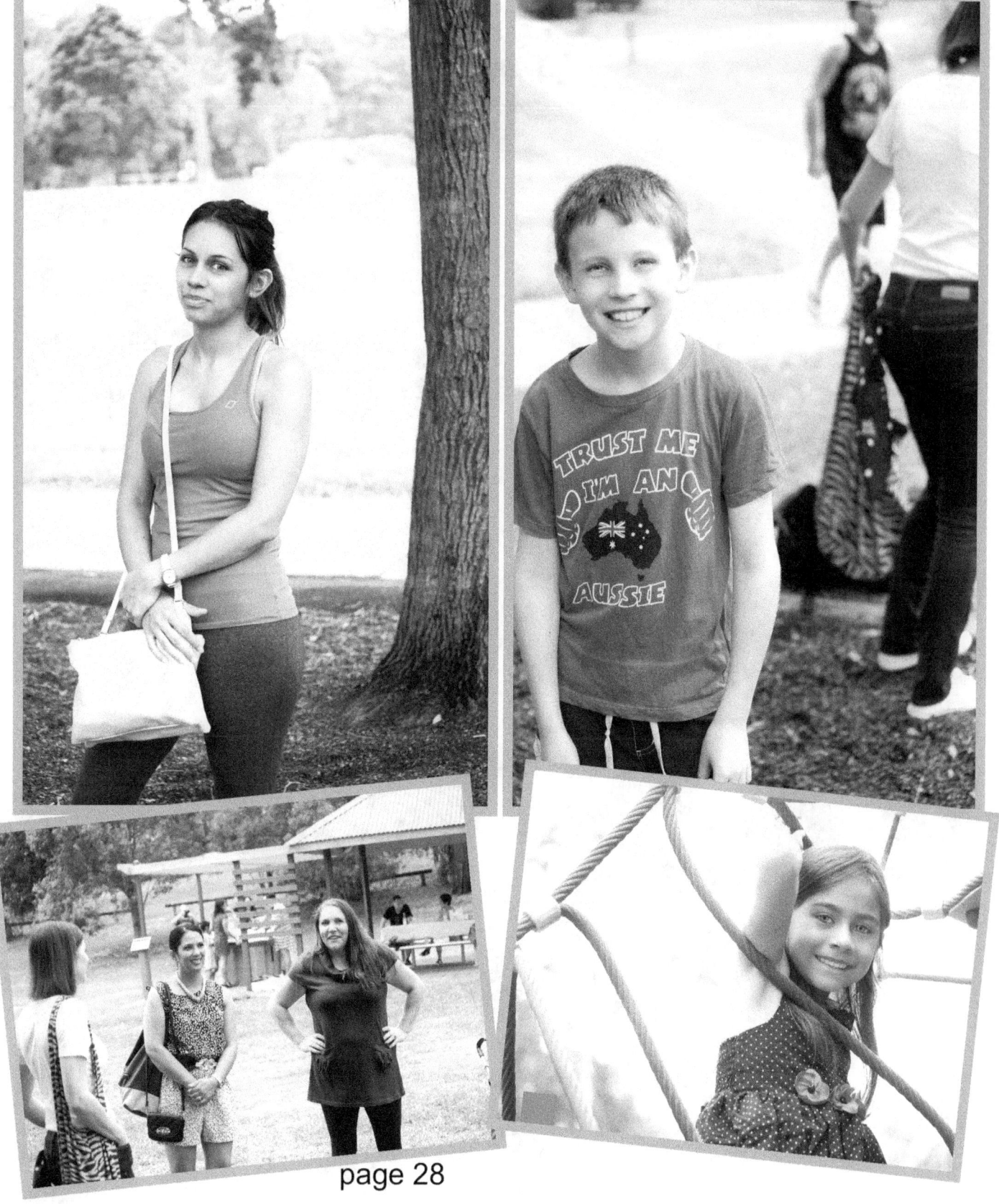

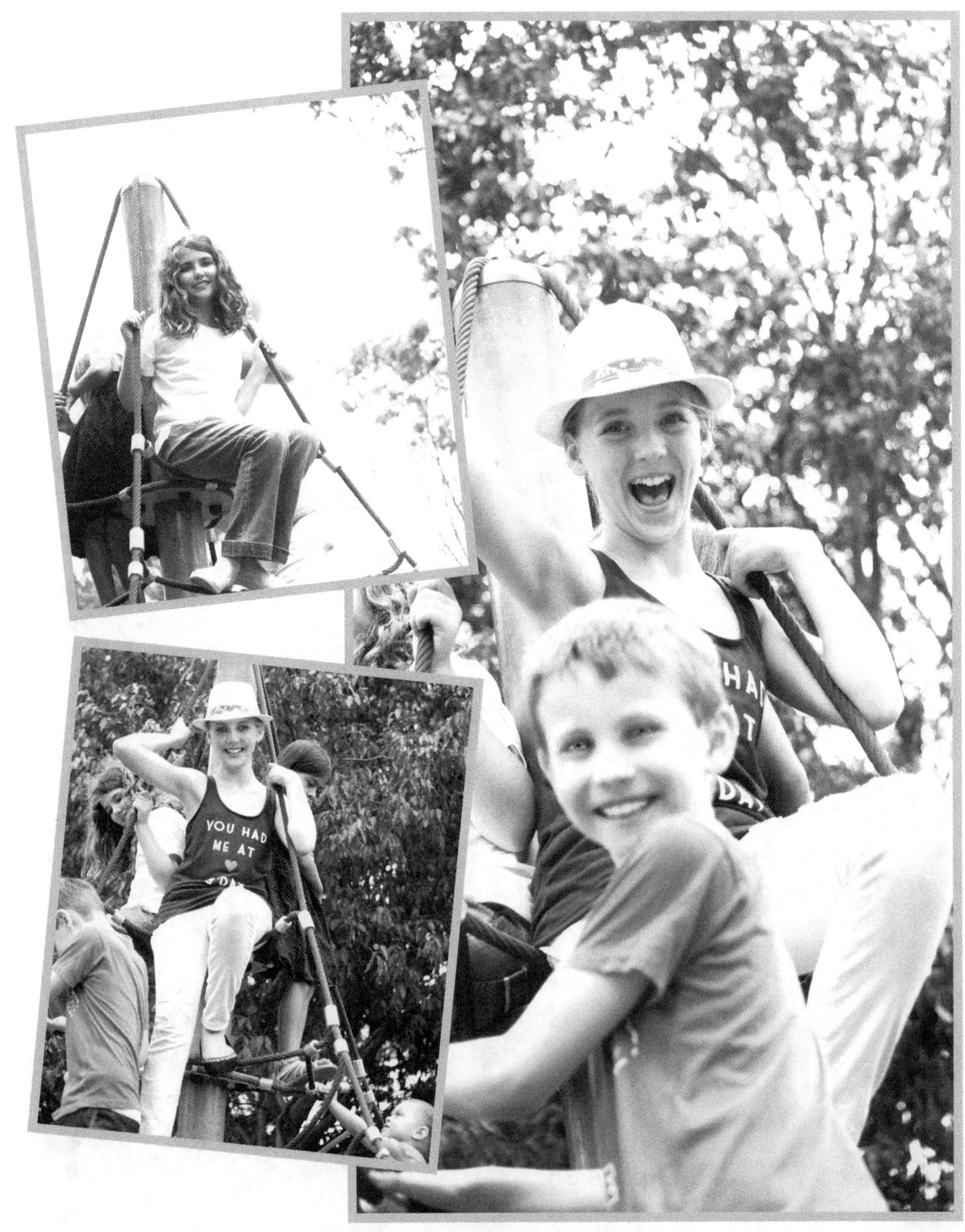

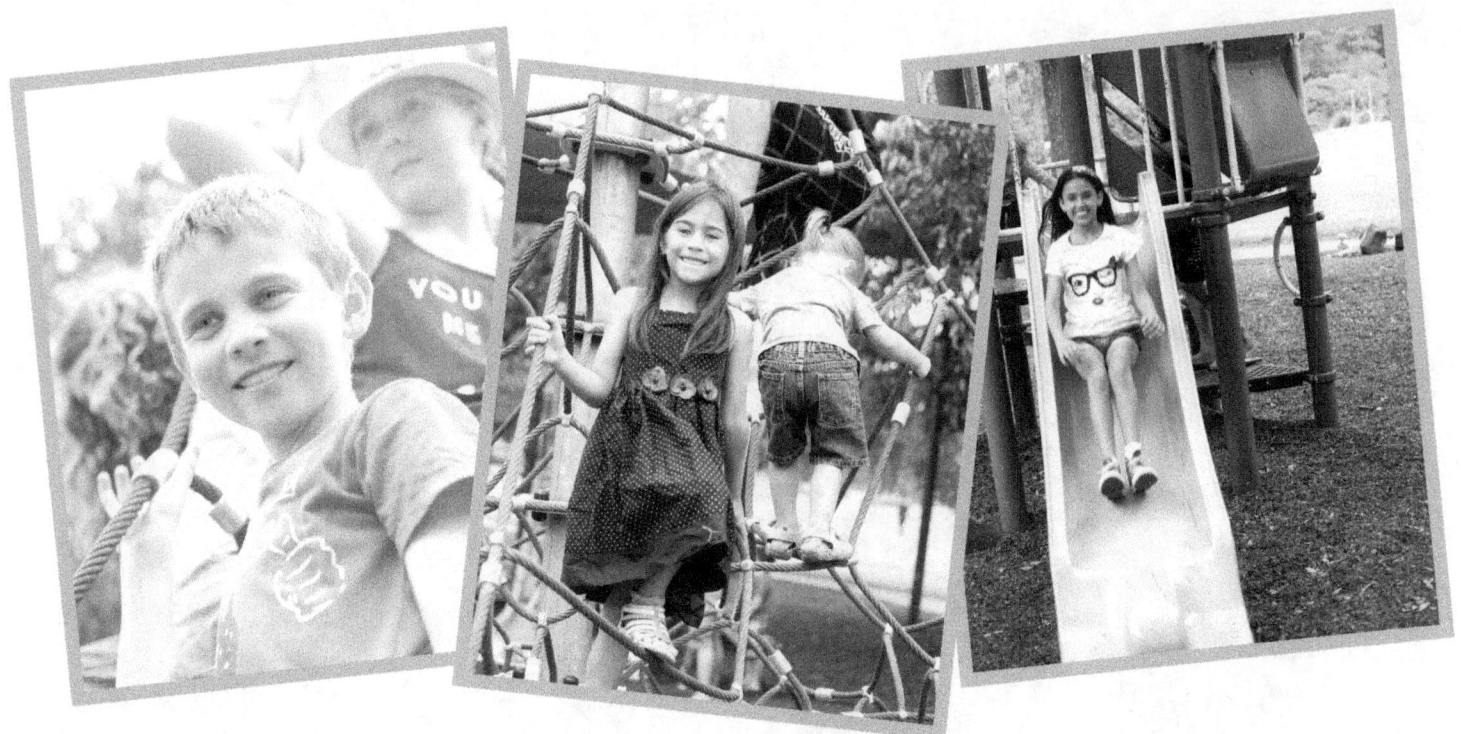

The photographs on this page, the preceding pages and the following pages were taken at the Sherwood Arboritum. This is a large park in Brisbane's inner western suburbs.

page 30

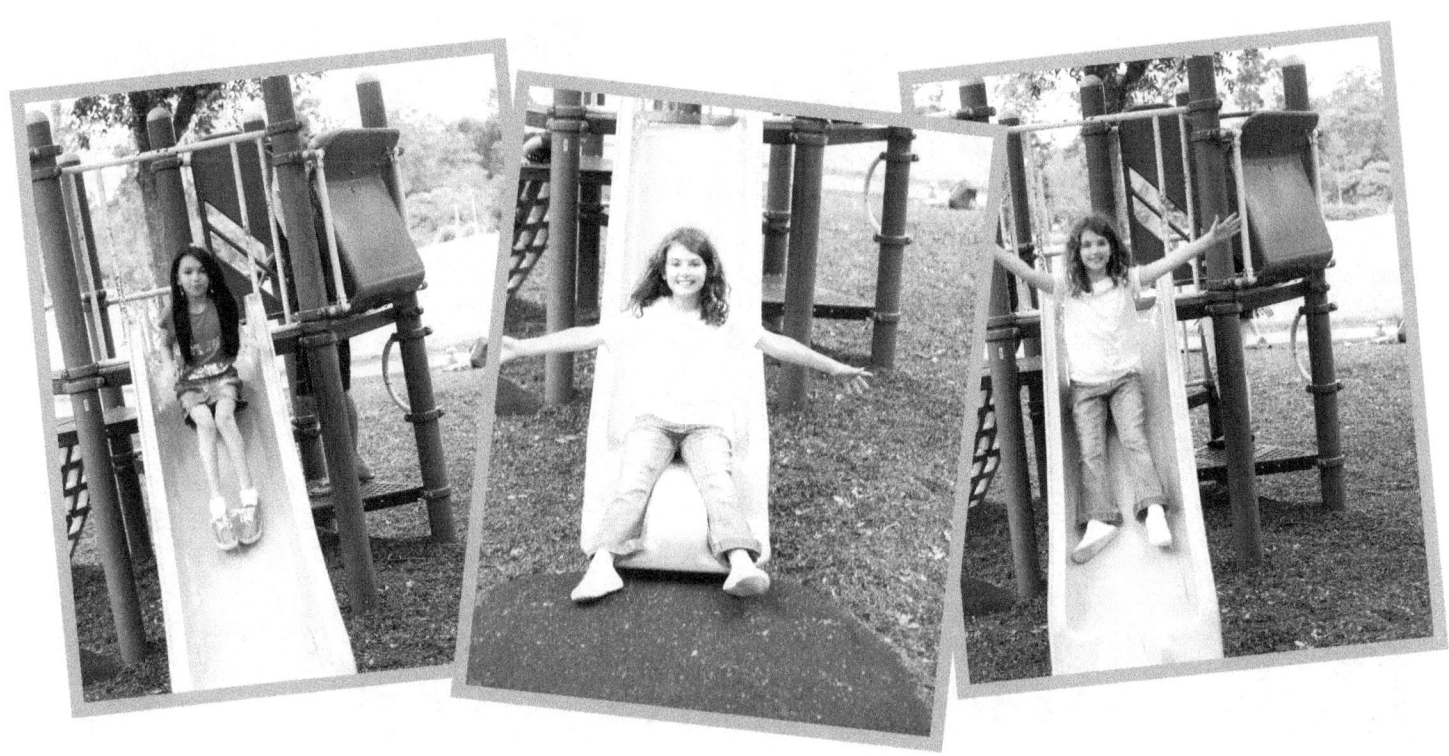

page 31

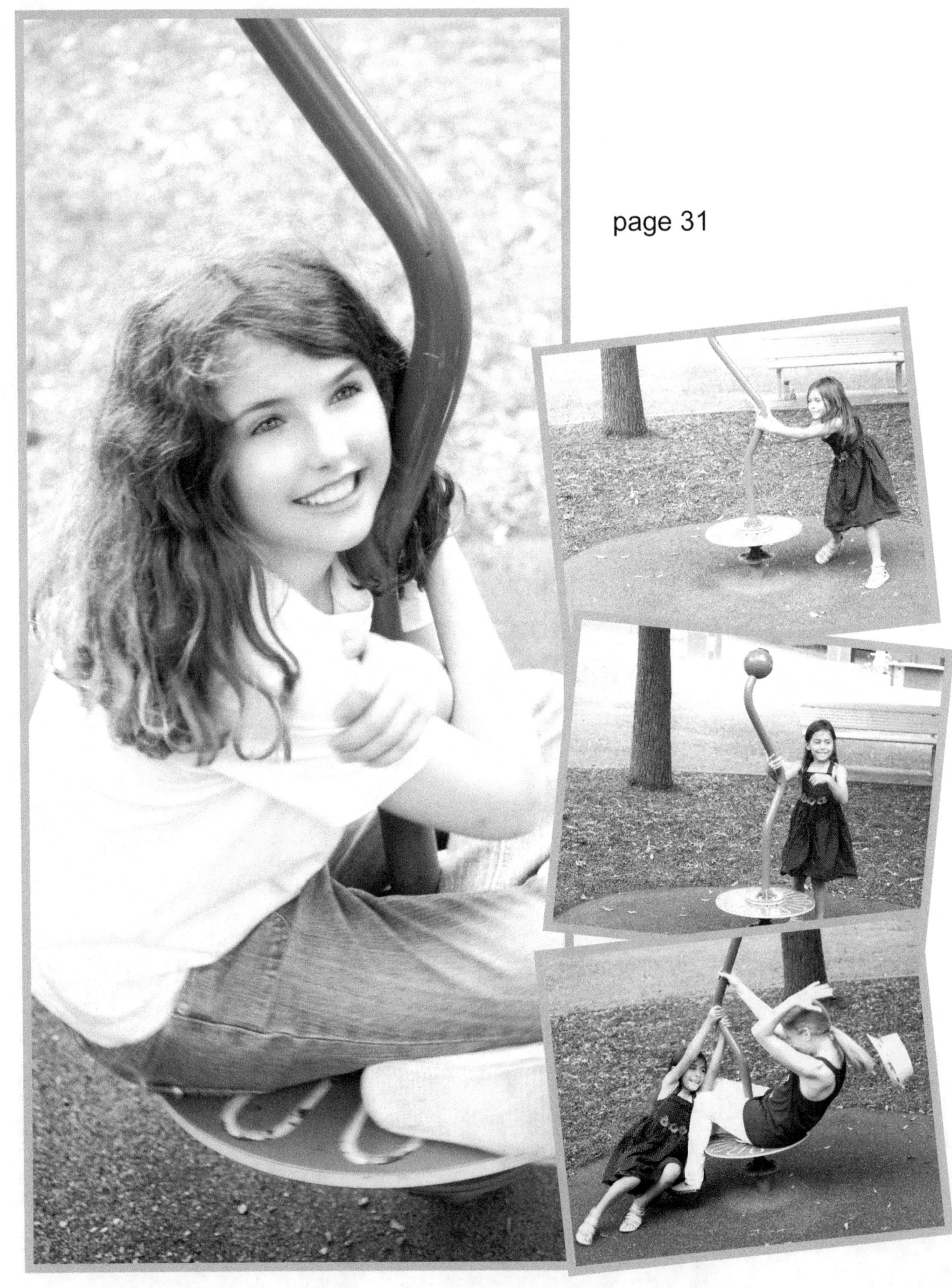

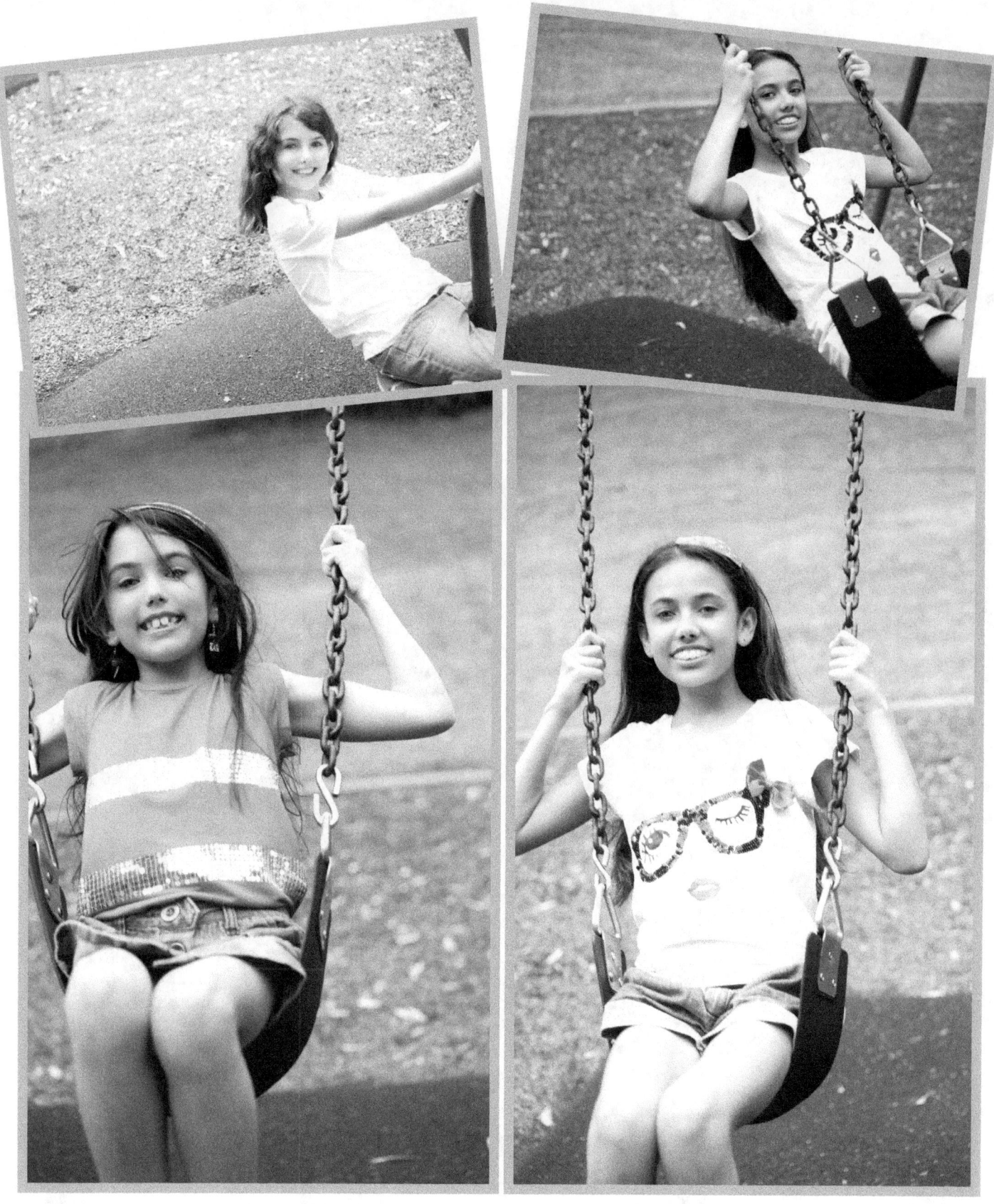

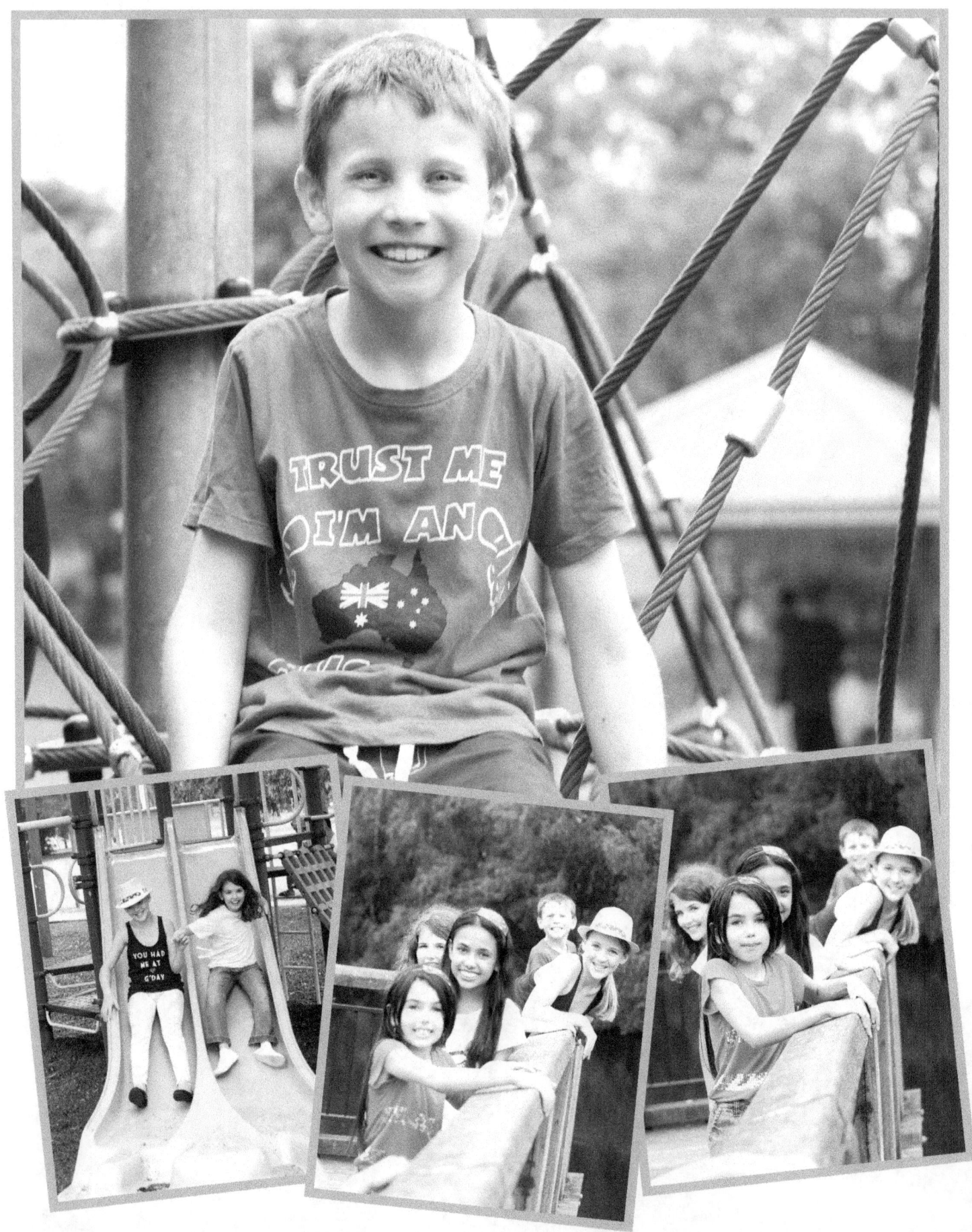

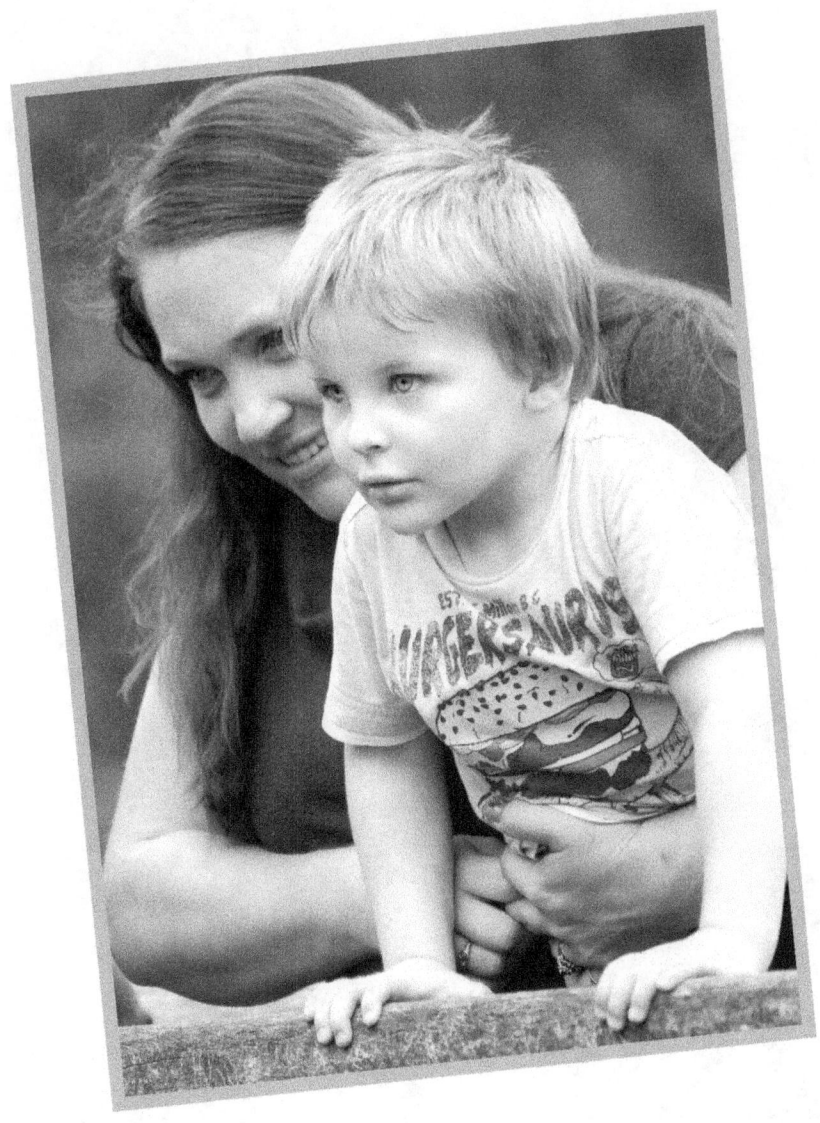

page 34

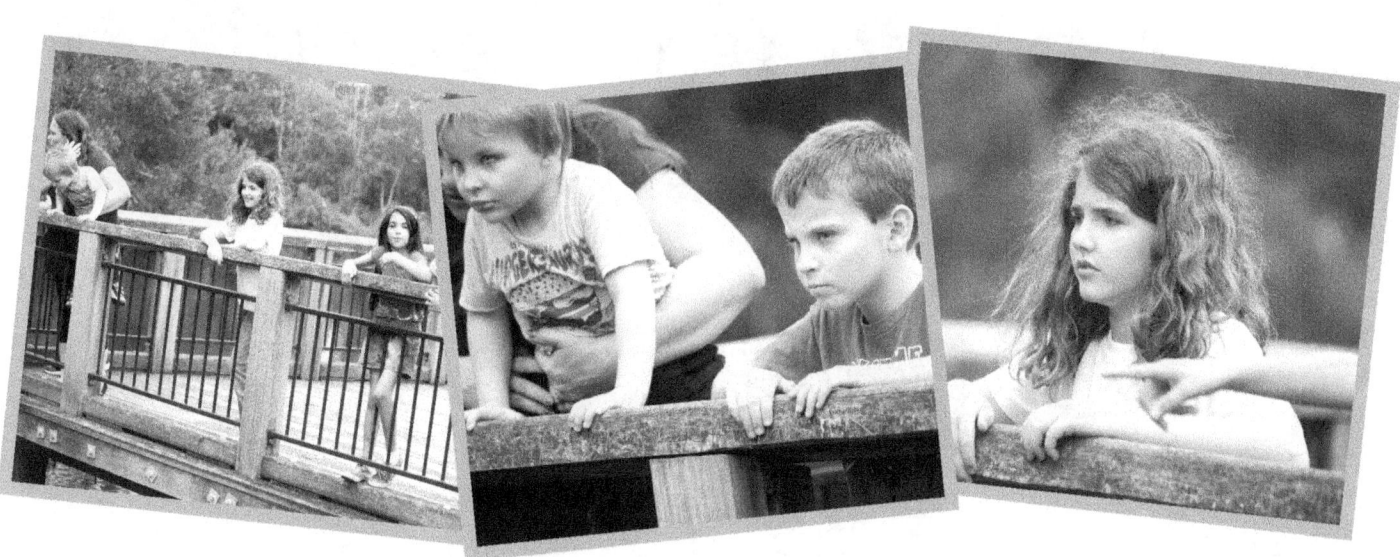

page 35

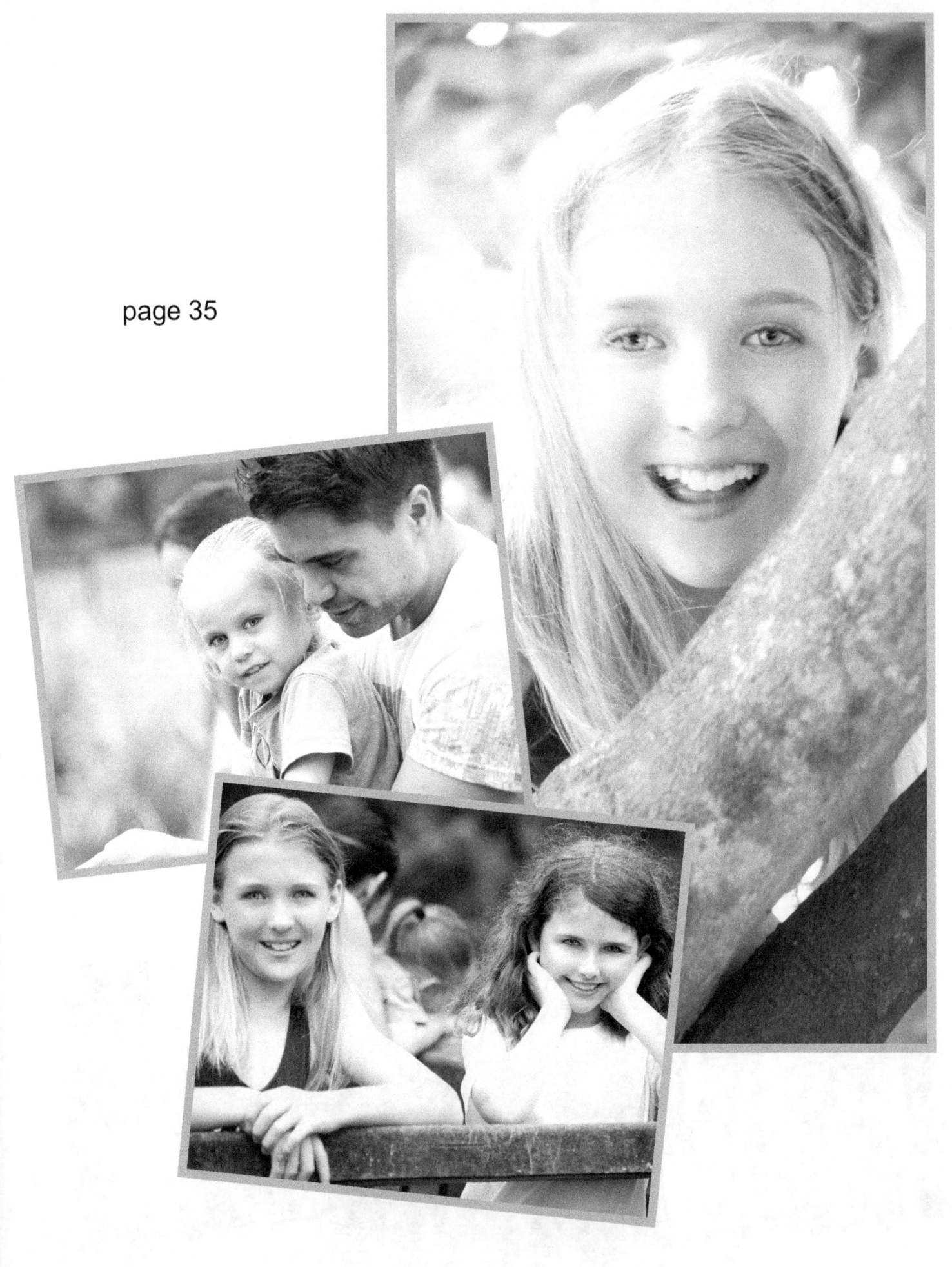

page 36

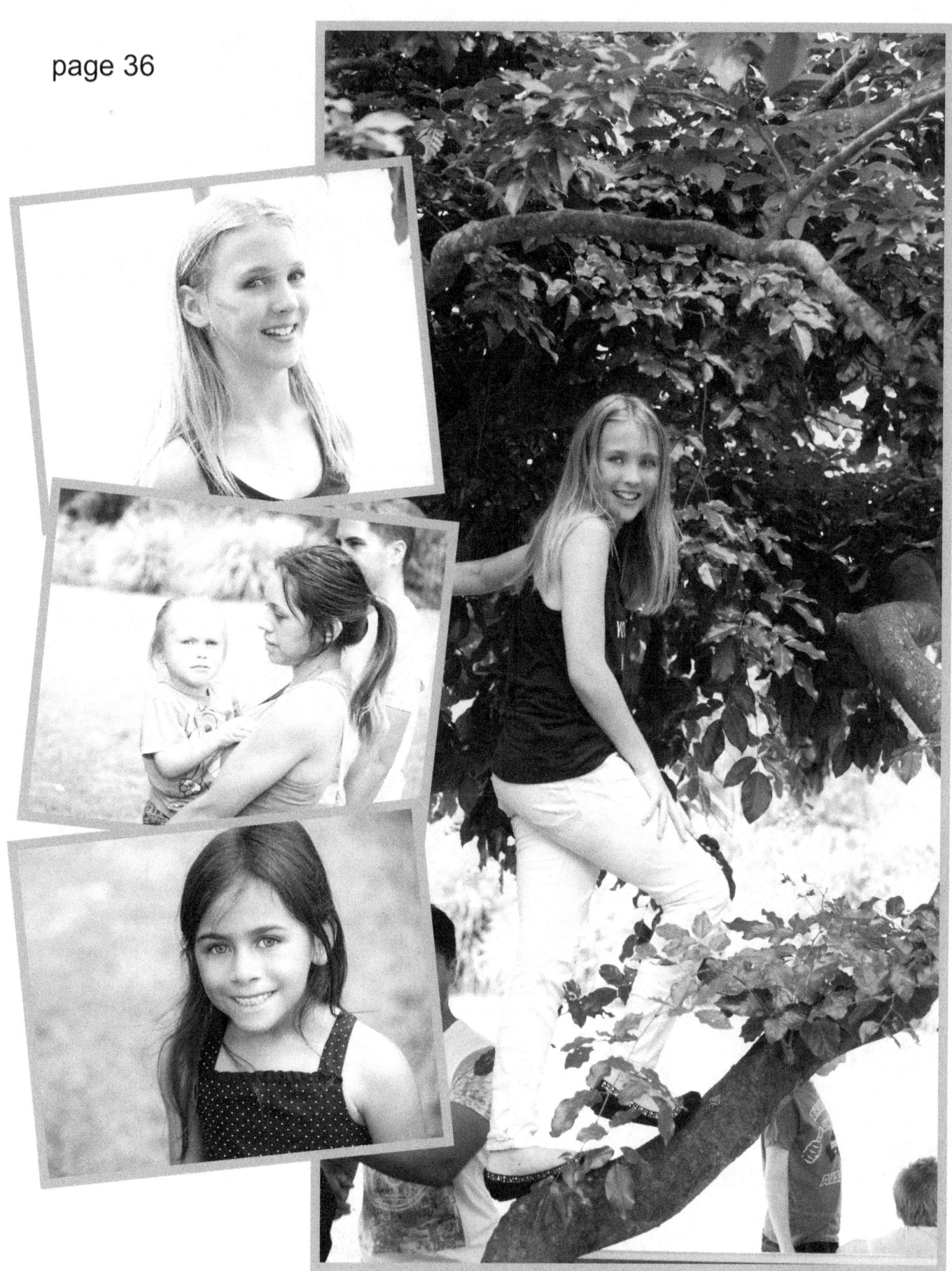

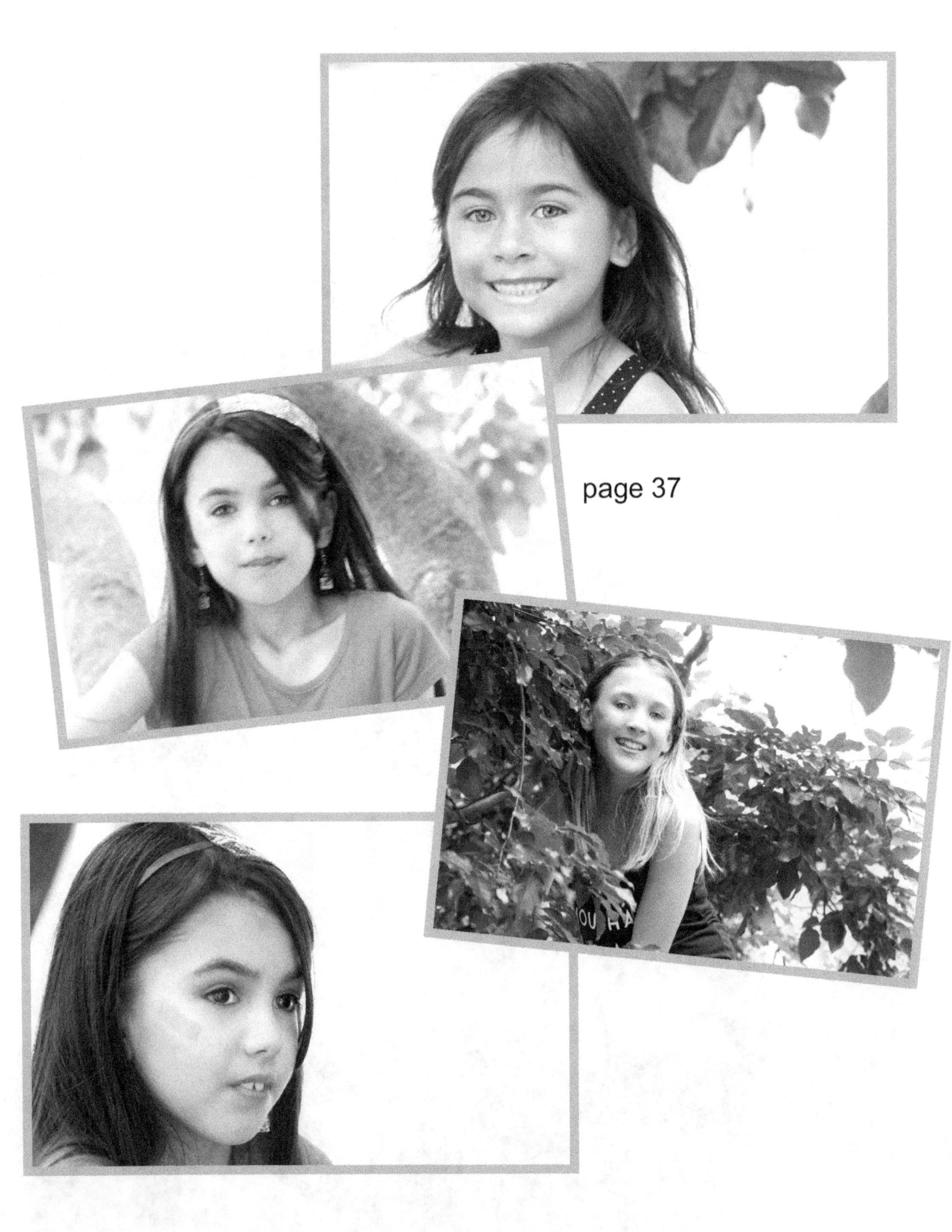

page 37

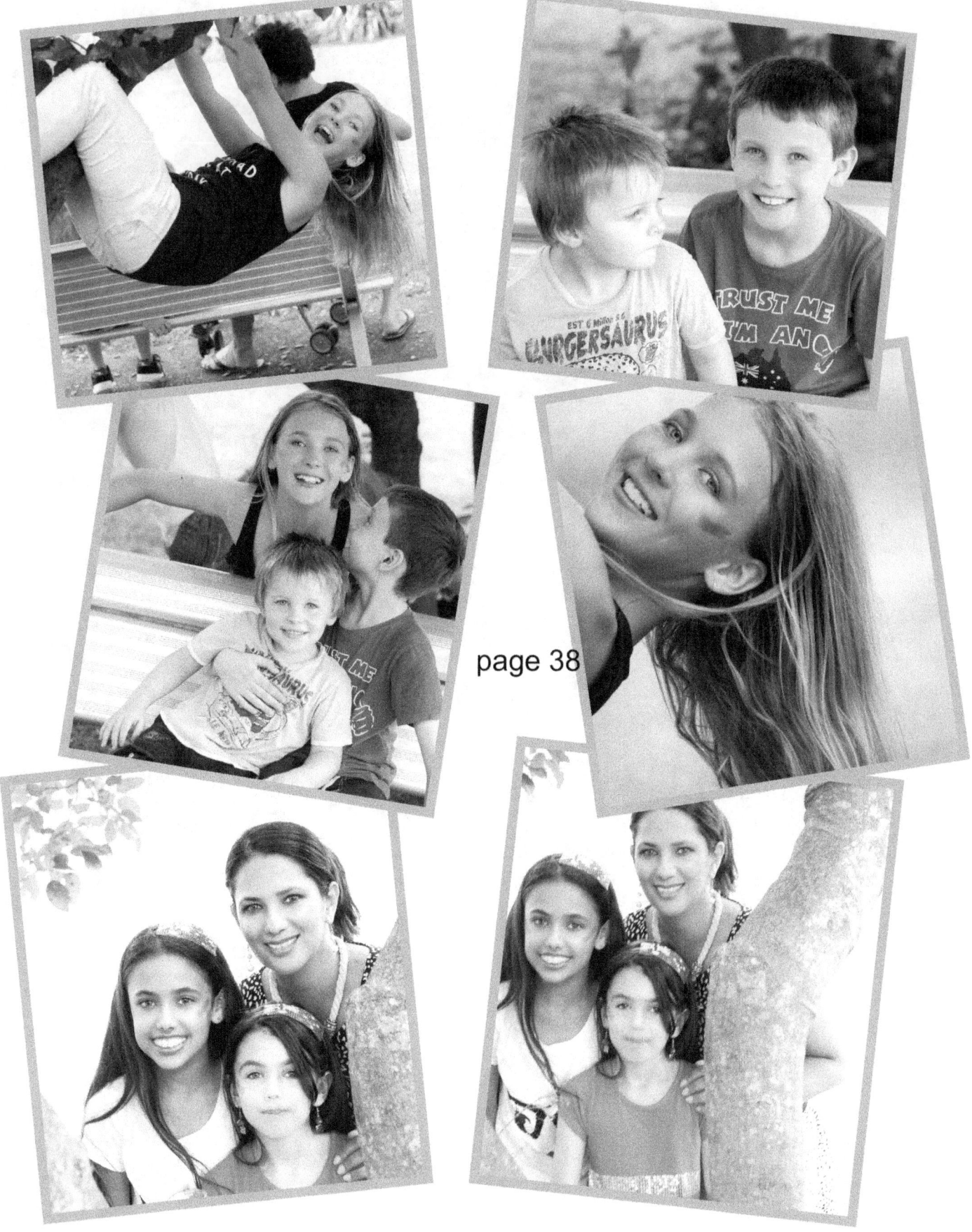

page 38

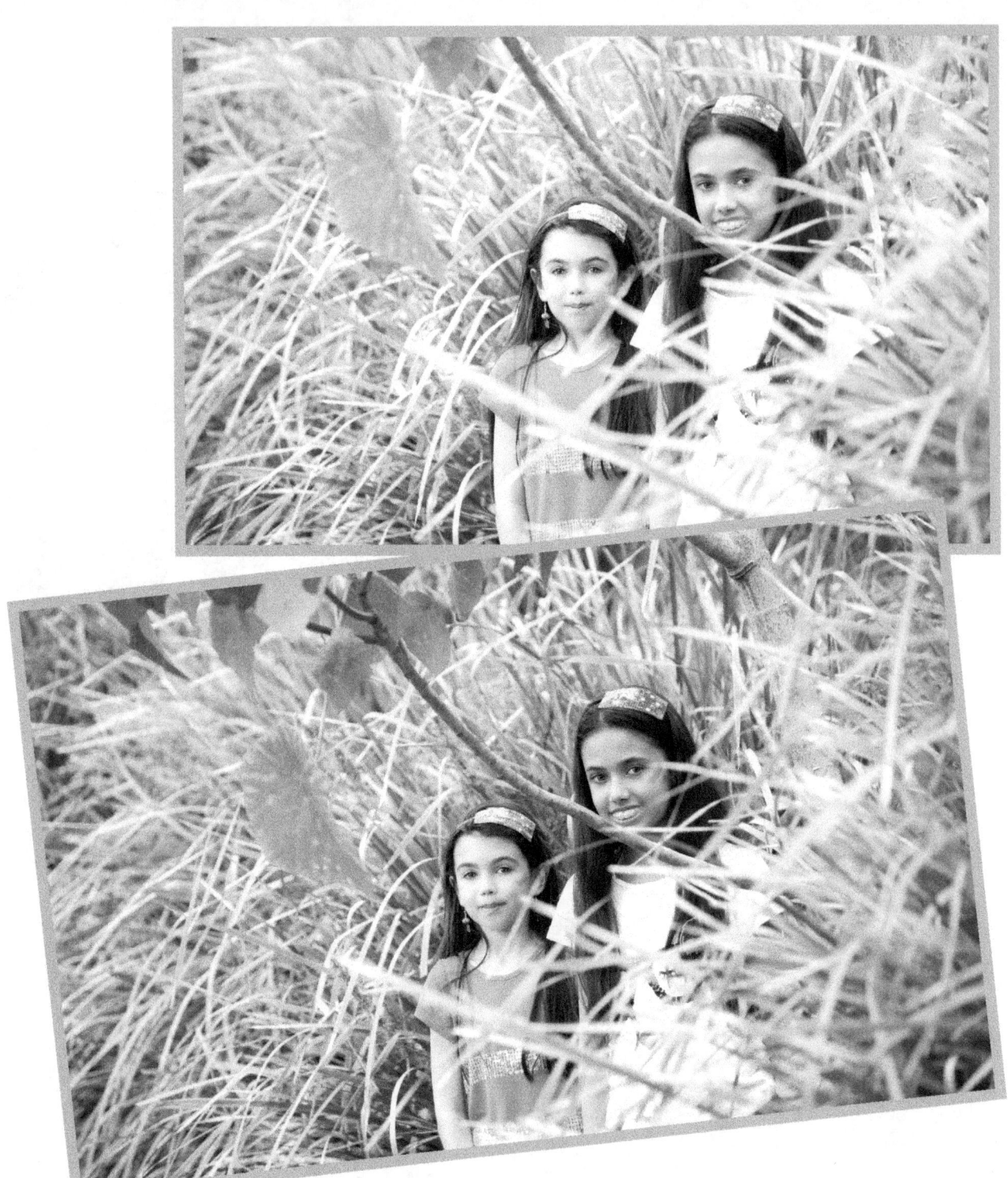

page 39

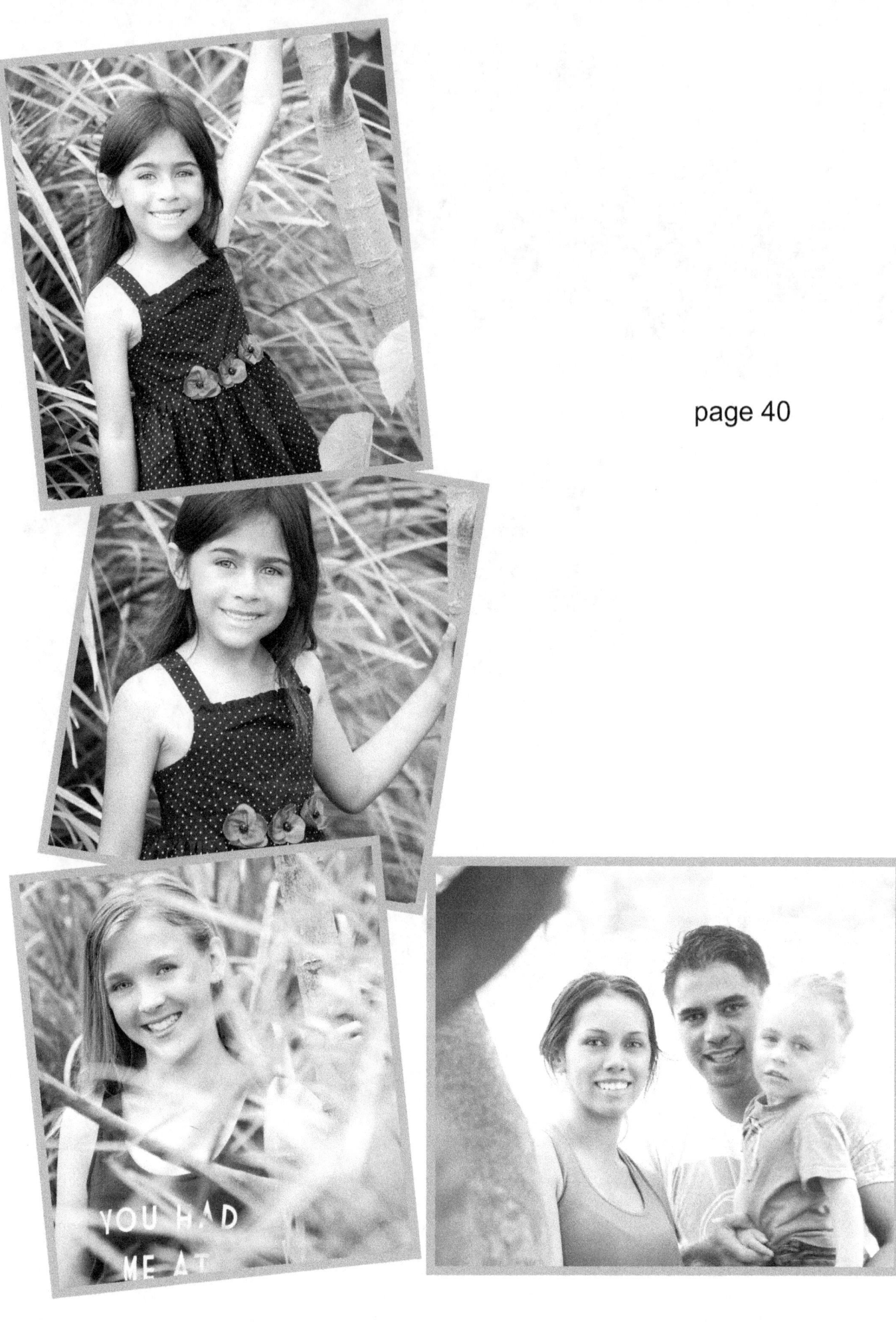

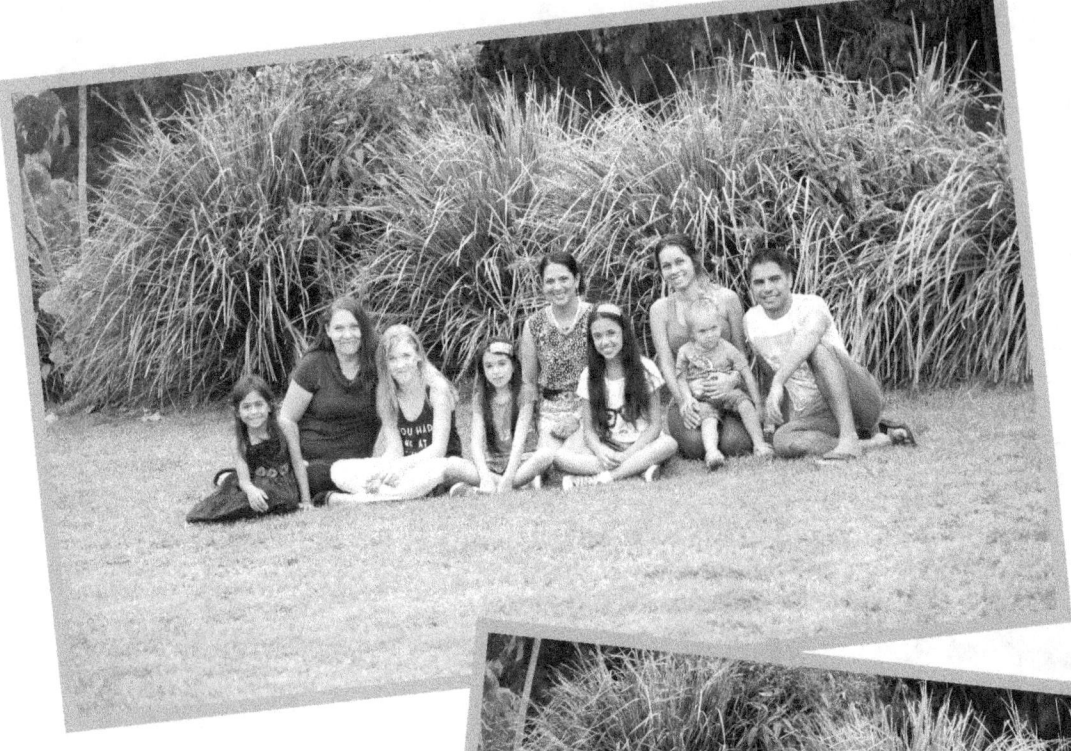

page 41

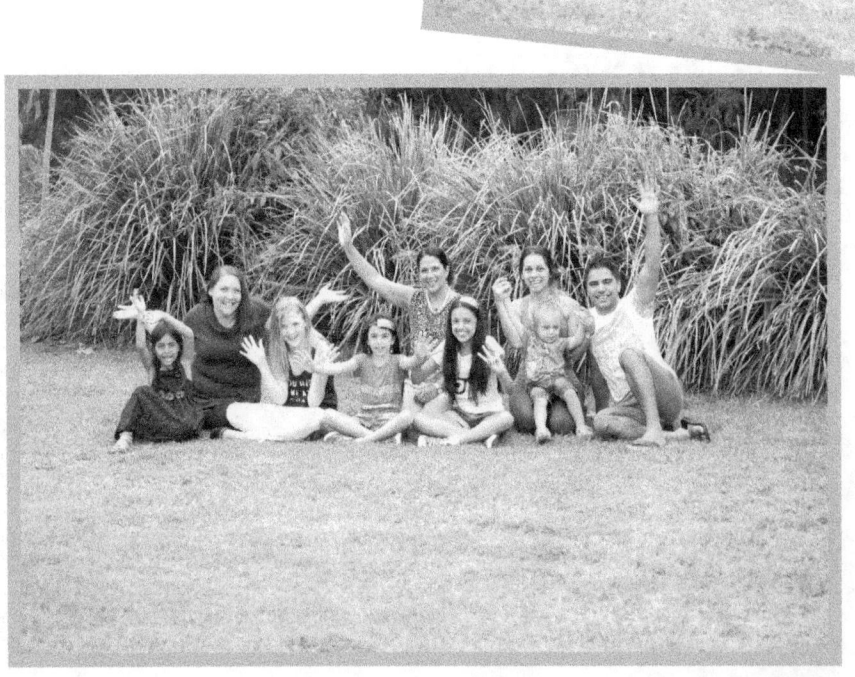

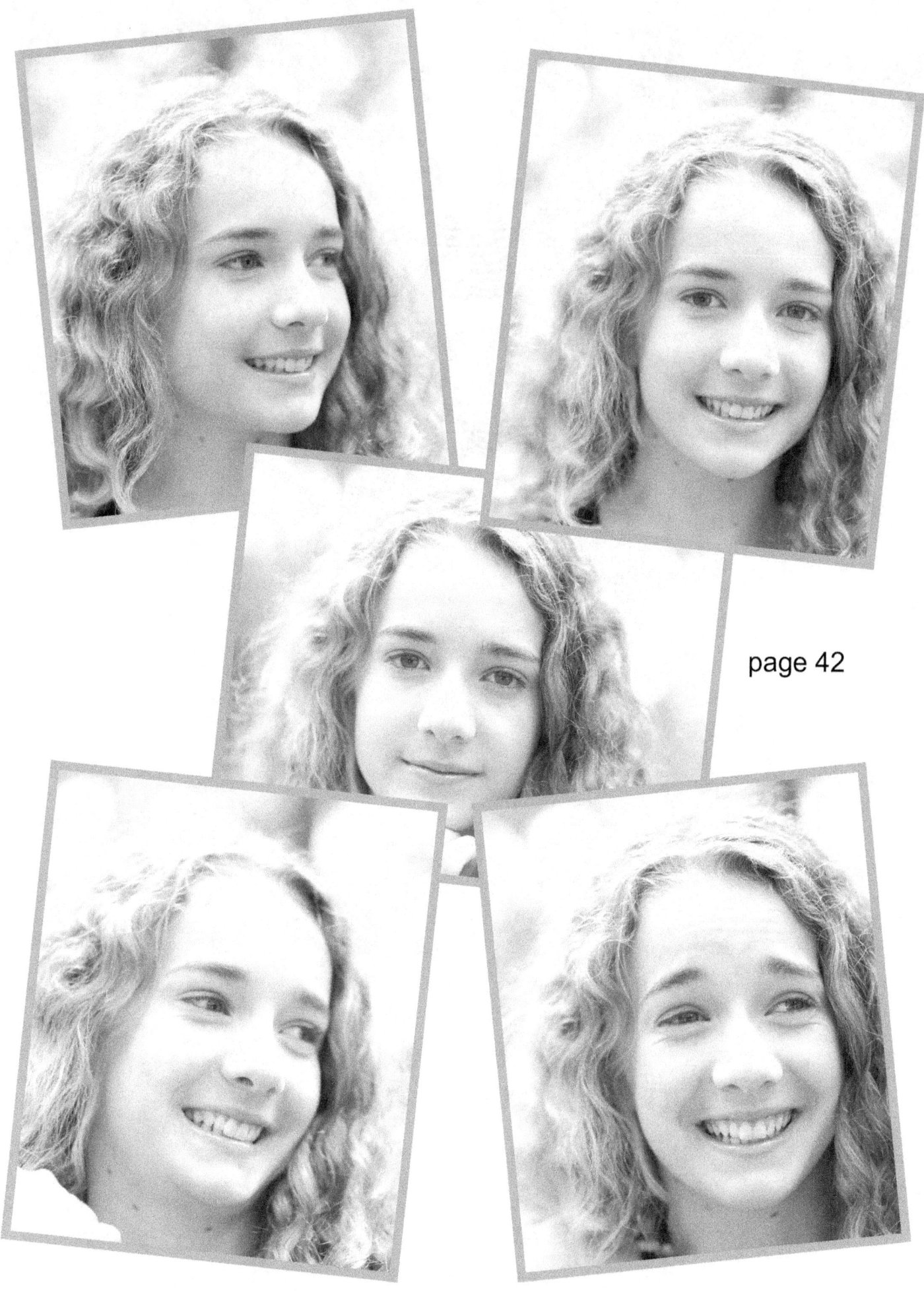

page 42

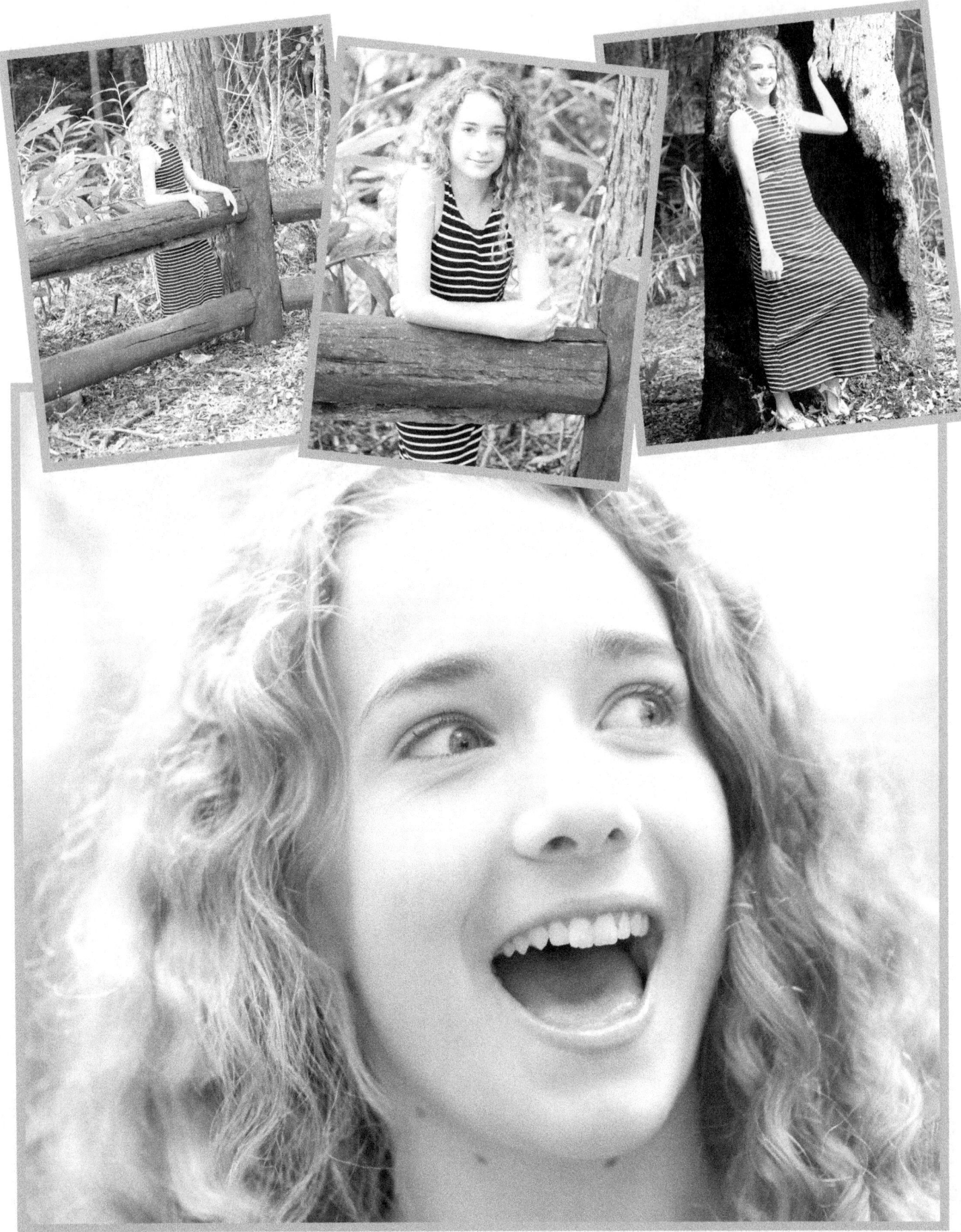

page 43

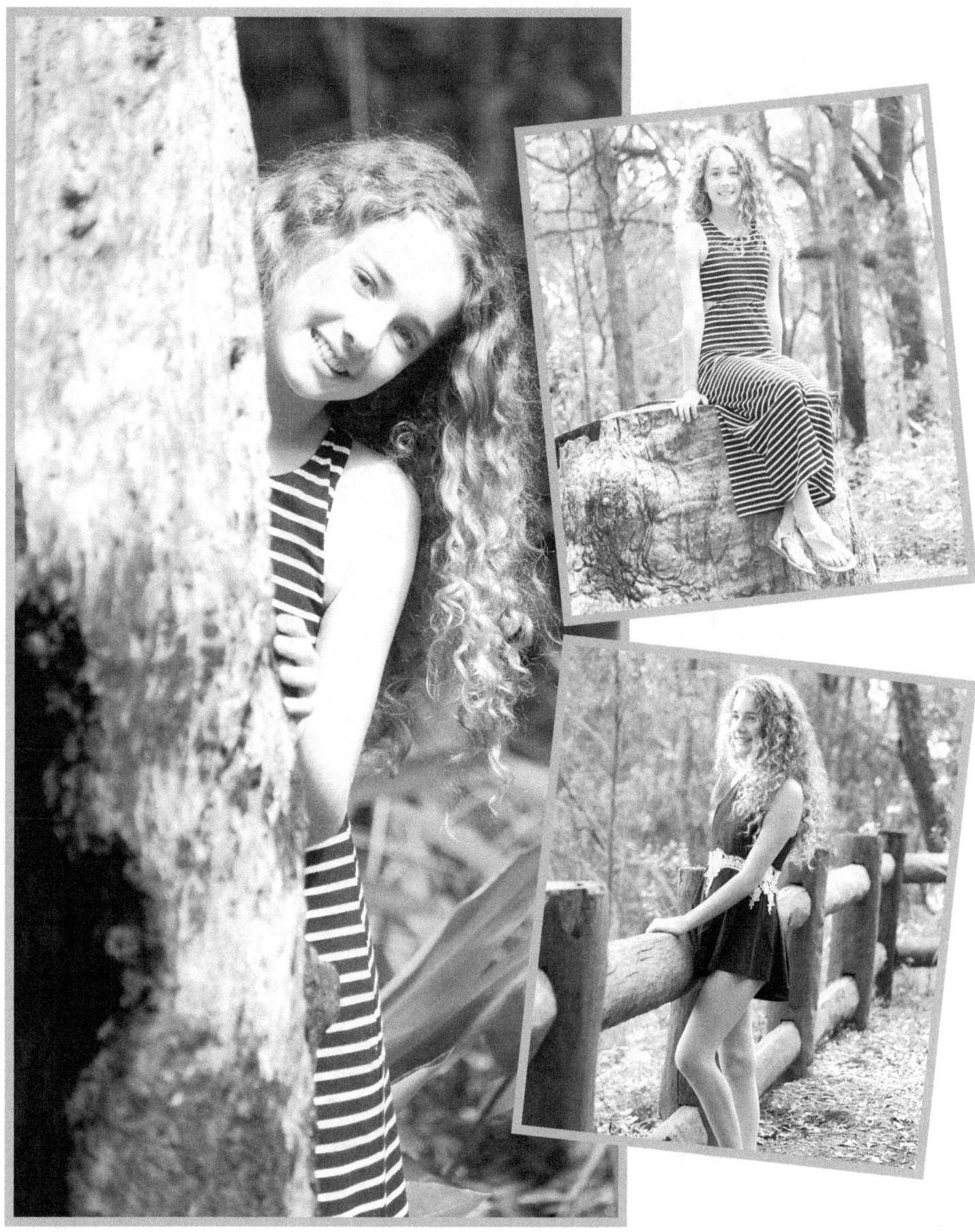

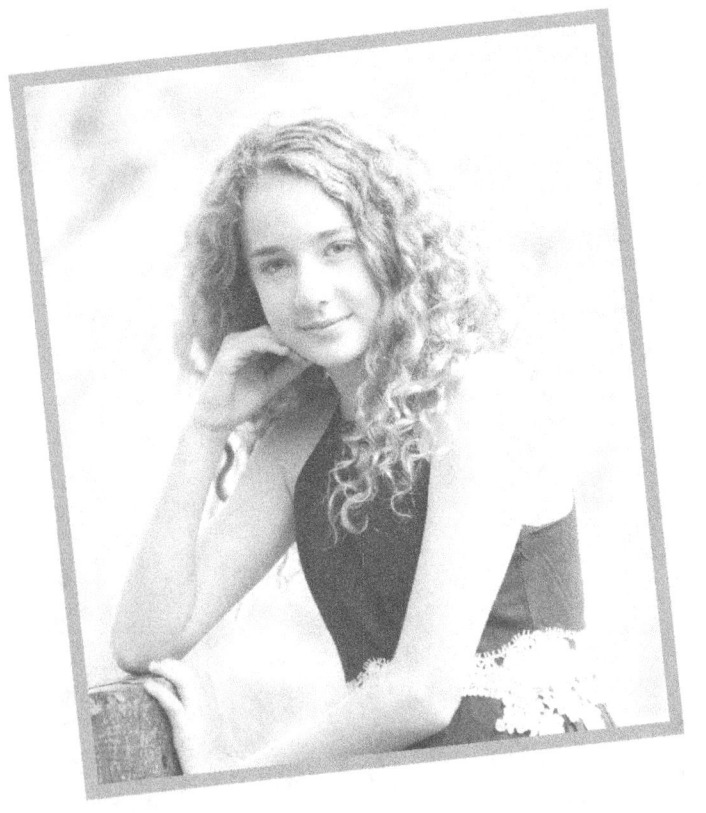
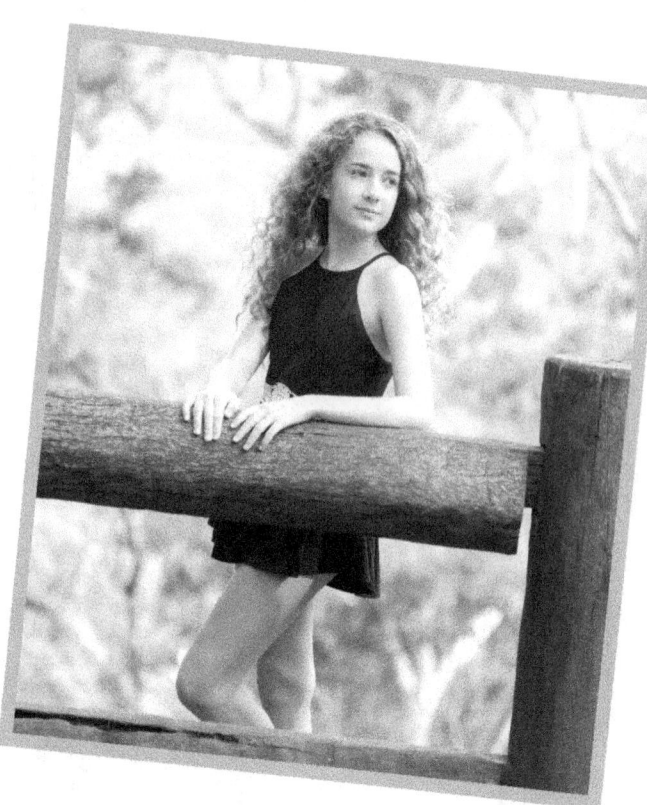

page 45

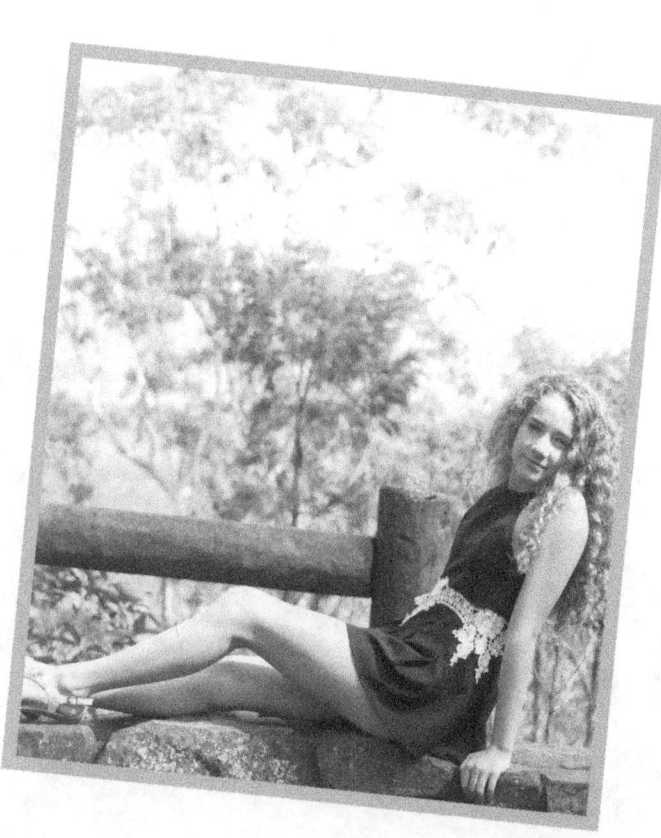
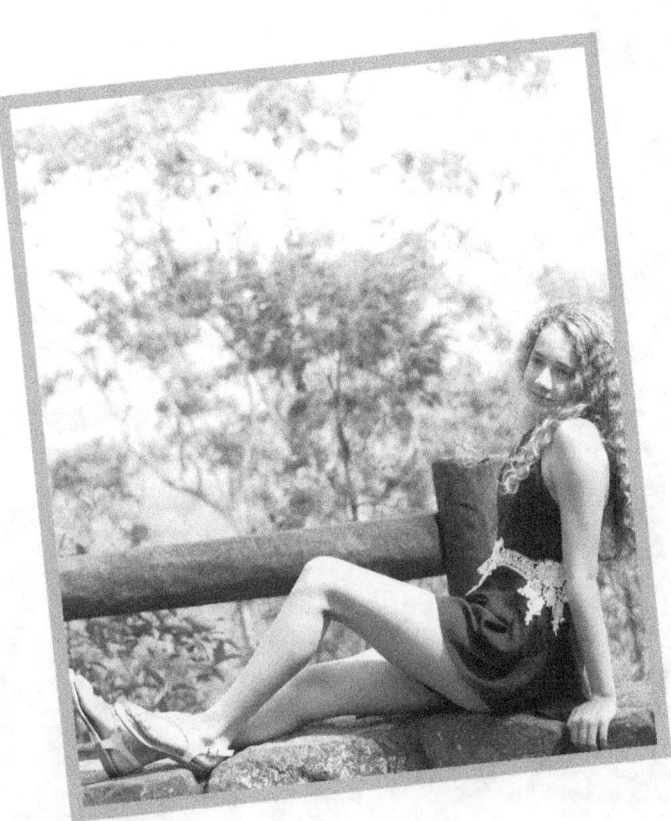

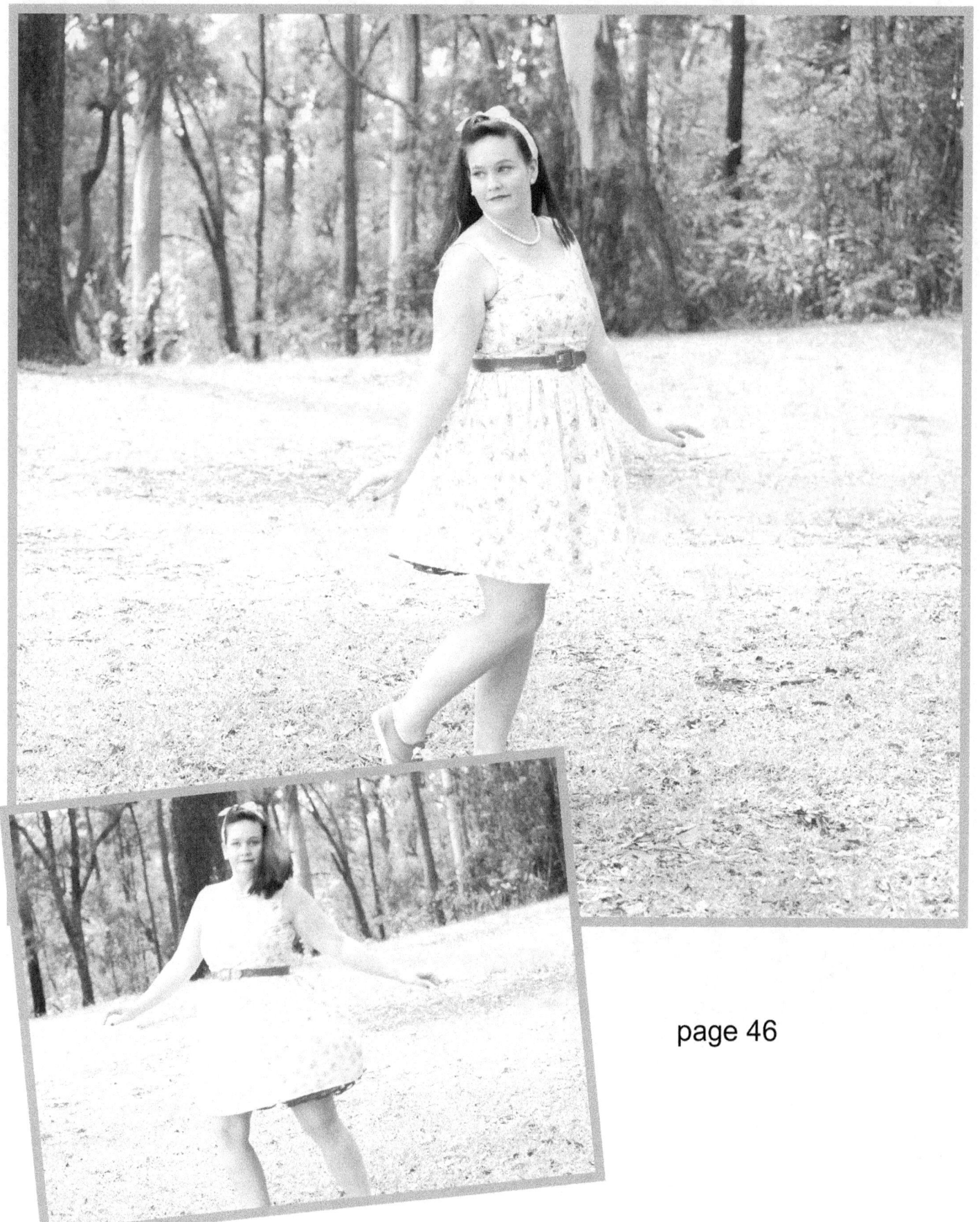

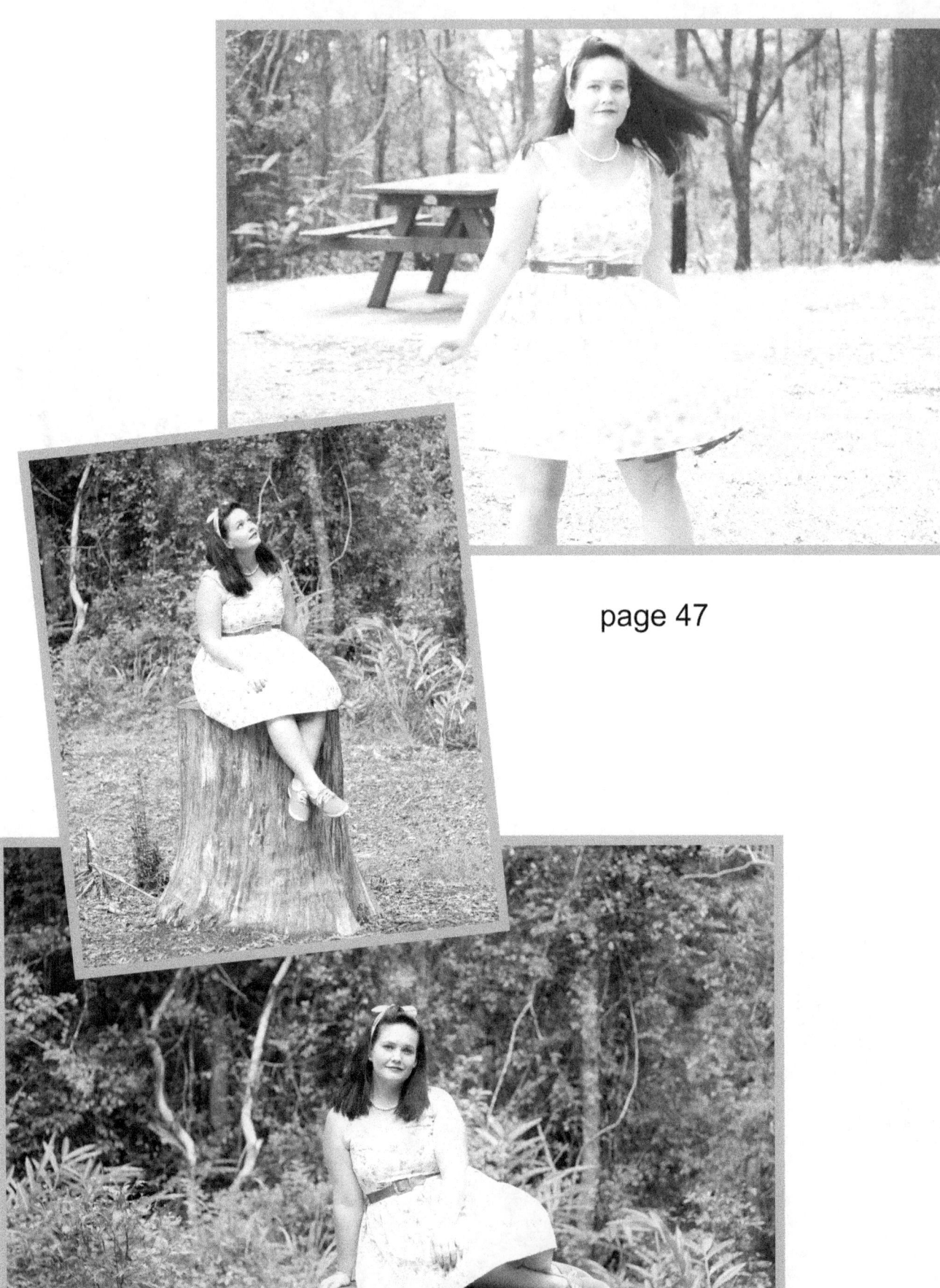

page 47

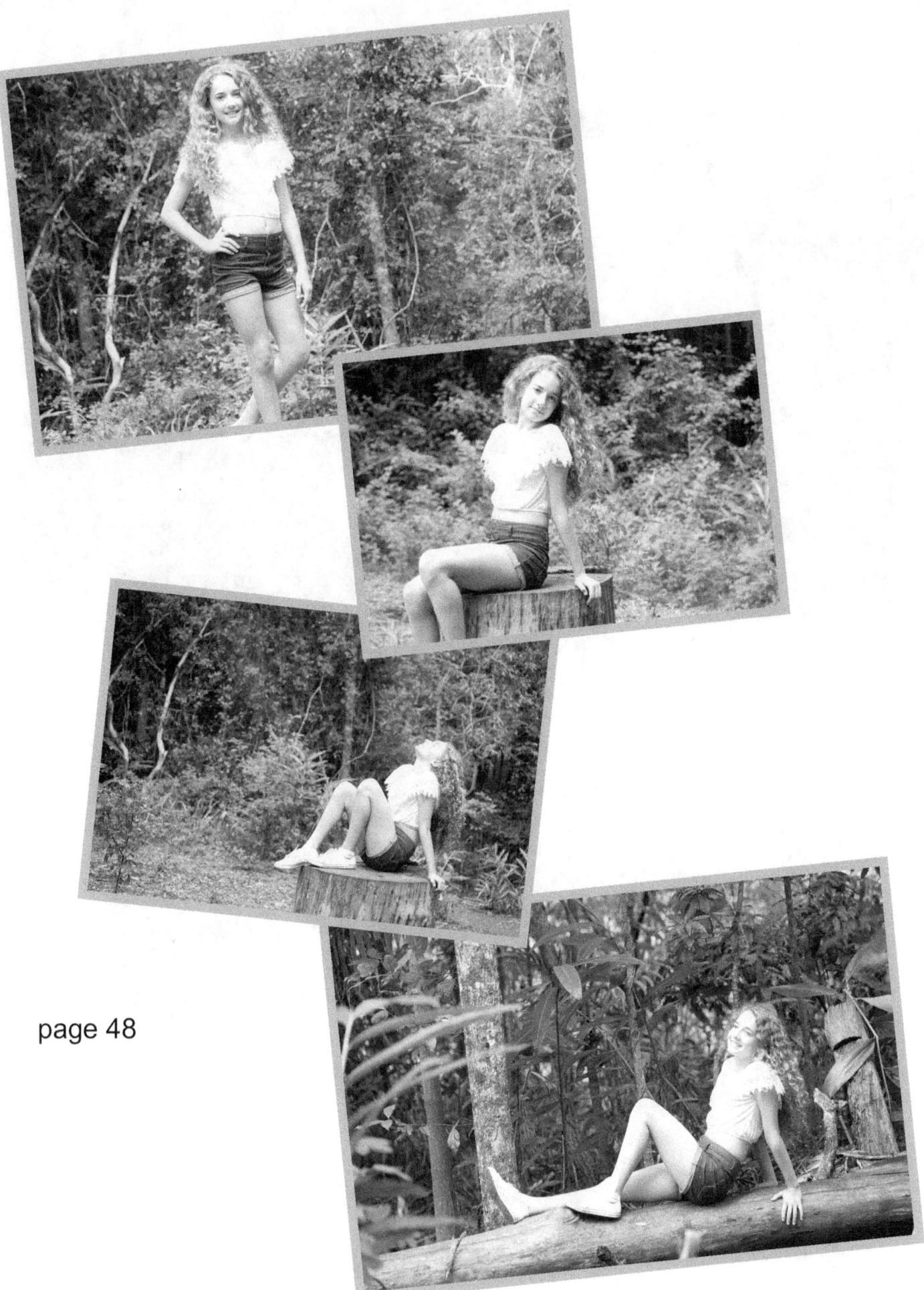

page 48

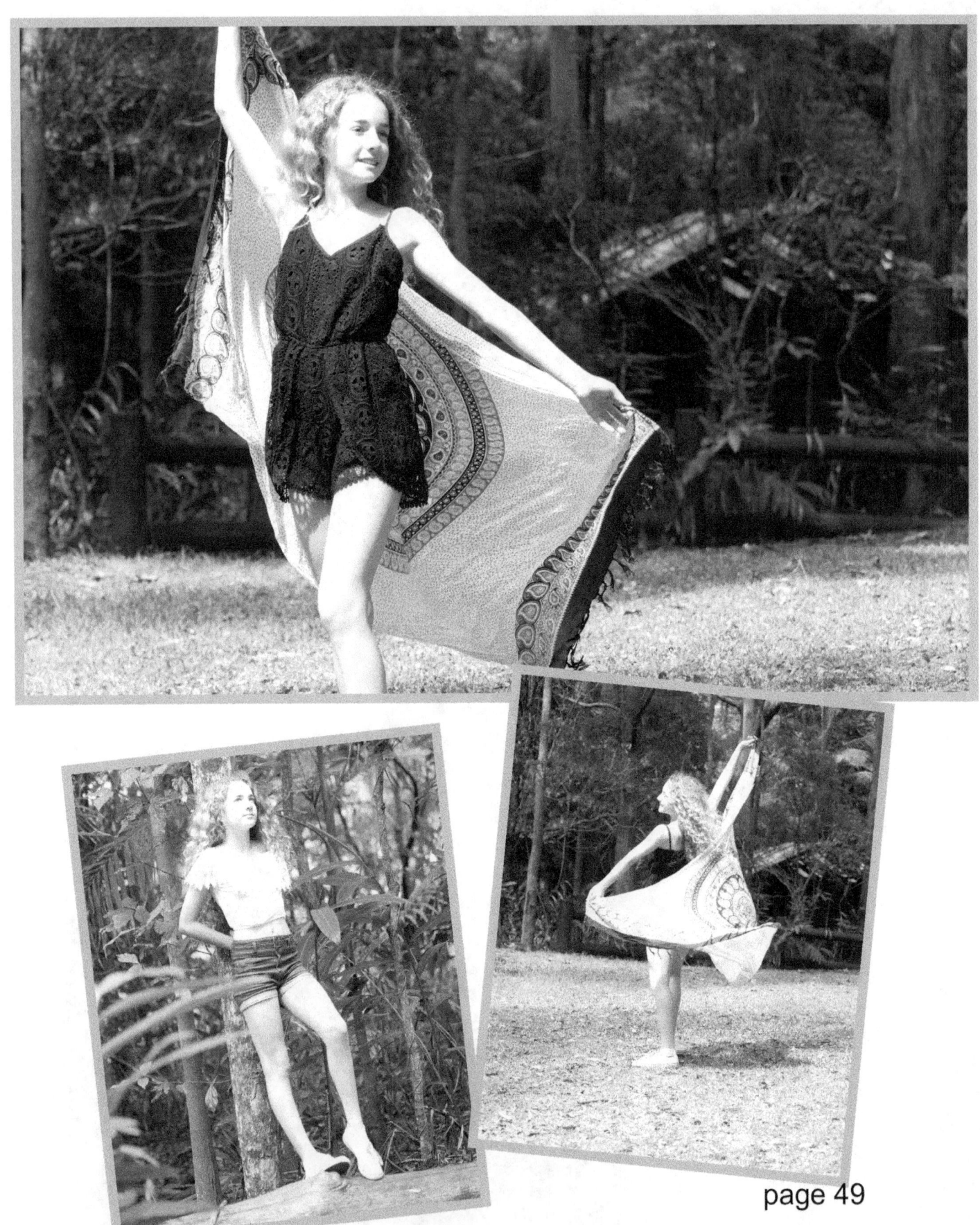

page 49

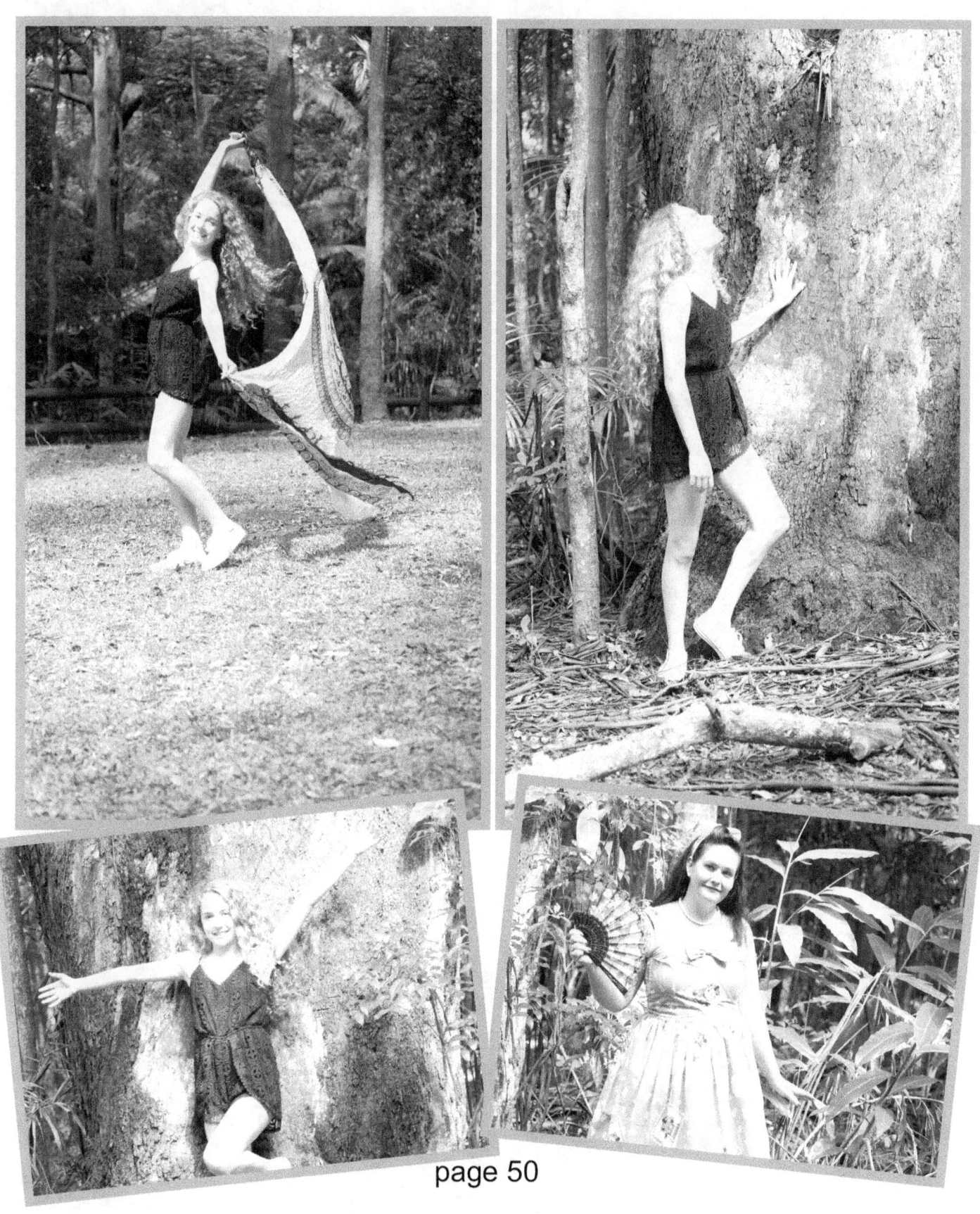

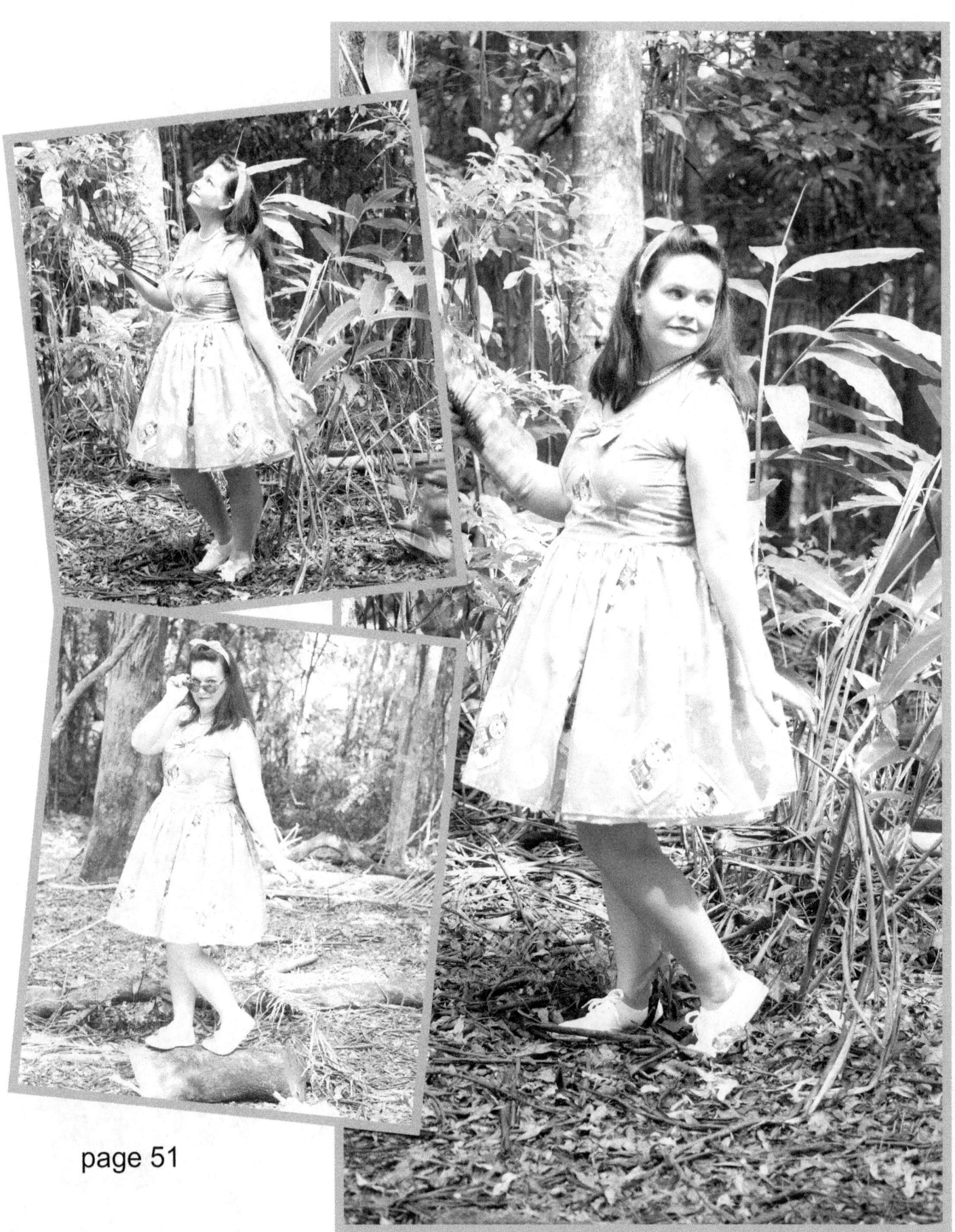

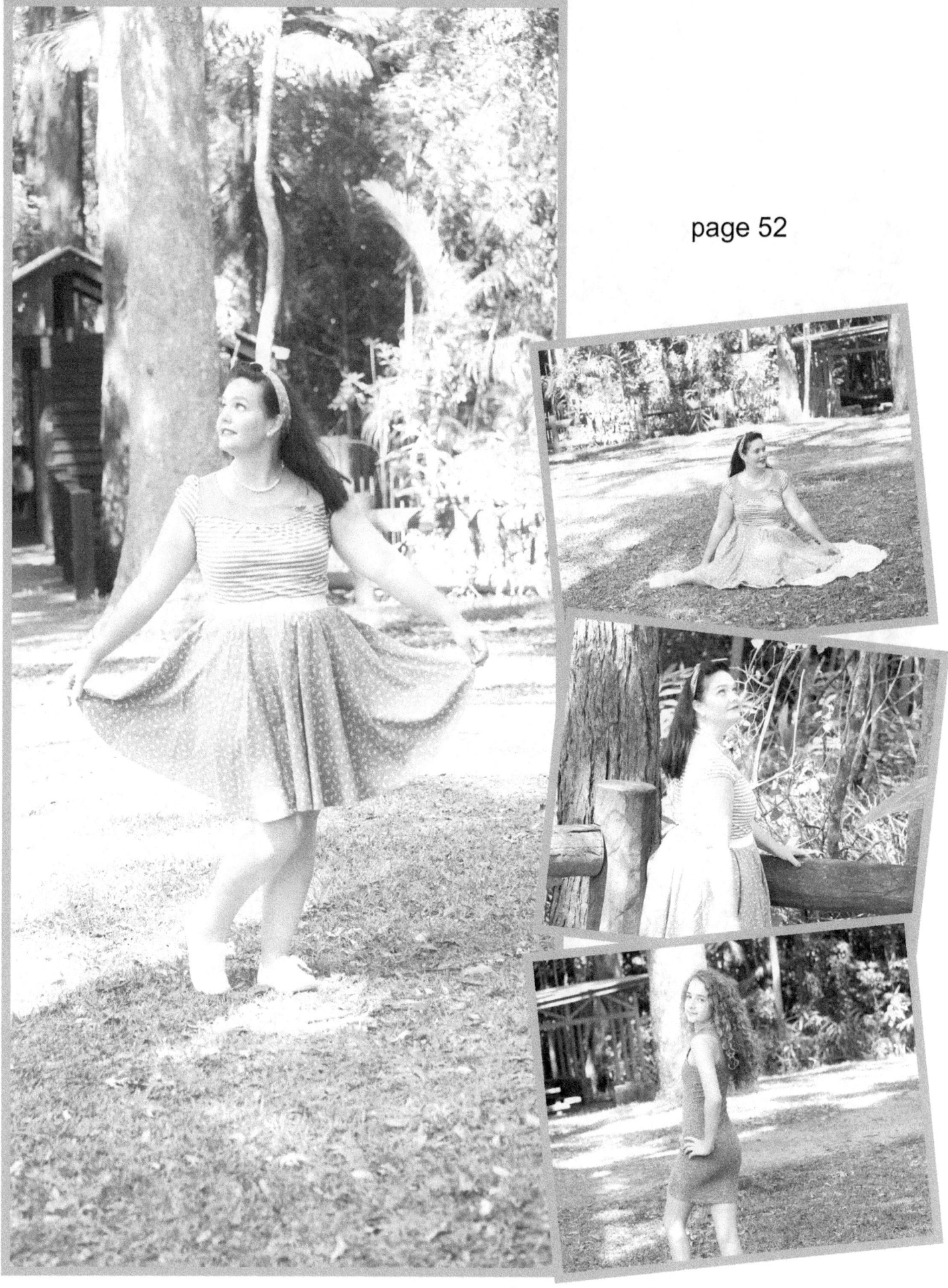

page 52

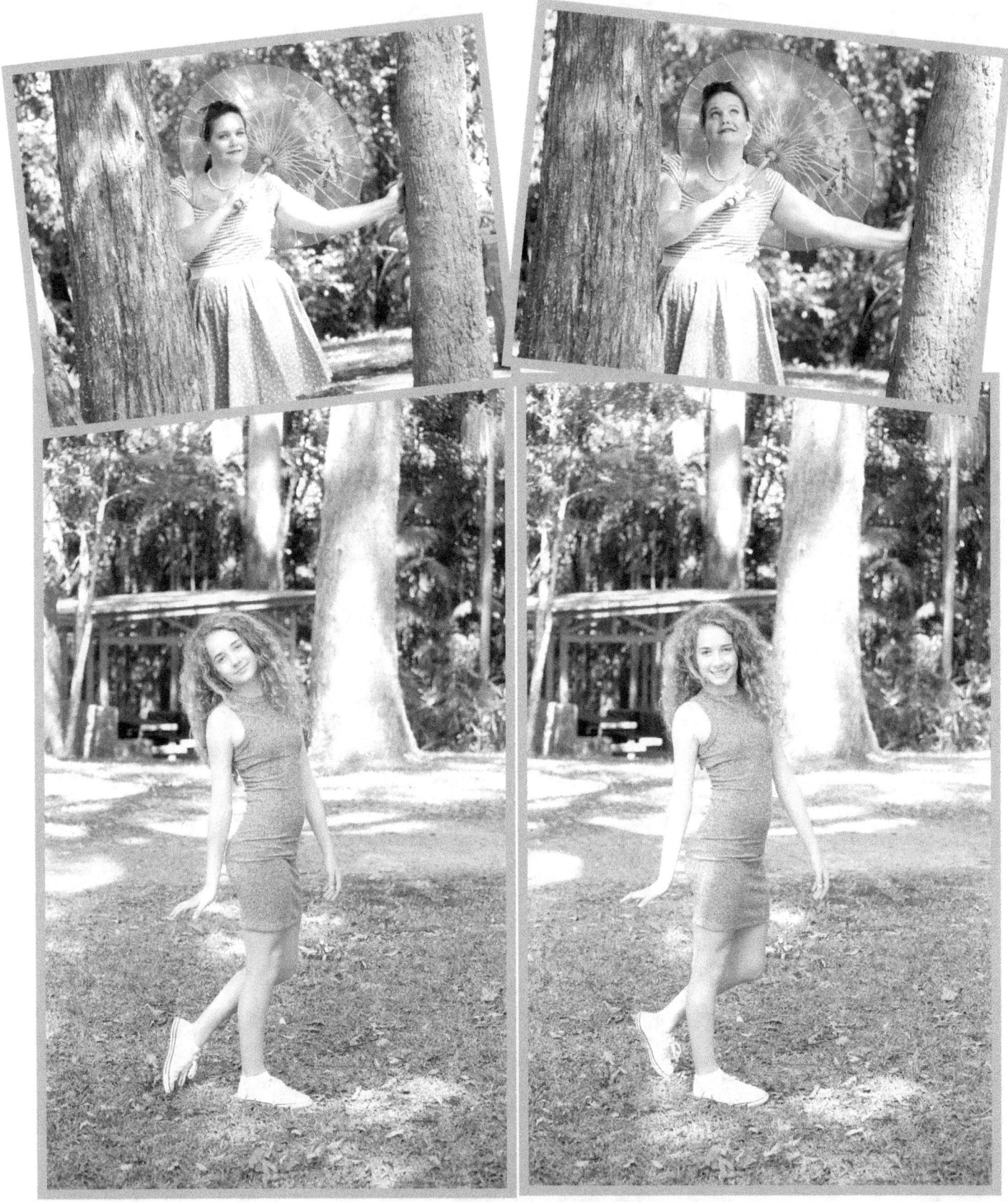

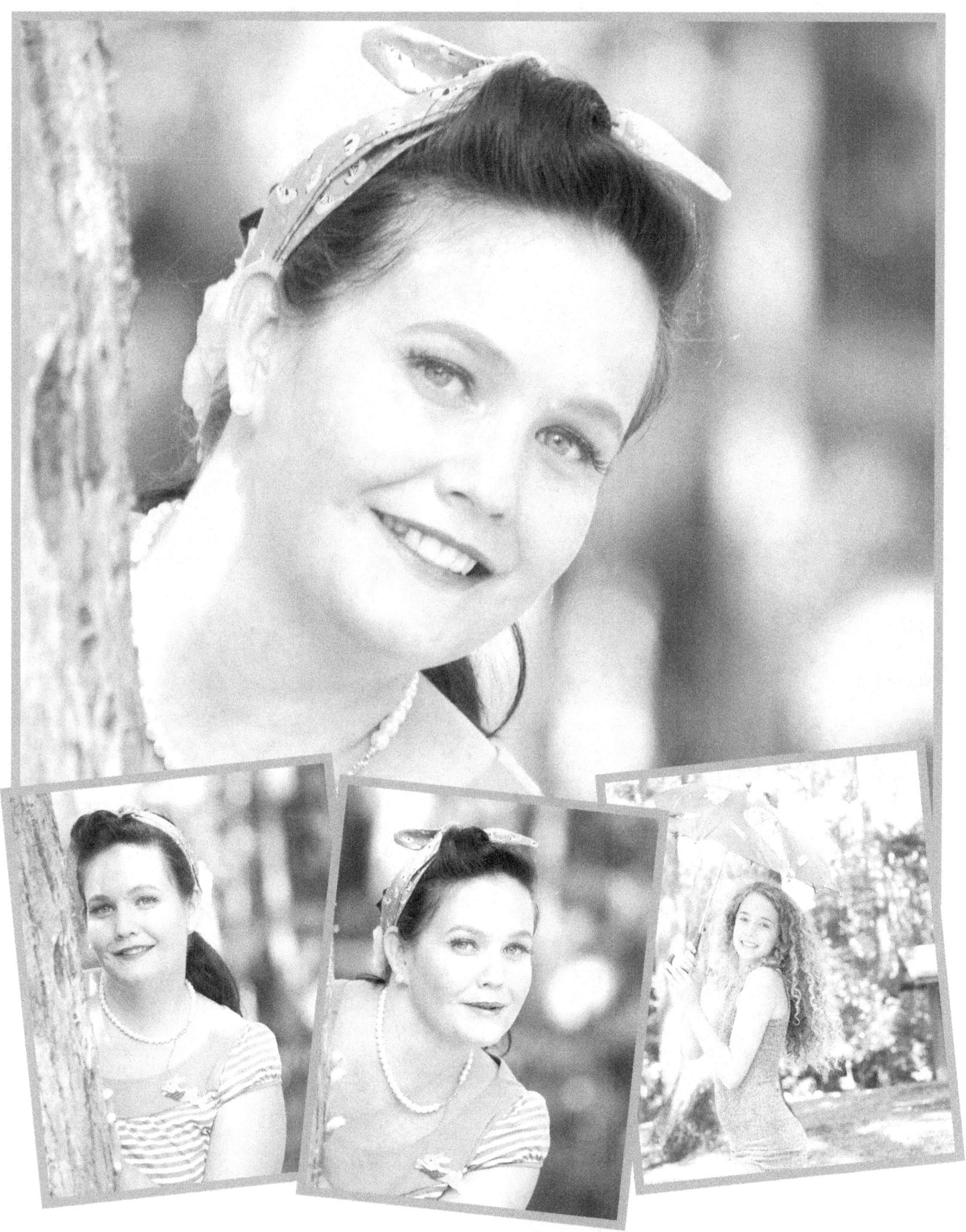

page 55

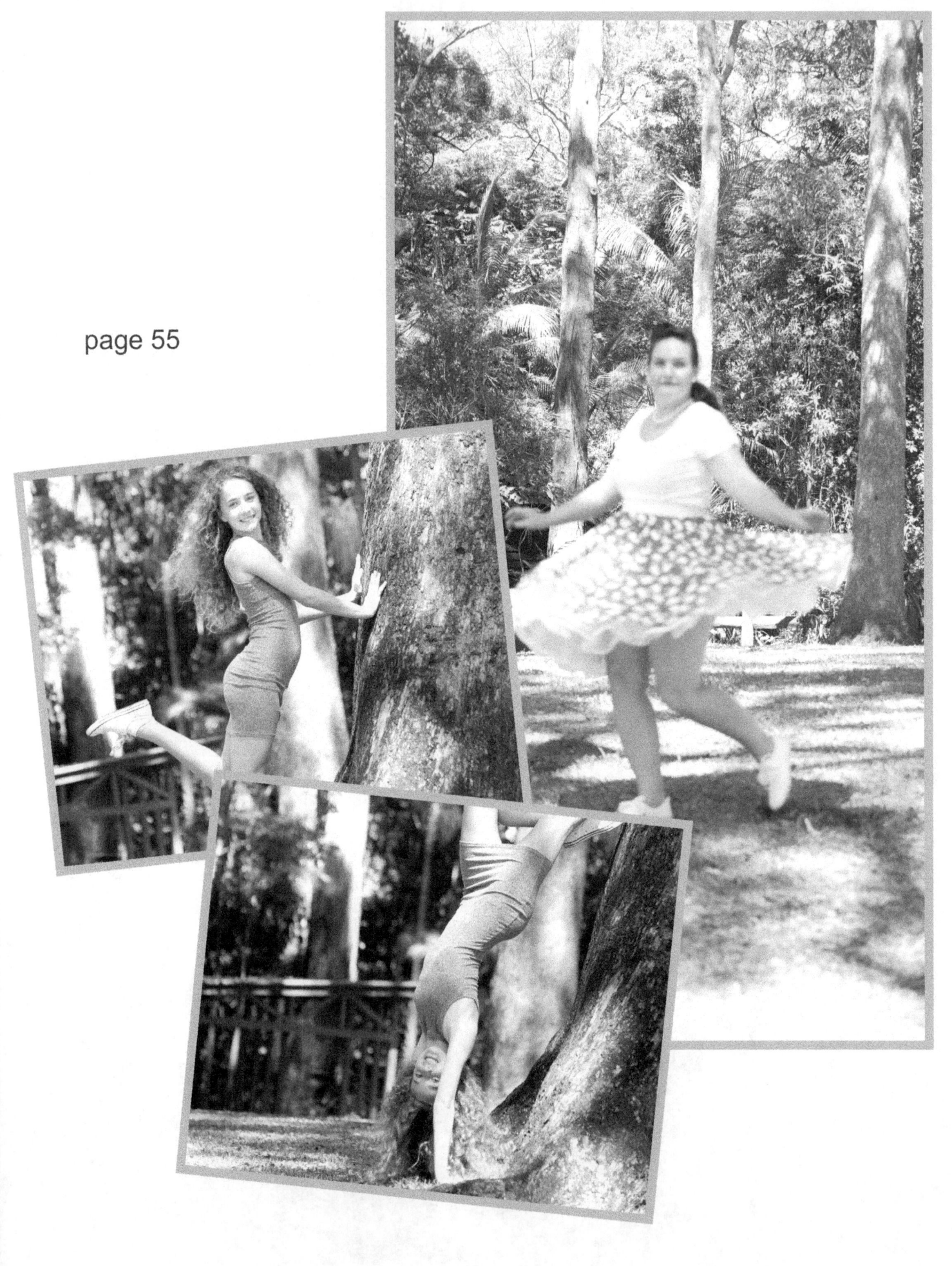

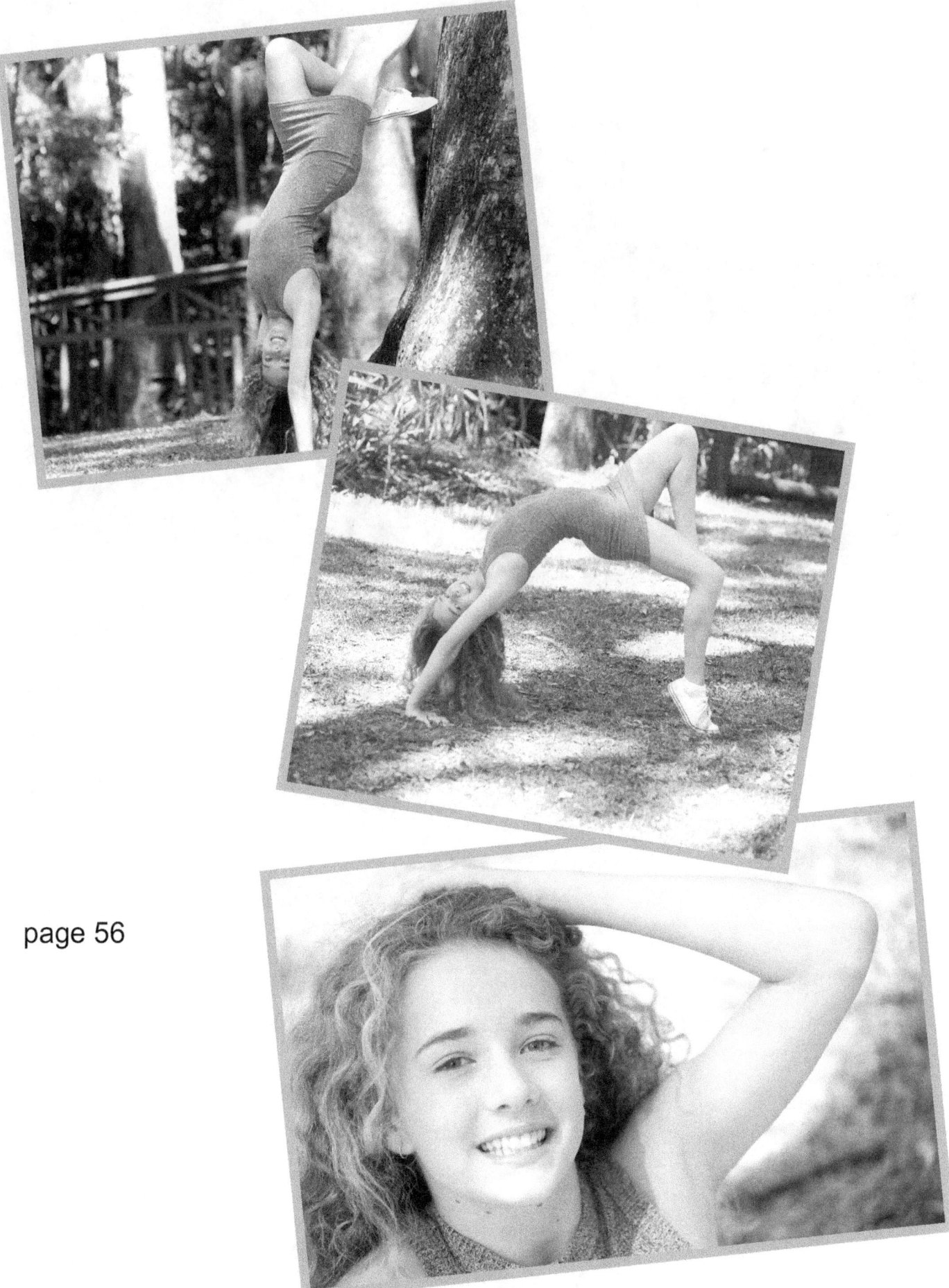

page 56

page 57

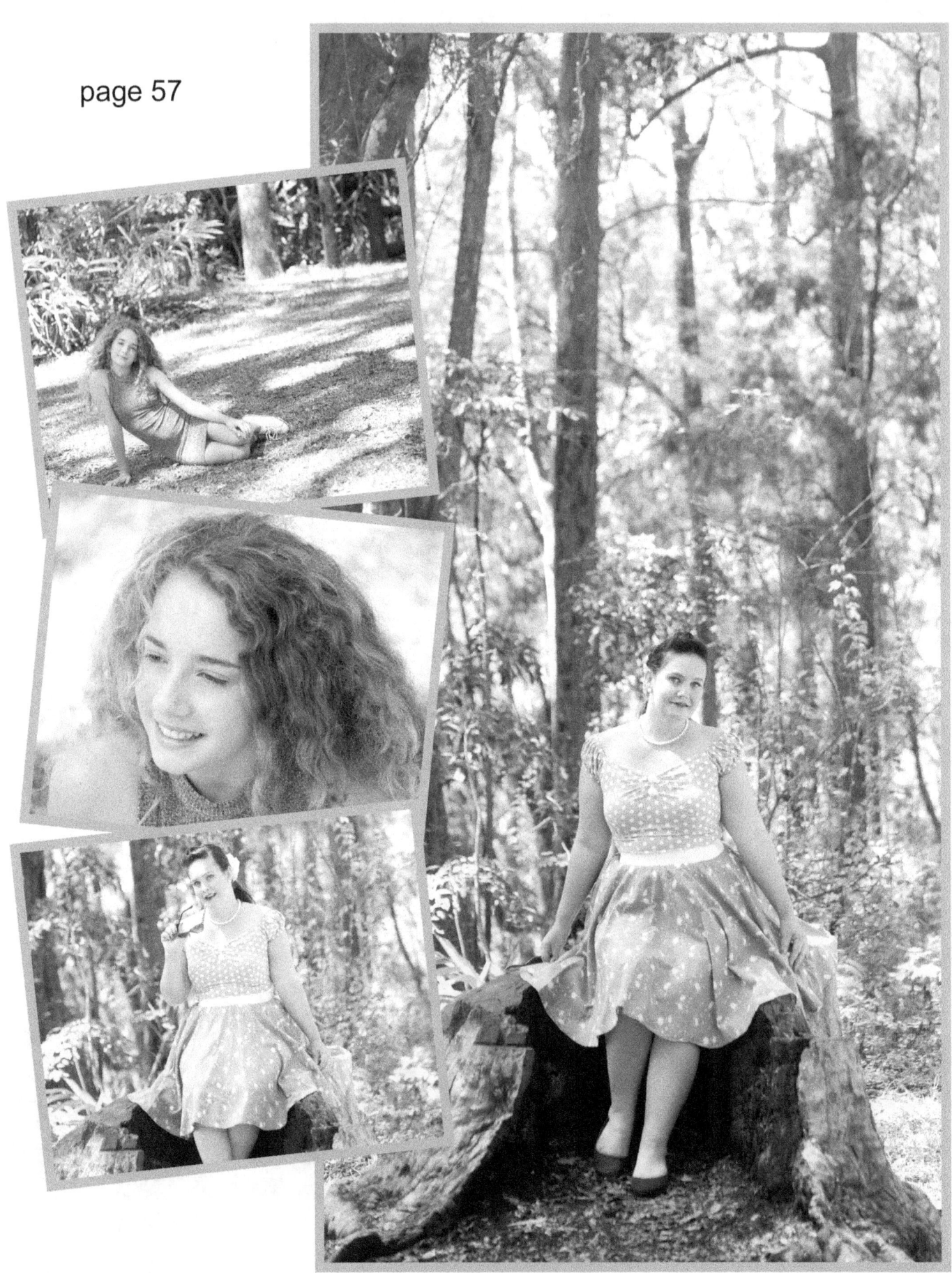

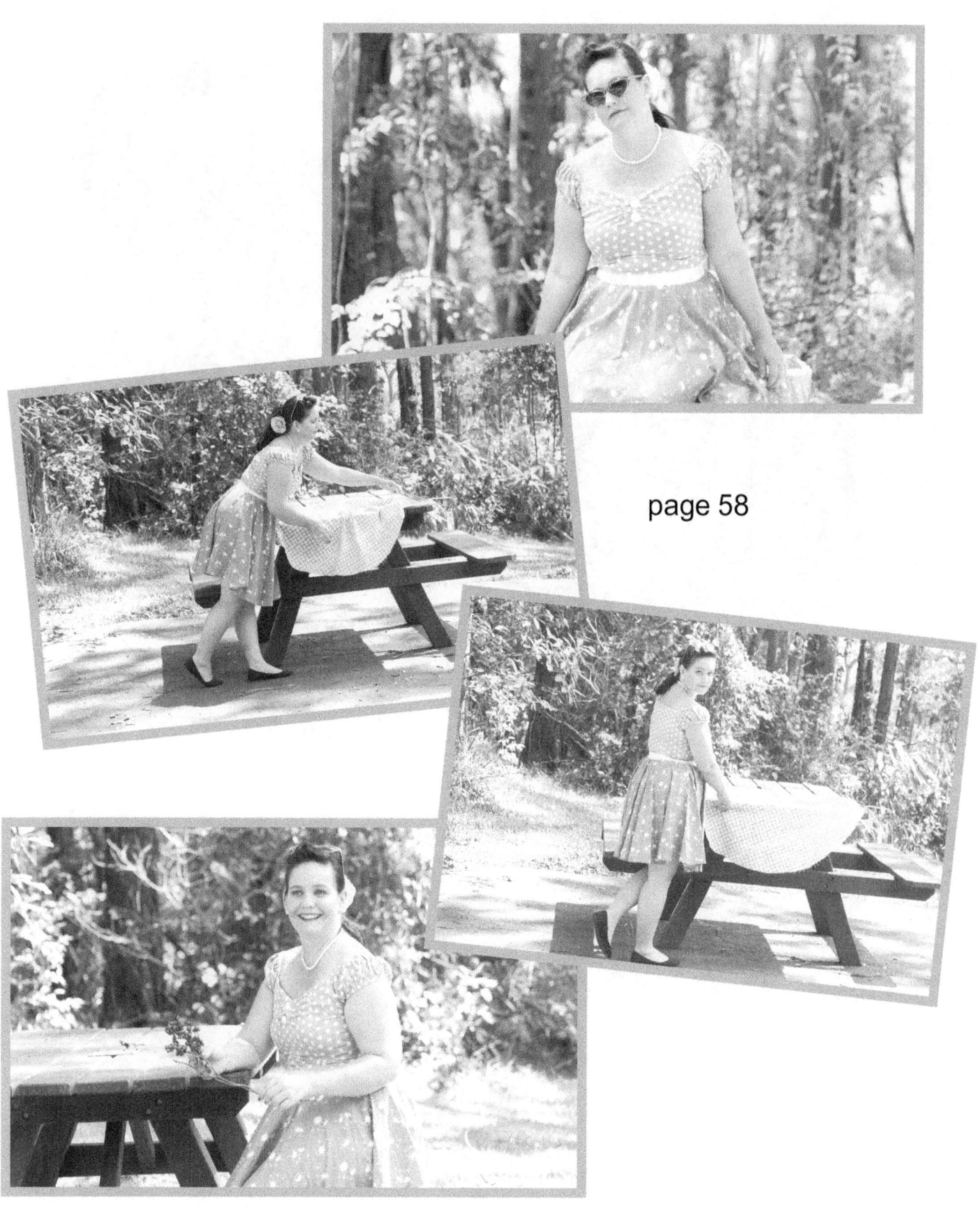

page 58

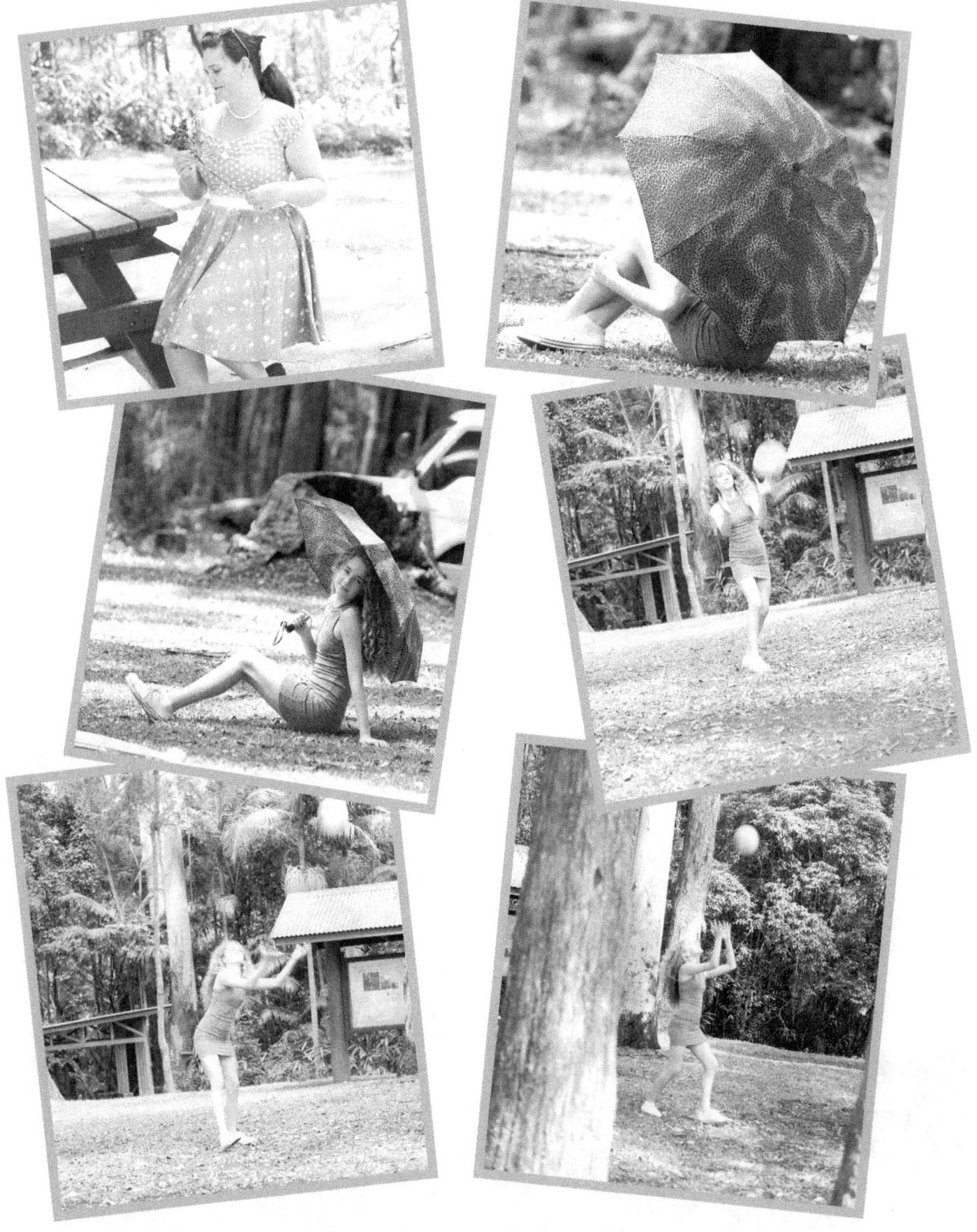

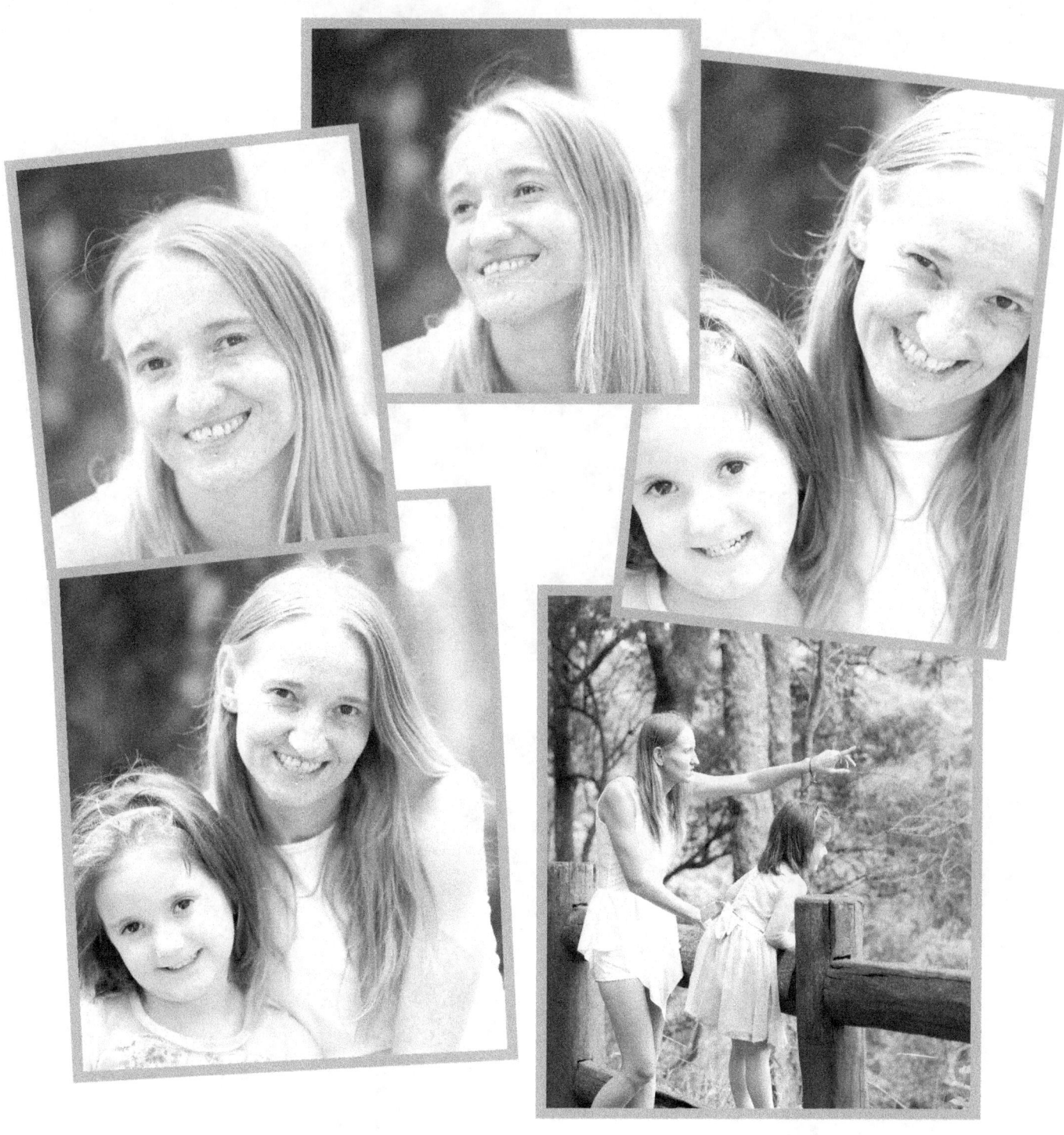

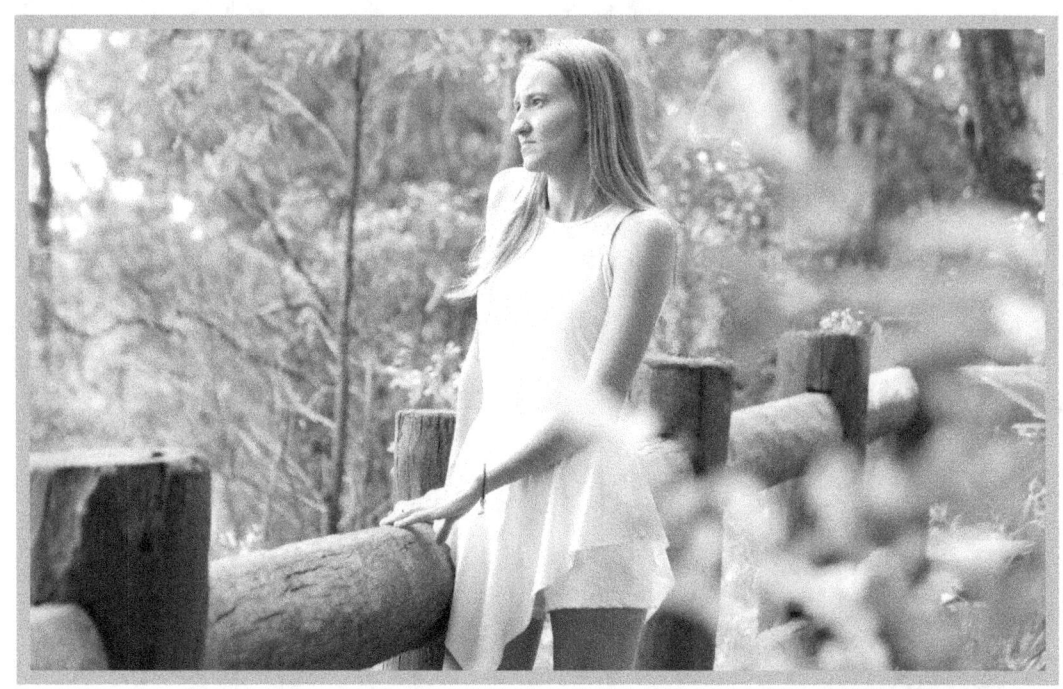

page 61

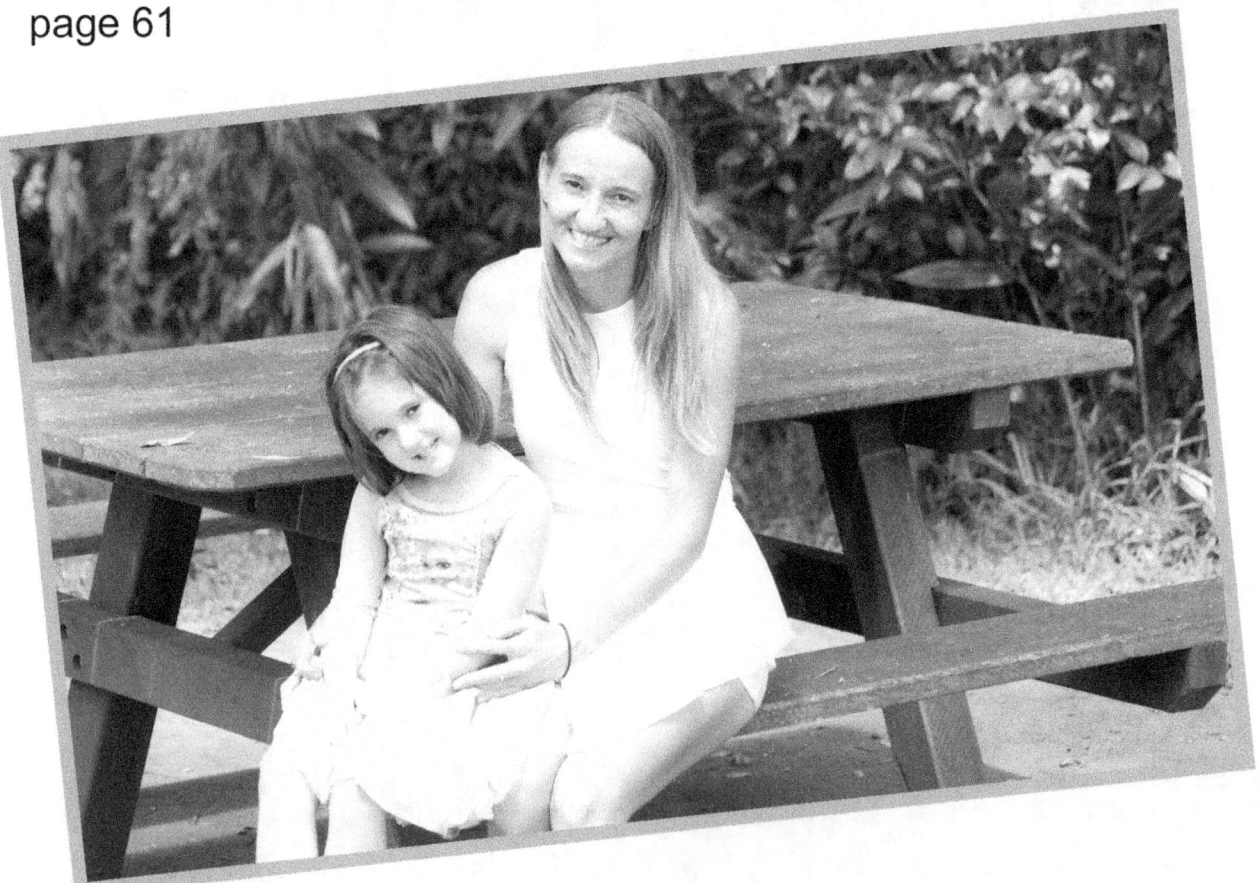

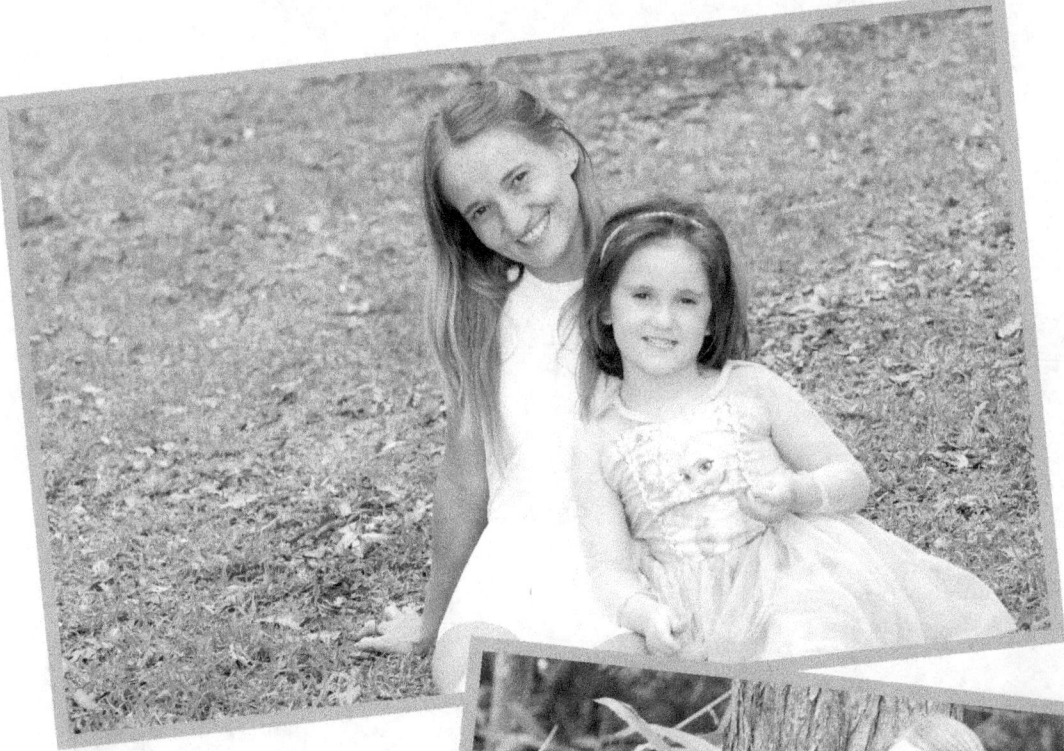

page 62

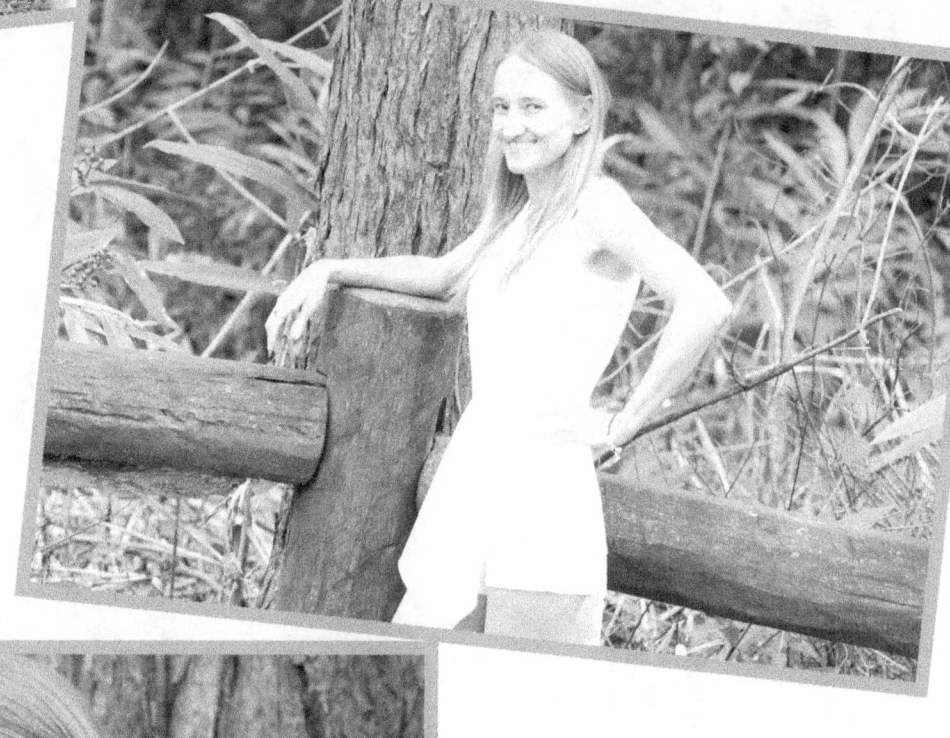

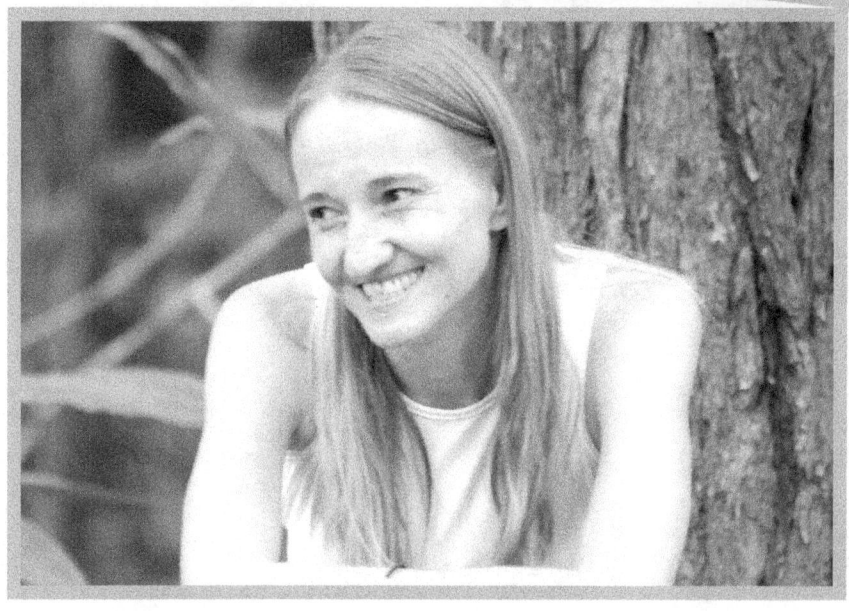

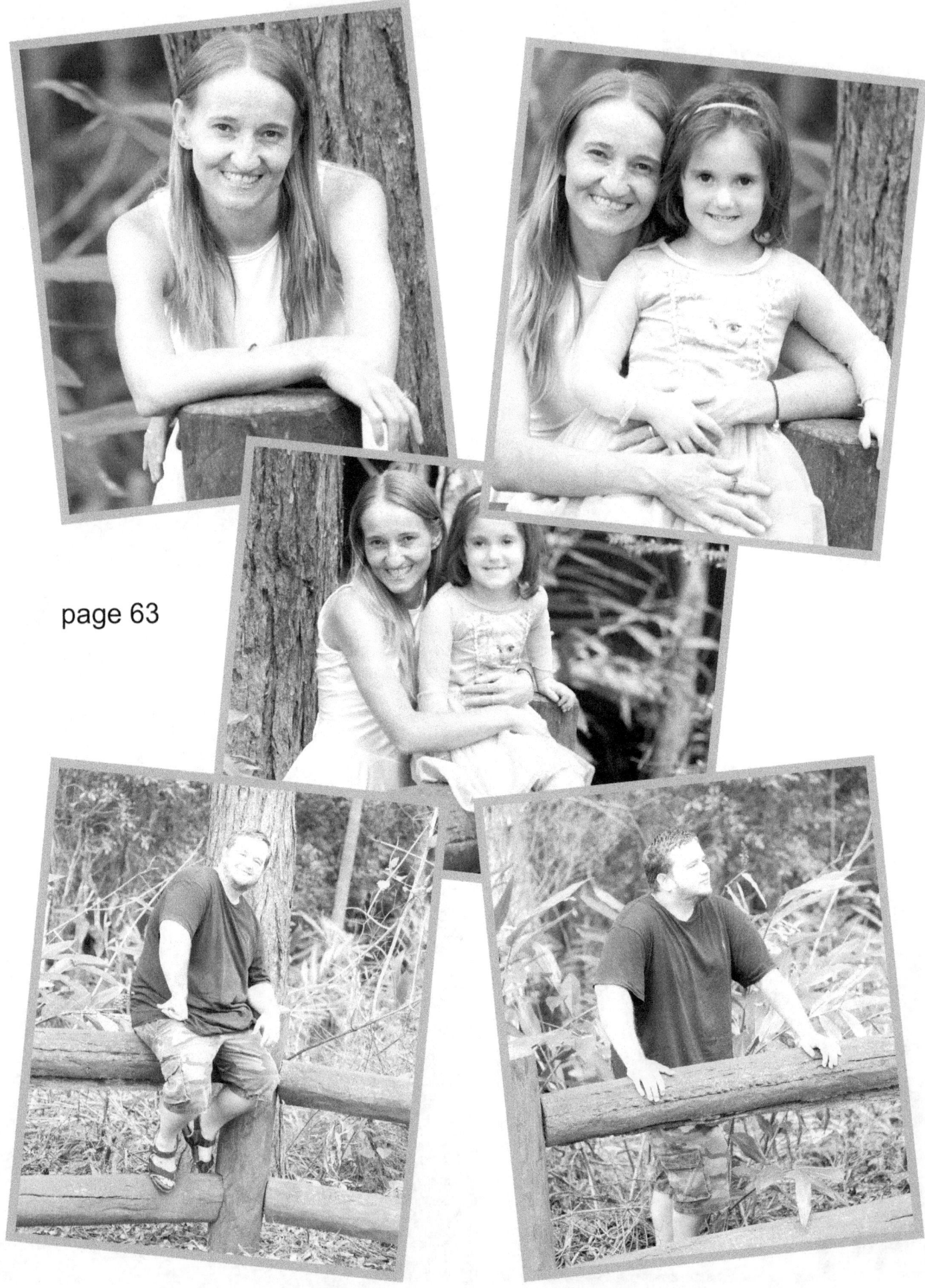

page 63

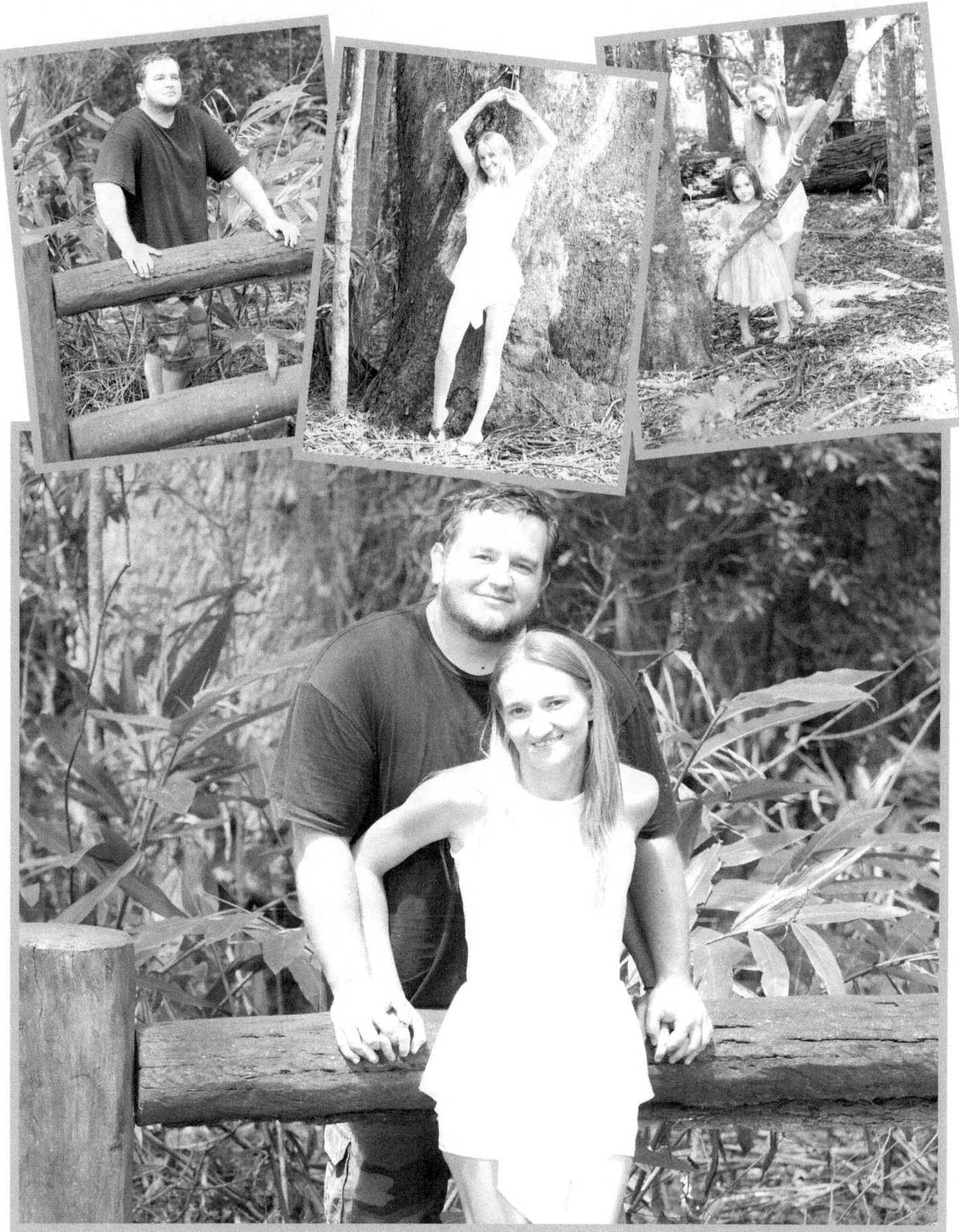

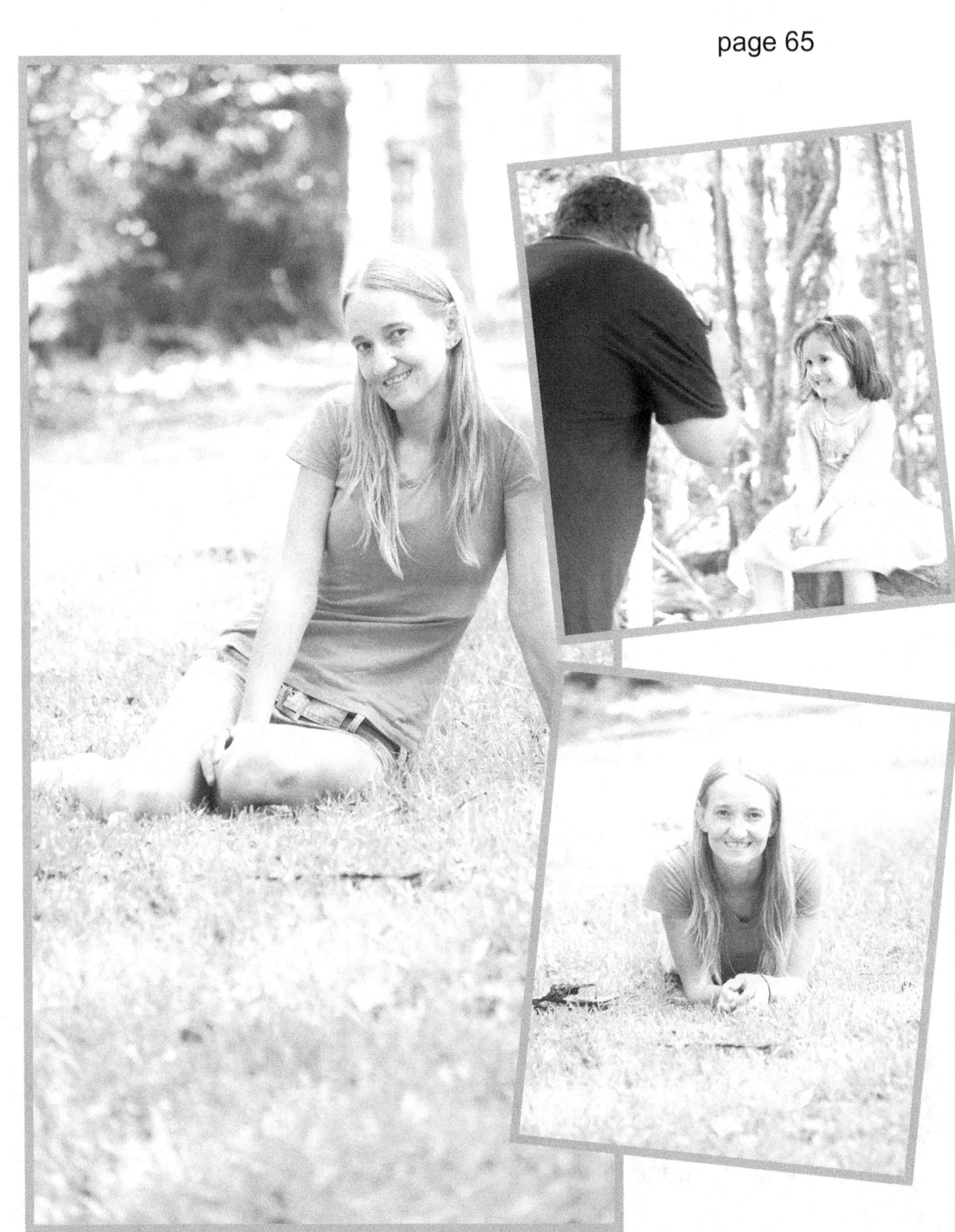

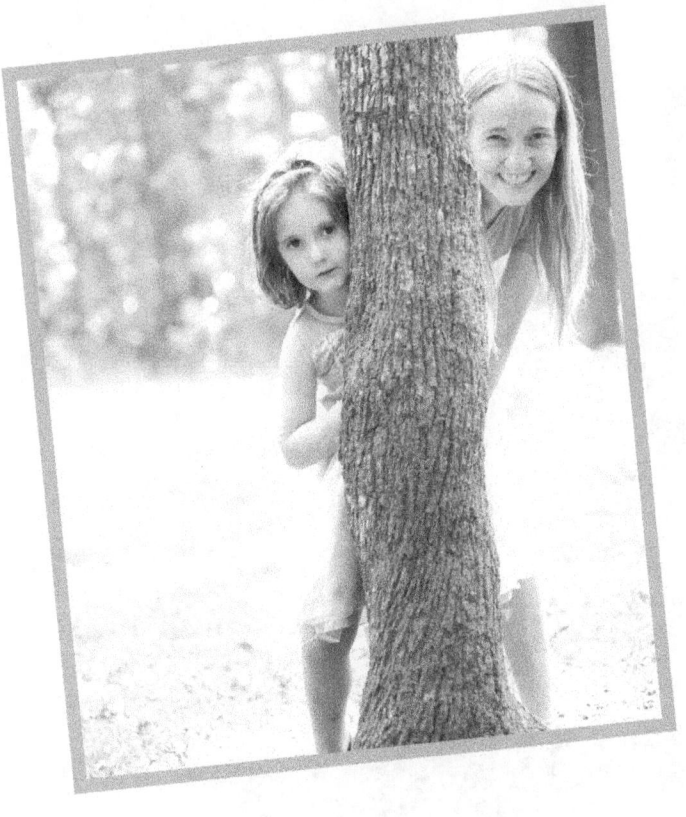
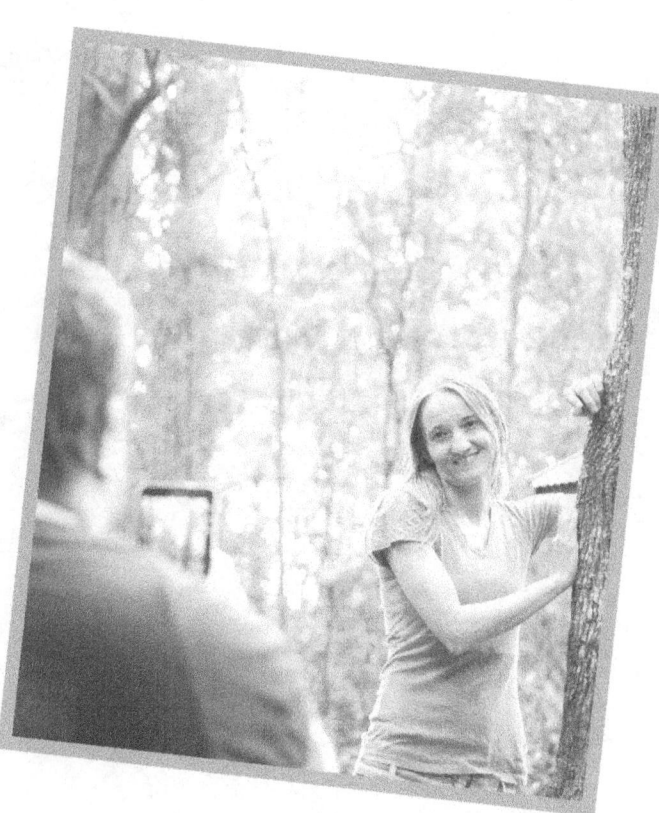

page 66

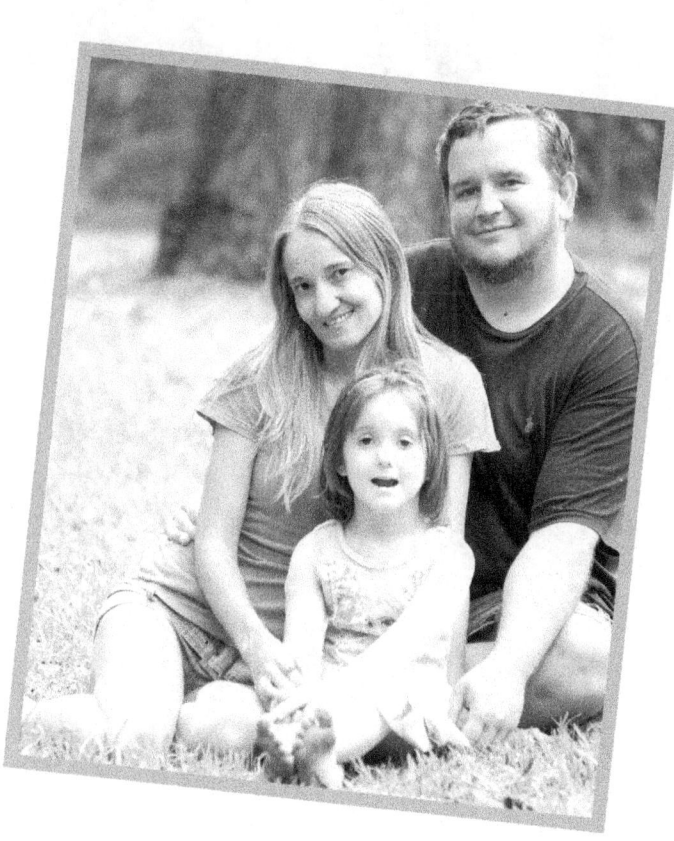
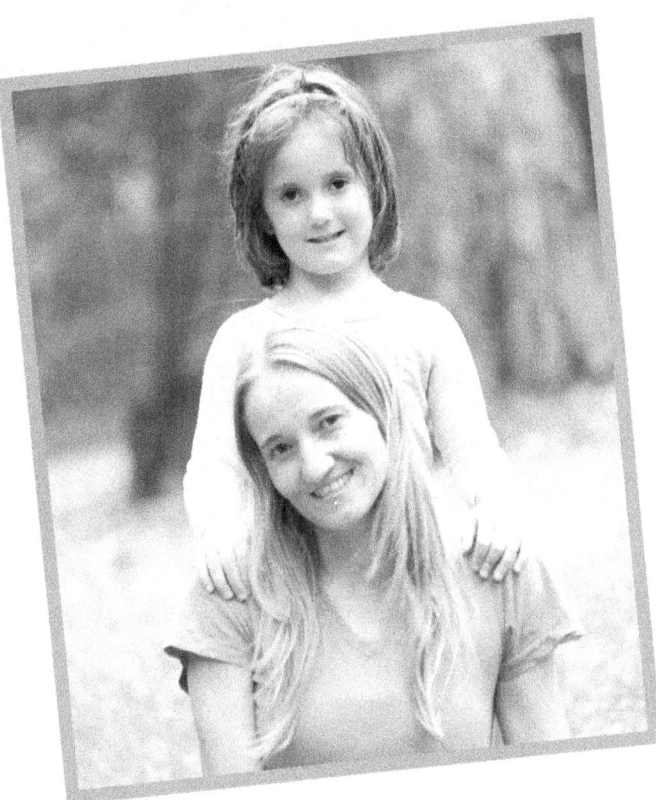

page 67

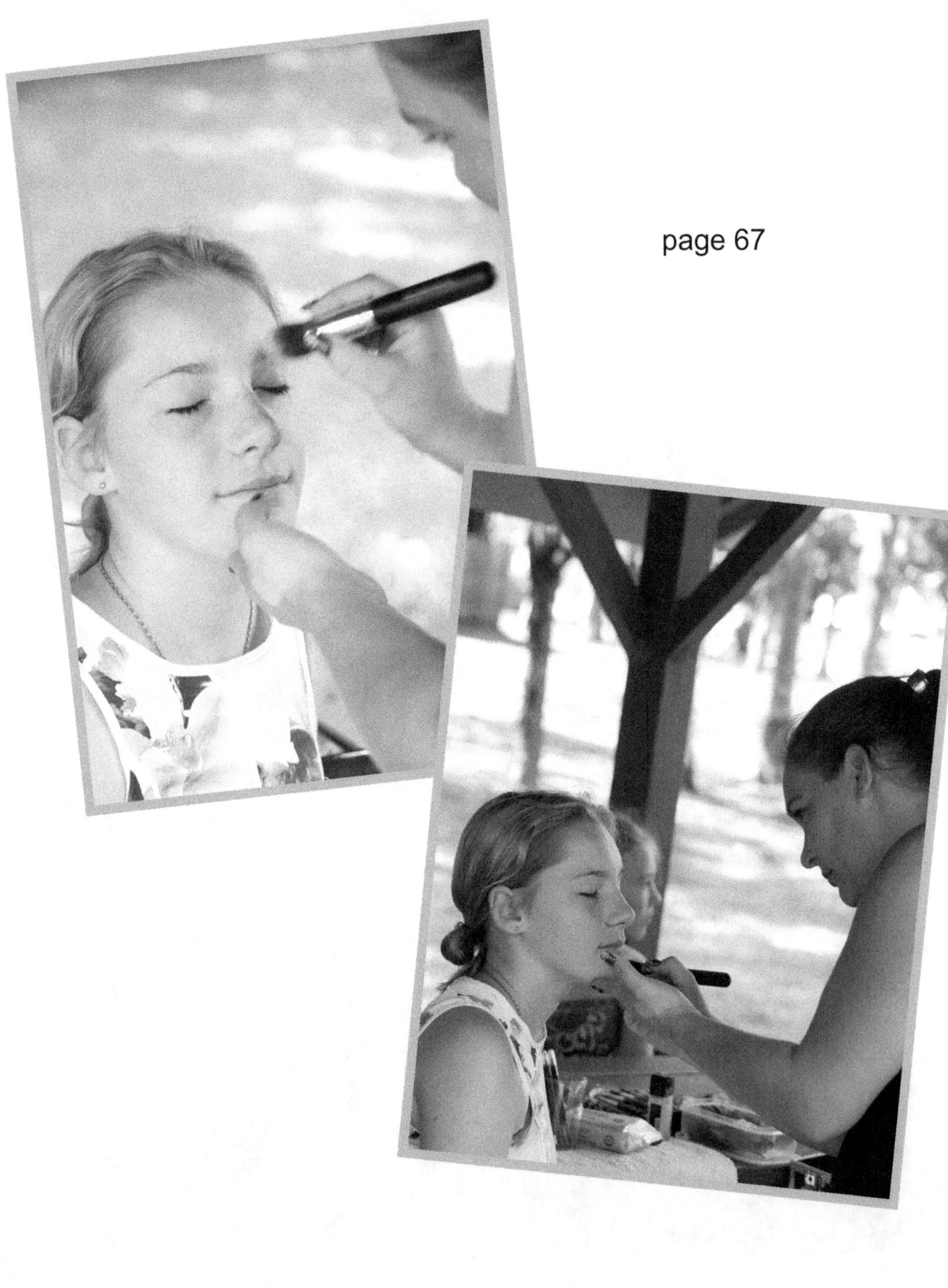

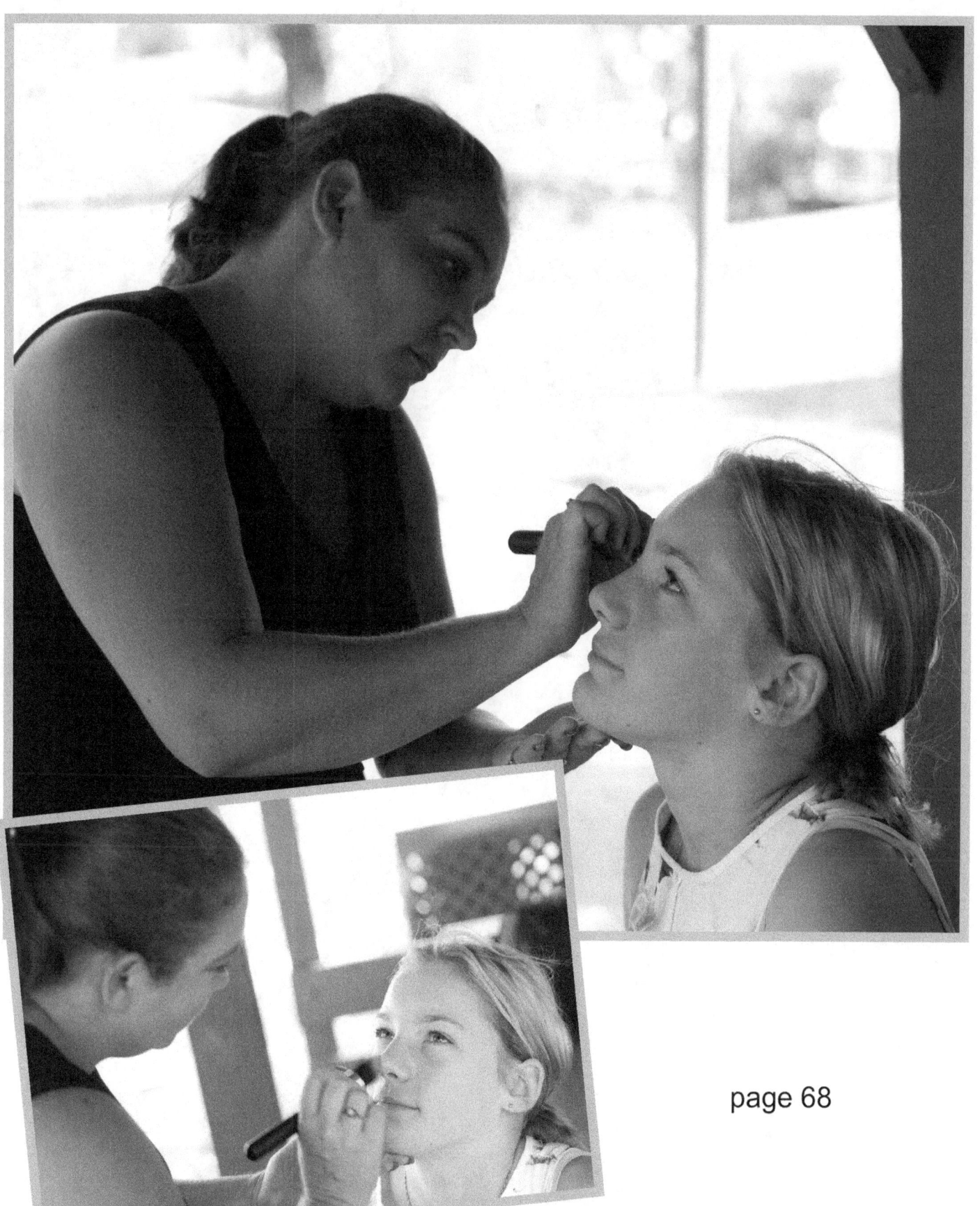

page 68

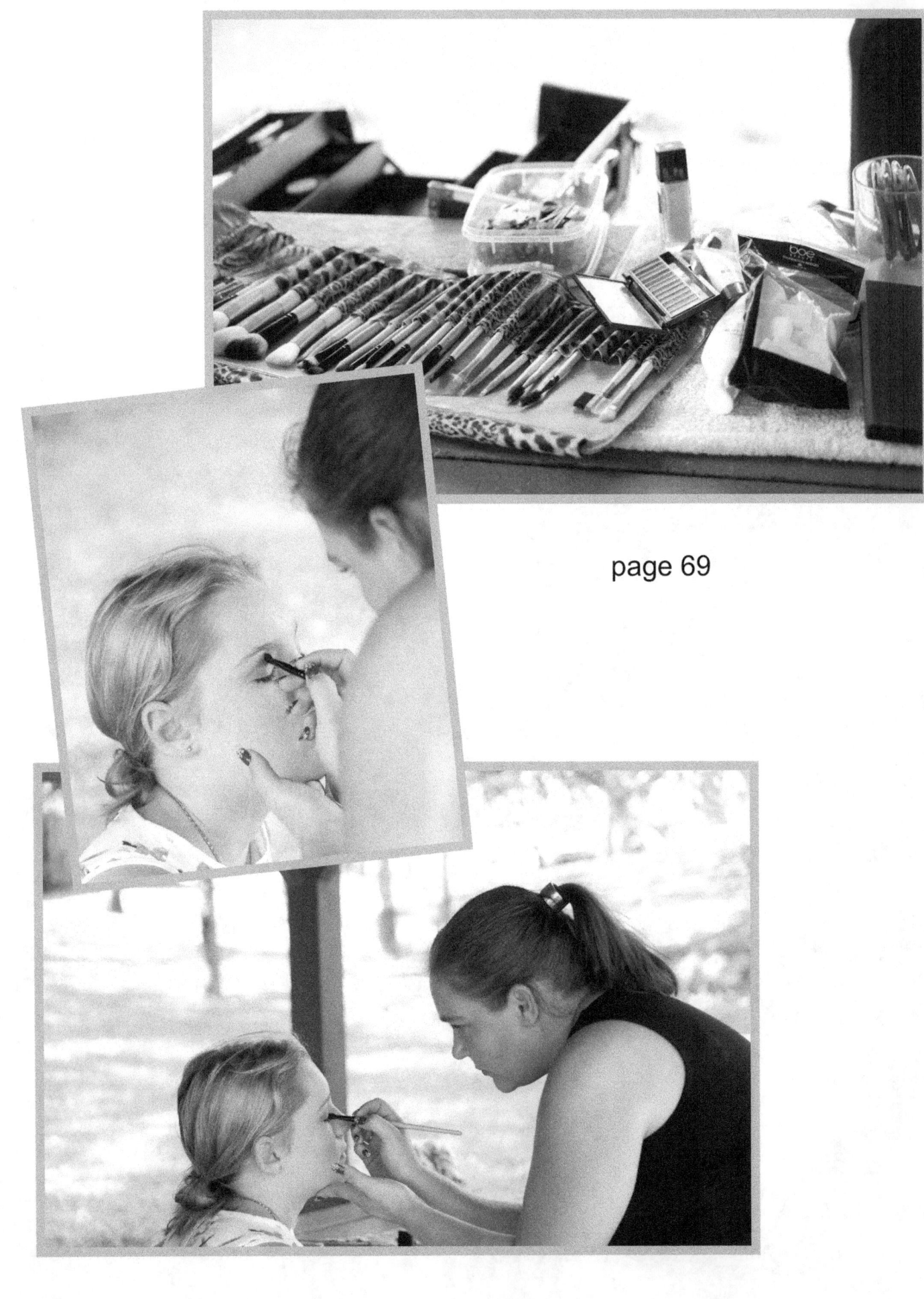

page 69

page 72

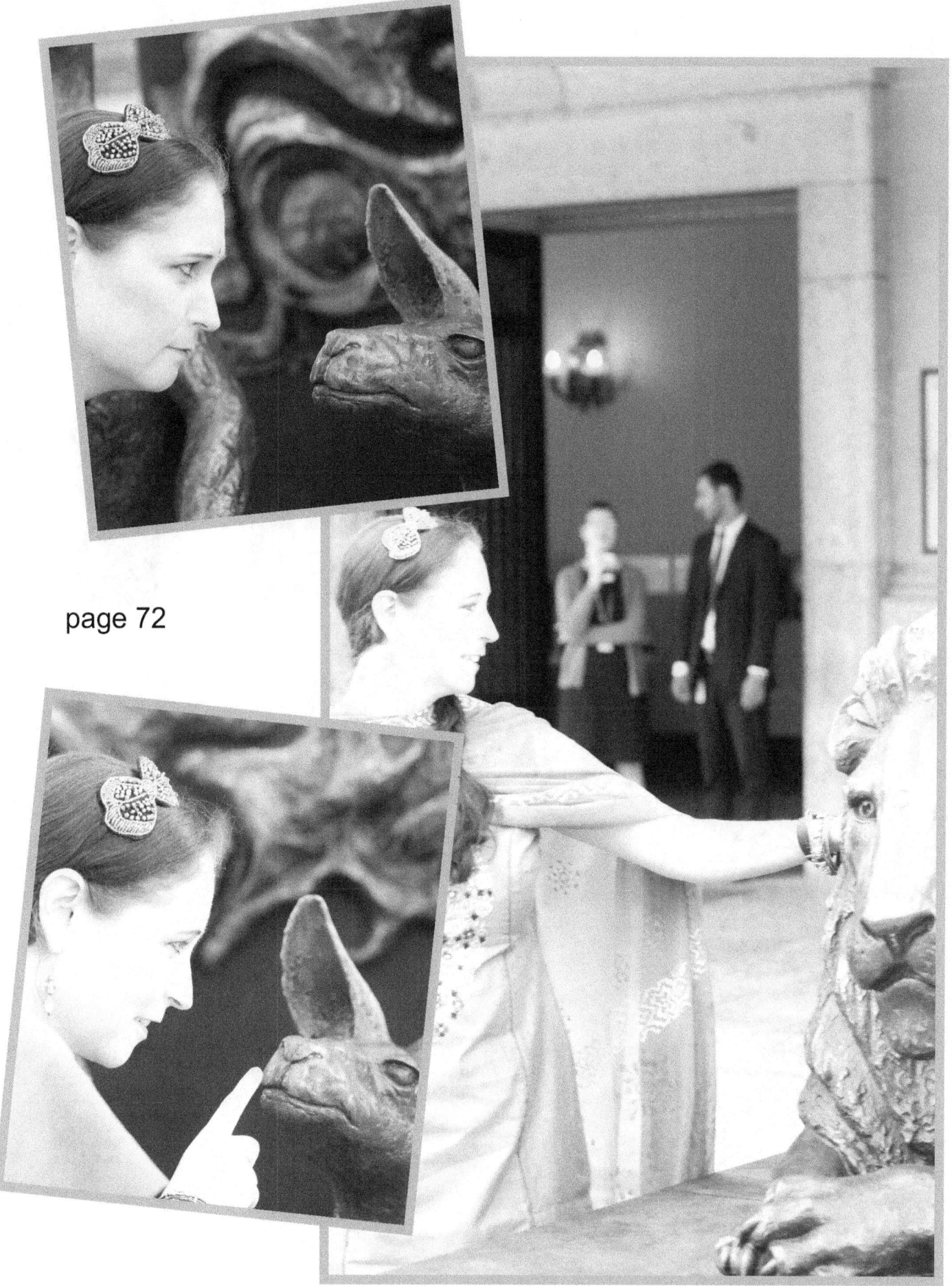

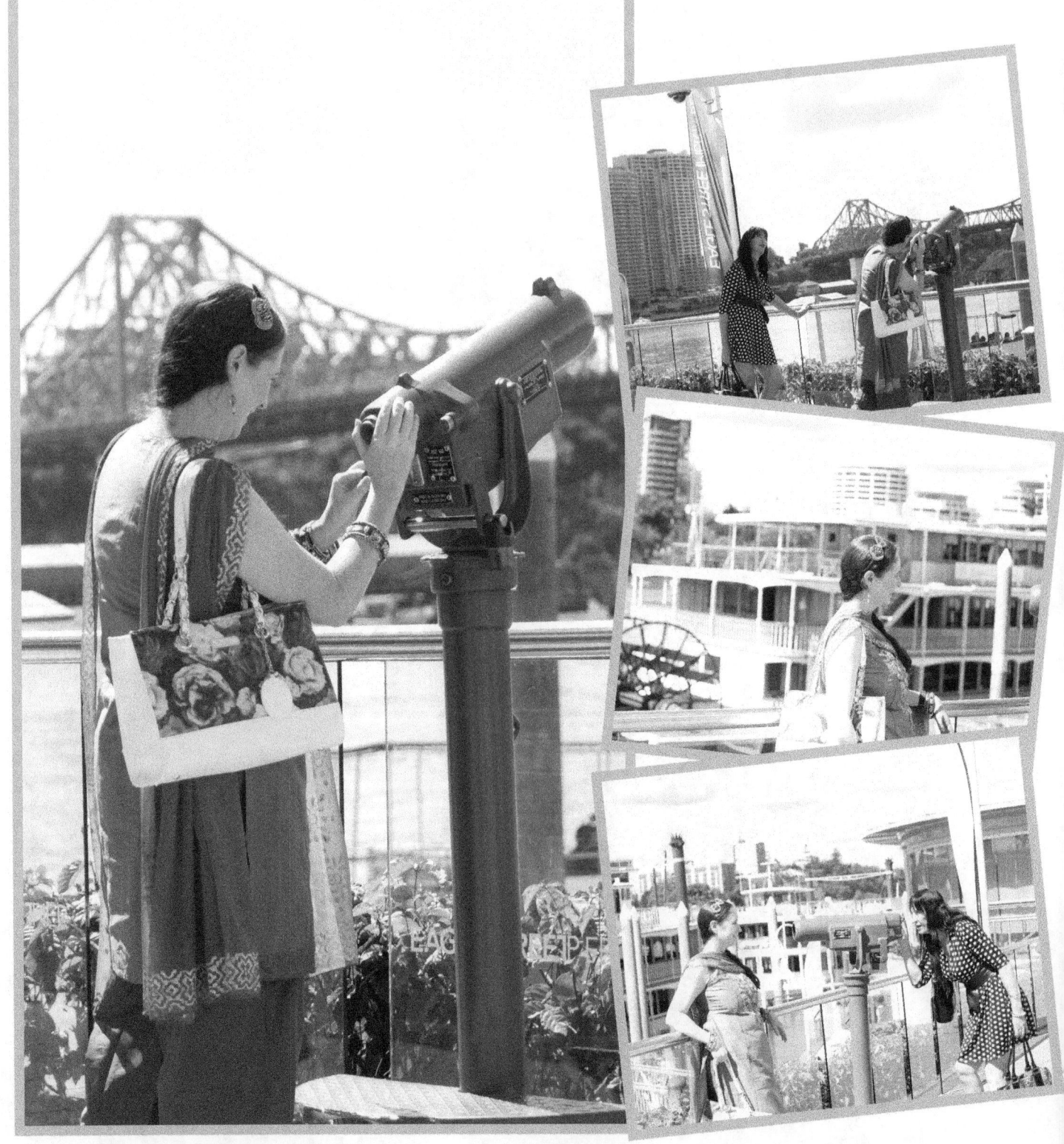

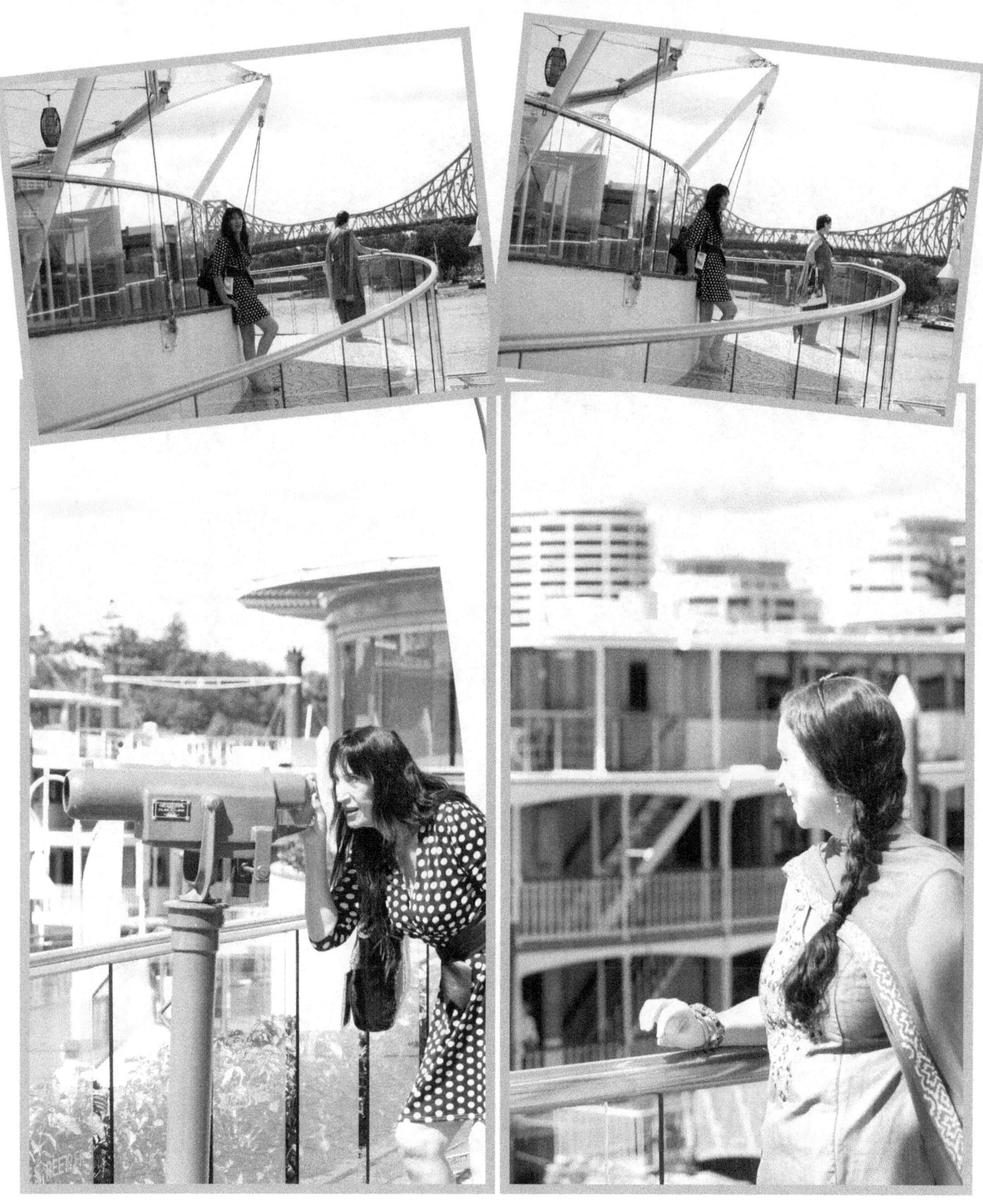

page 75

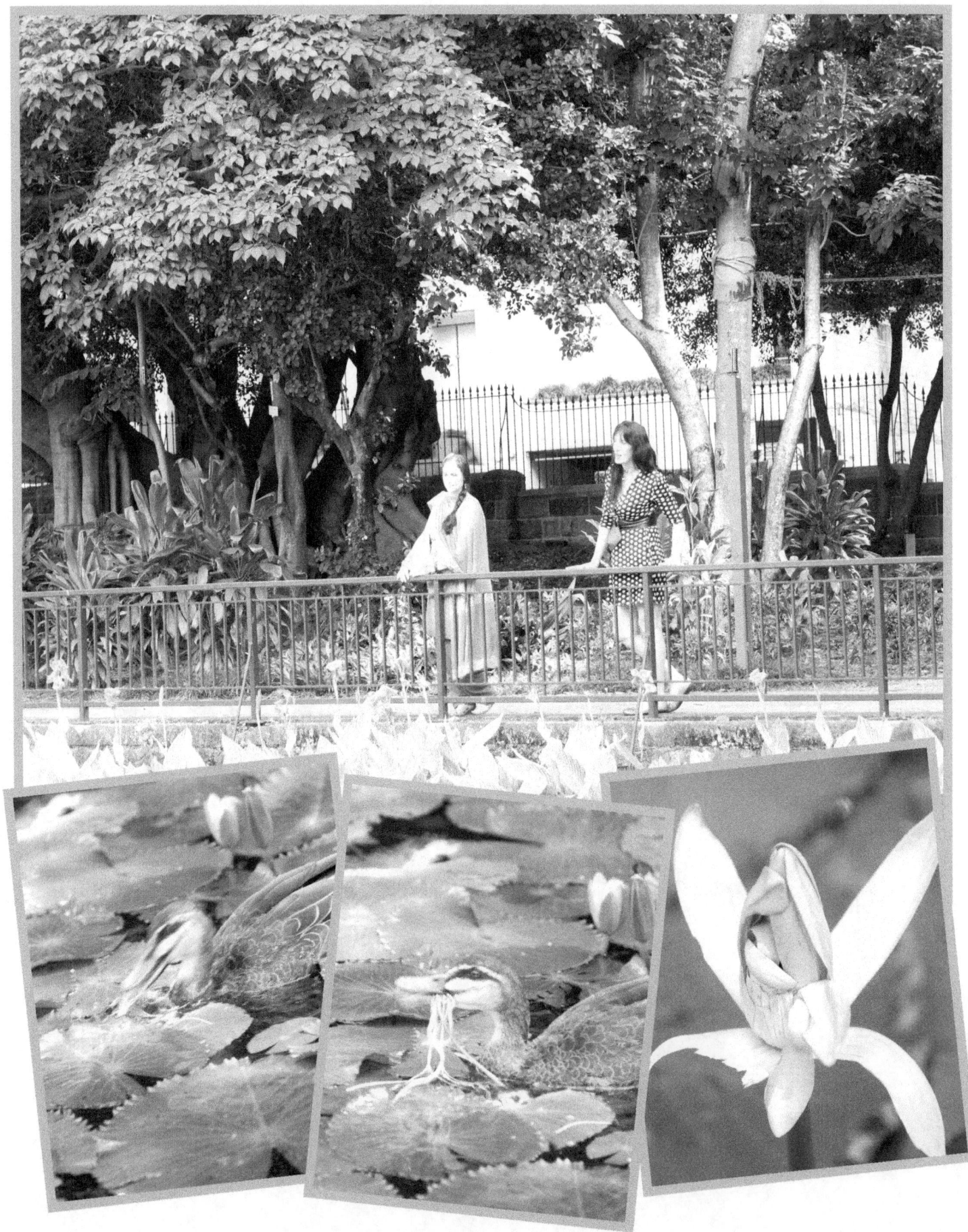

page 76

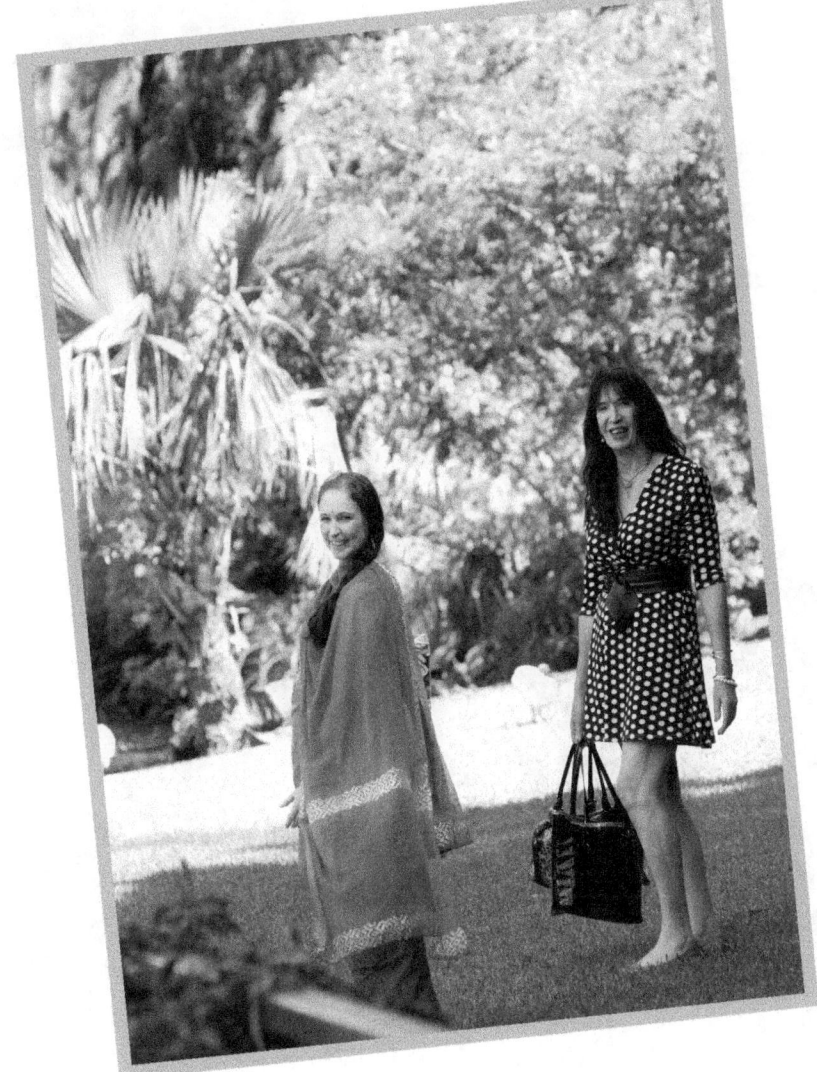

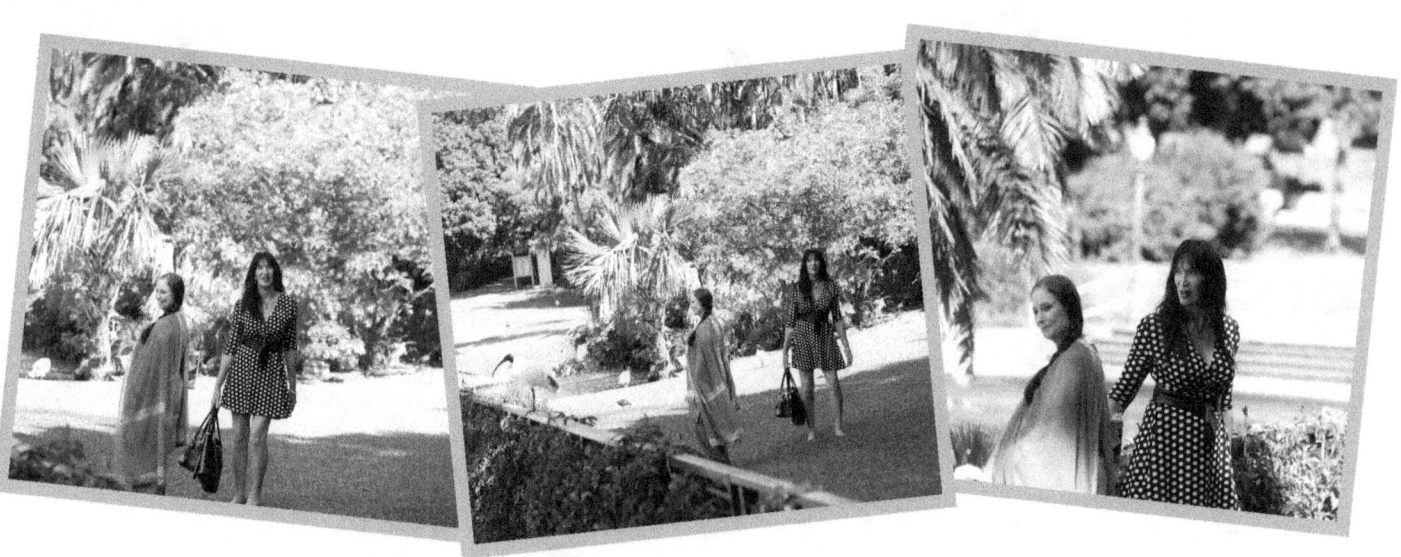

page 77

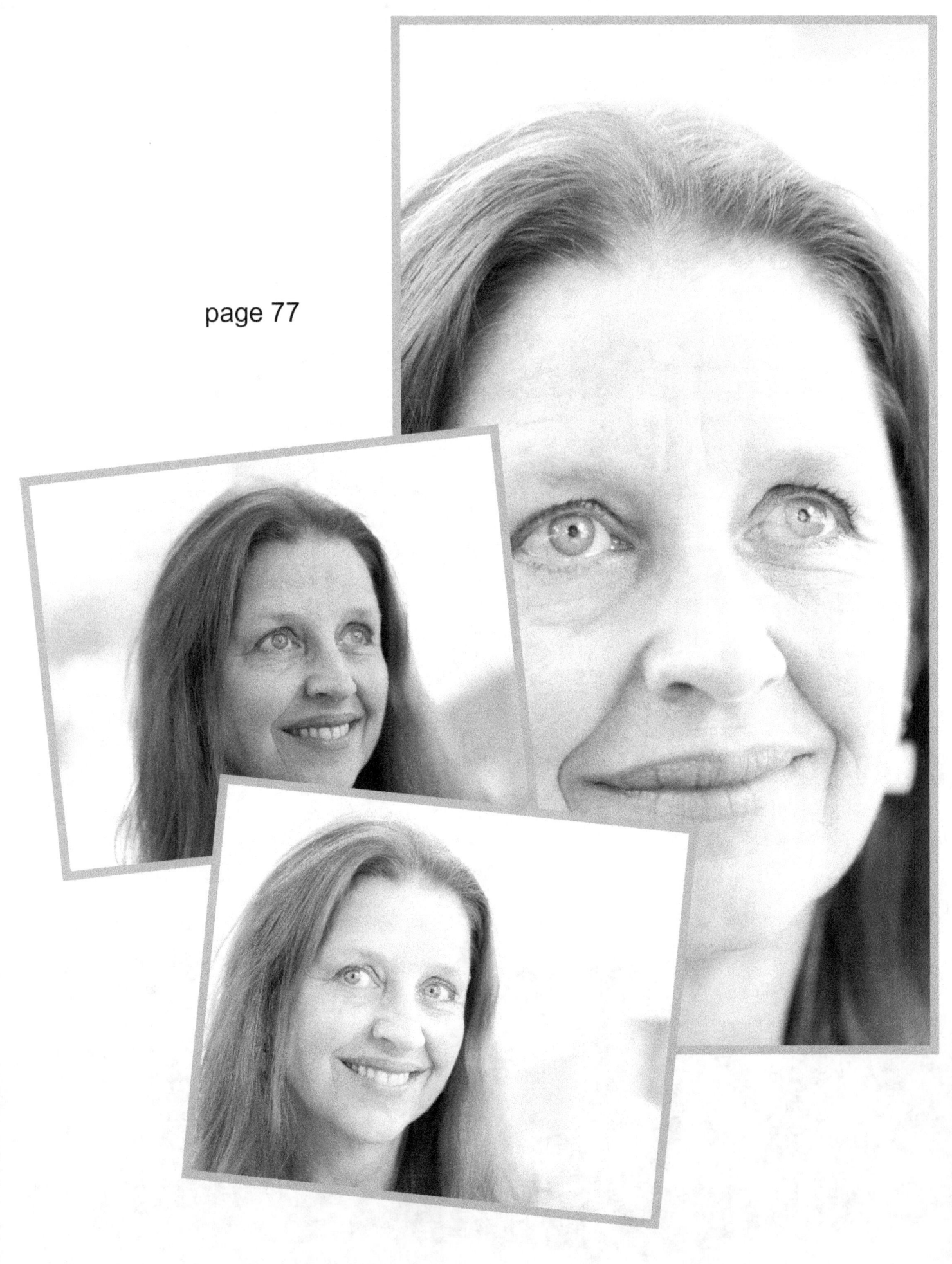

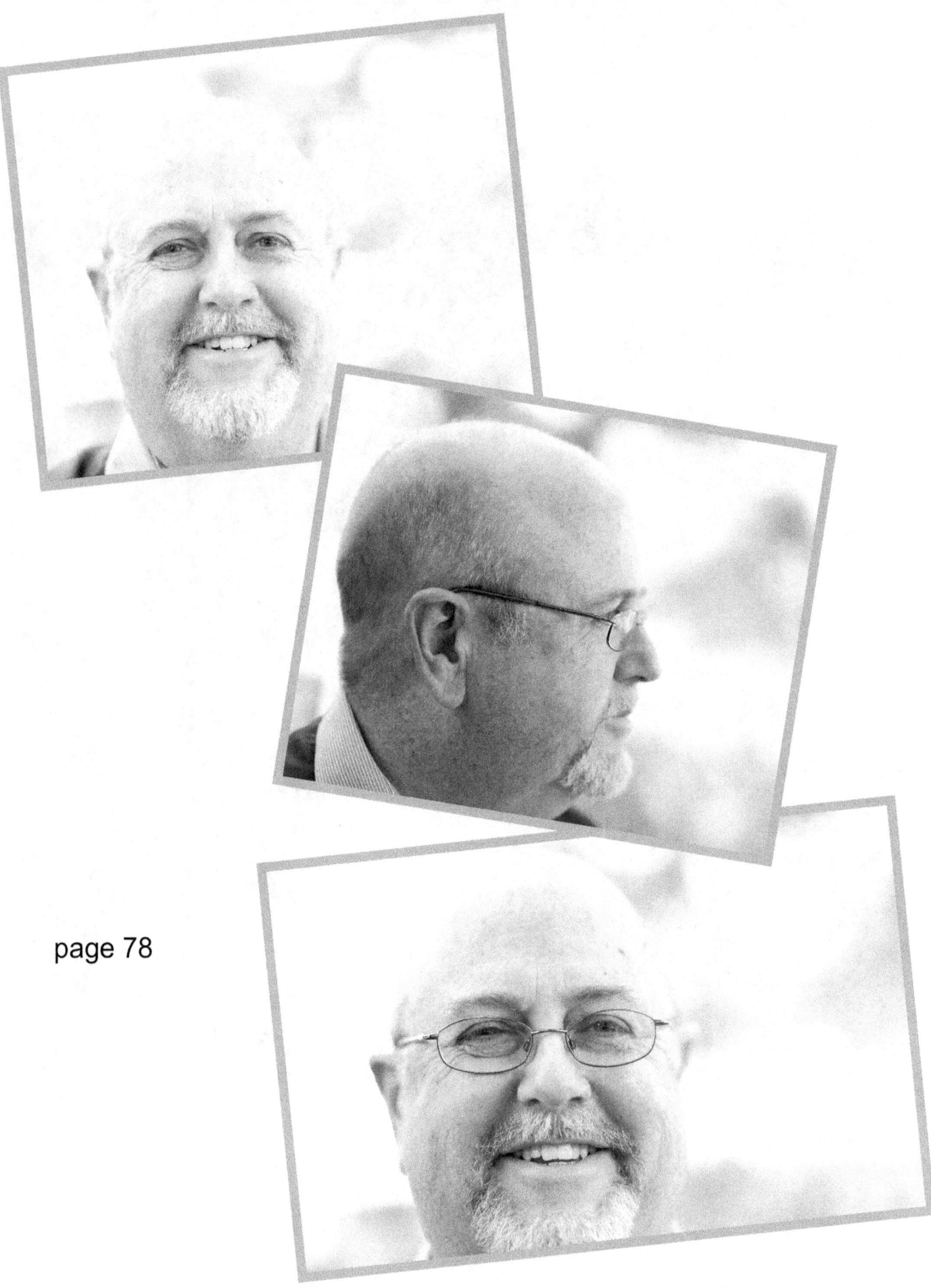

page 78

page 79

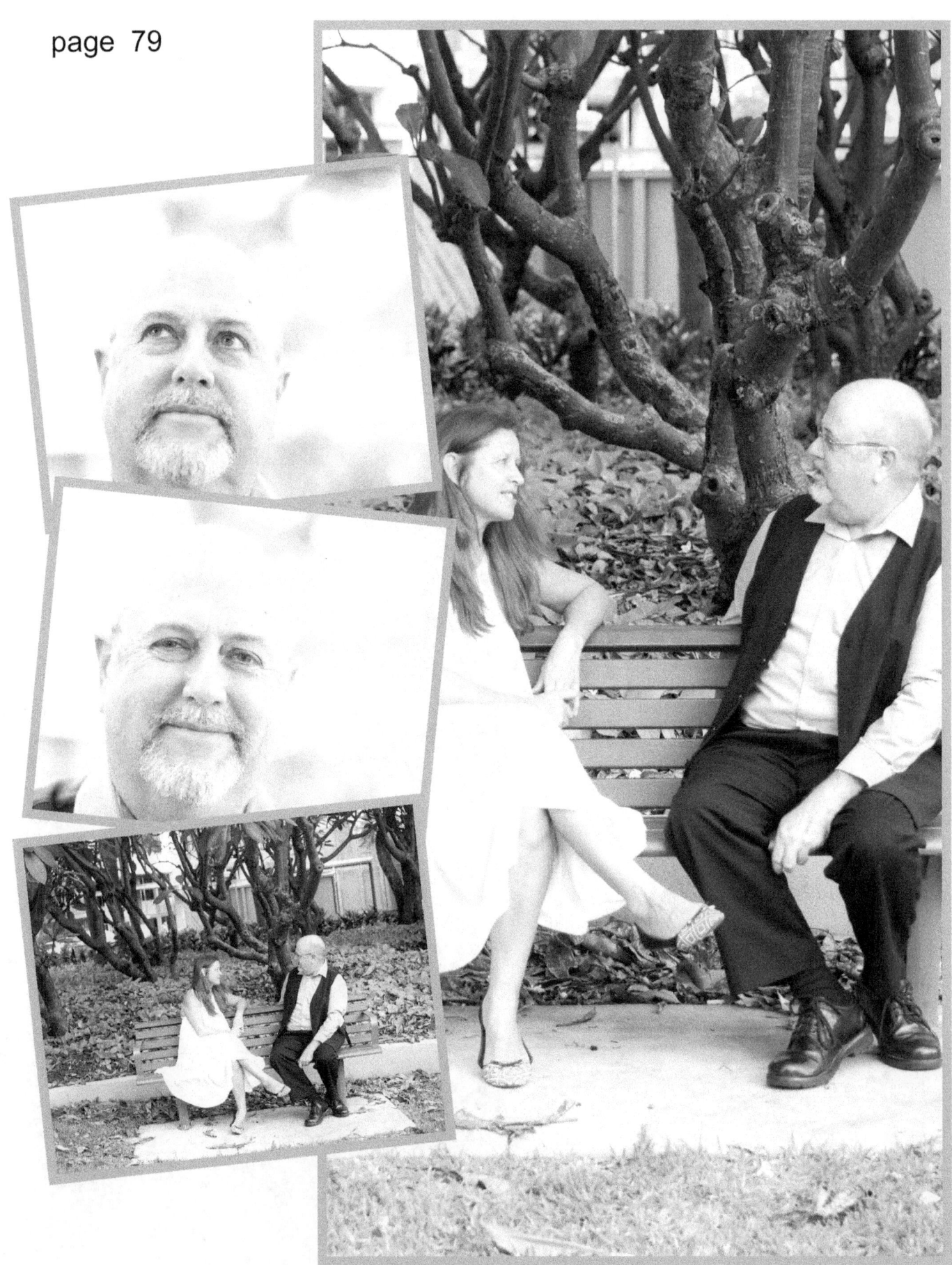

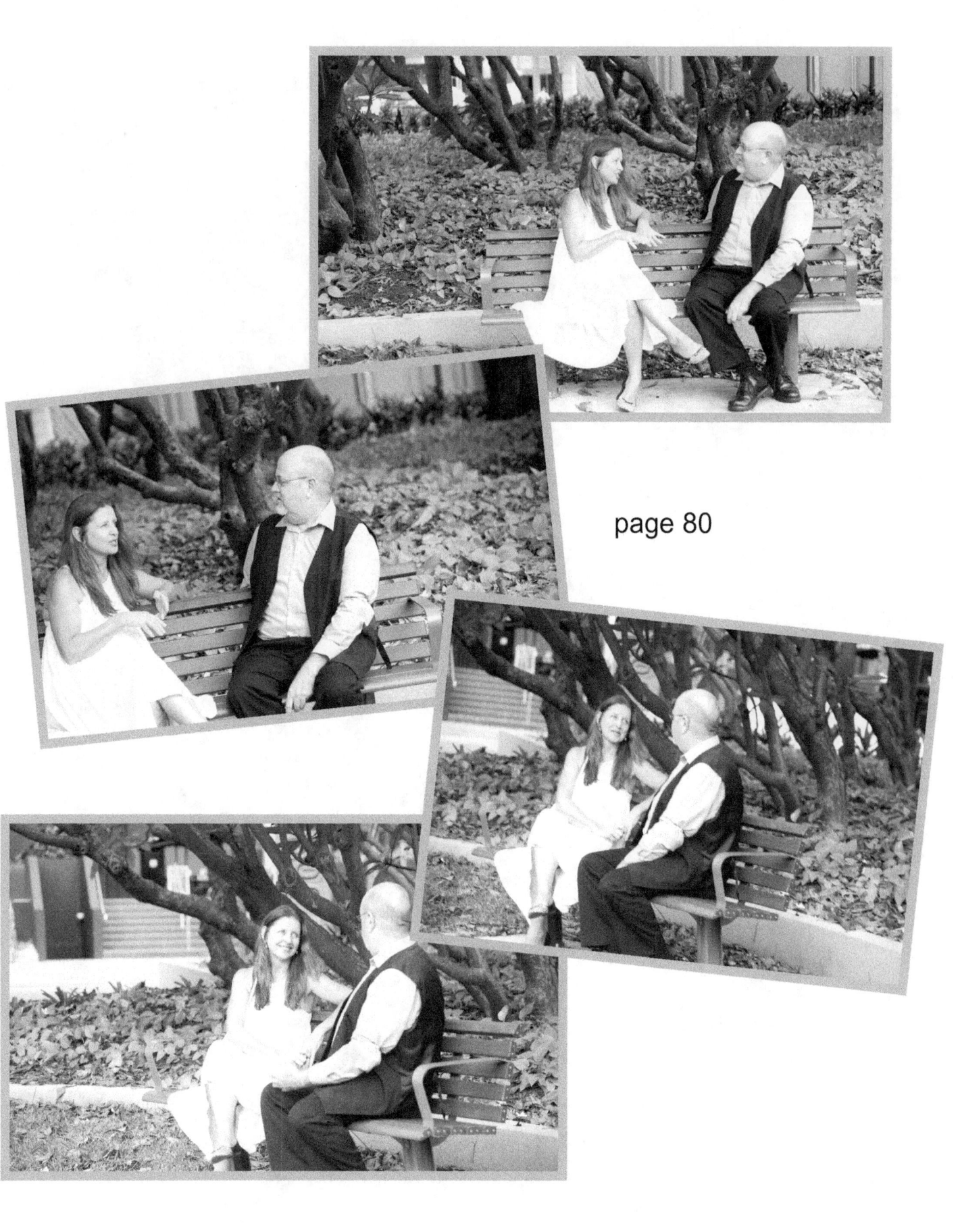

page 80

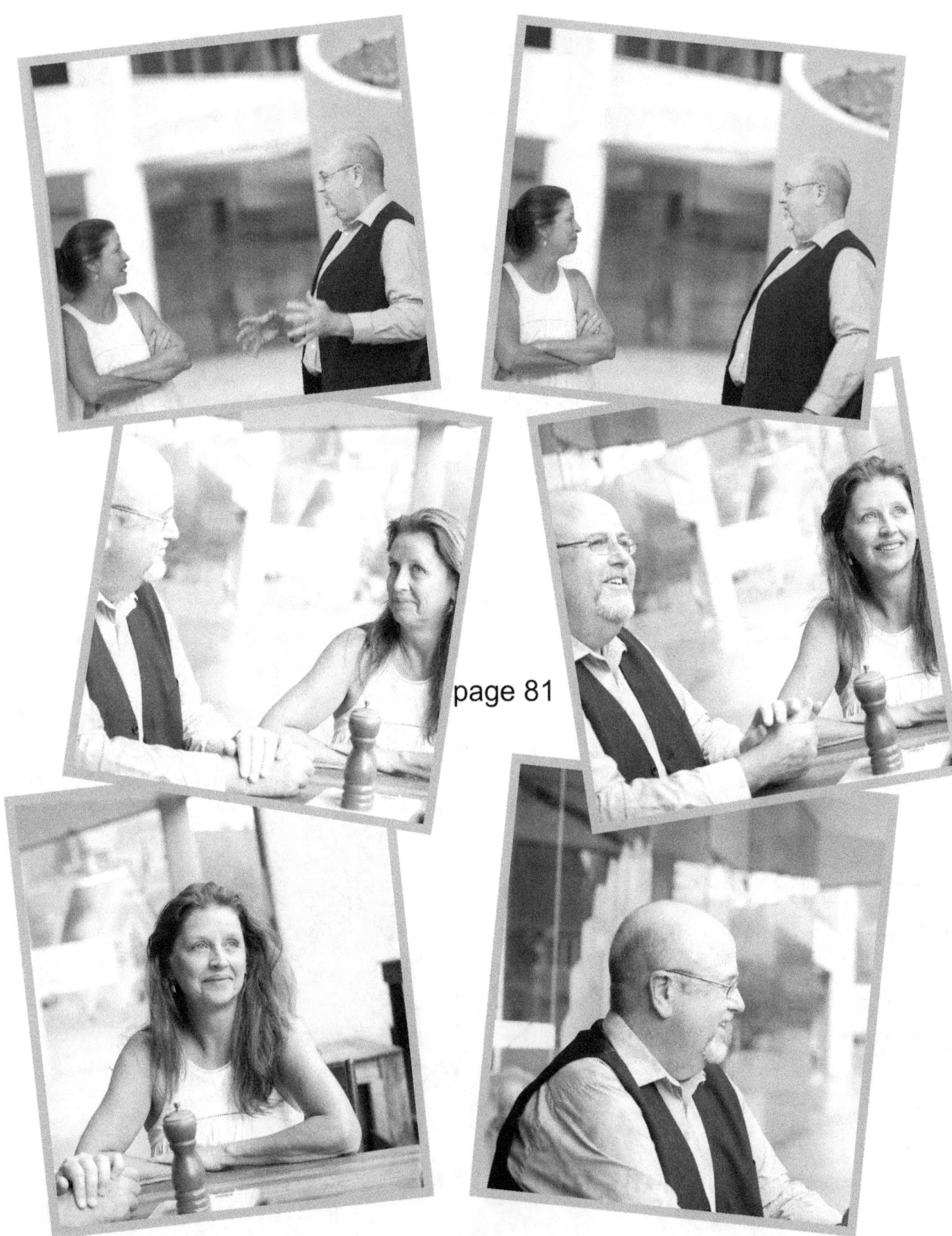

page 81

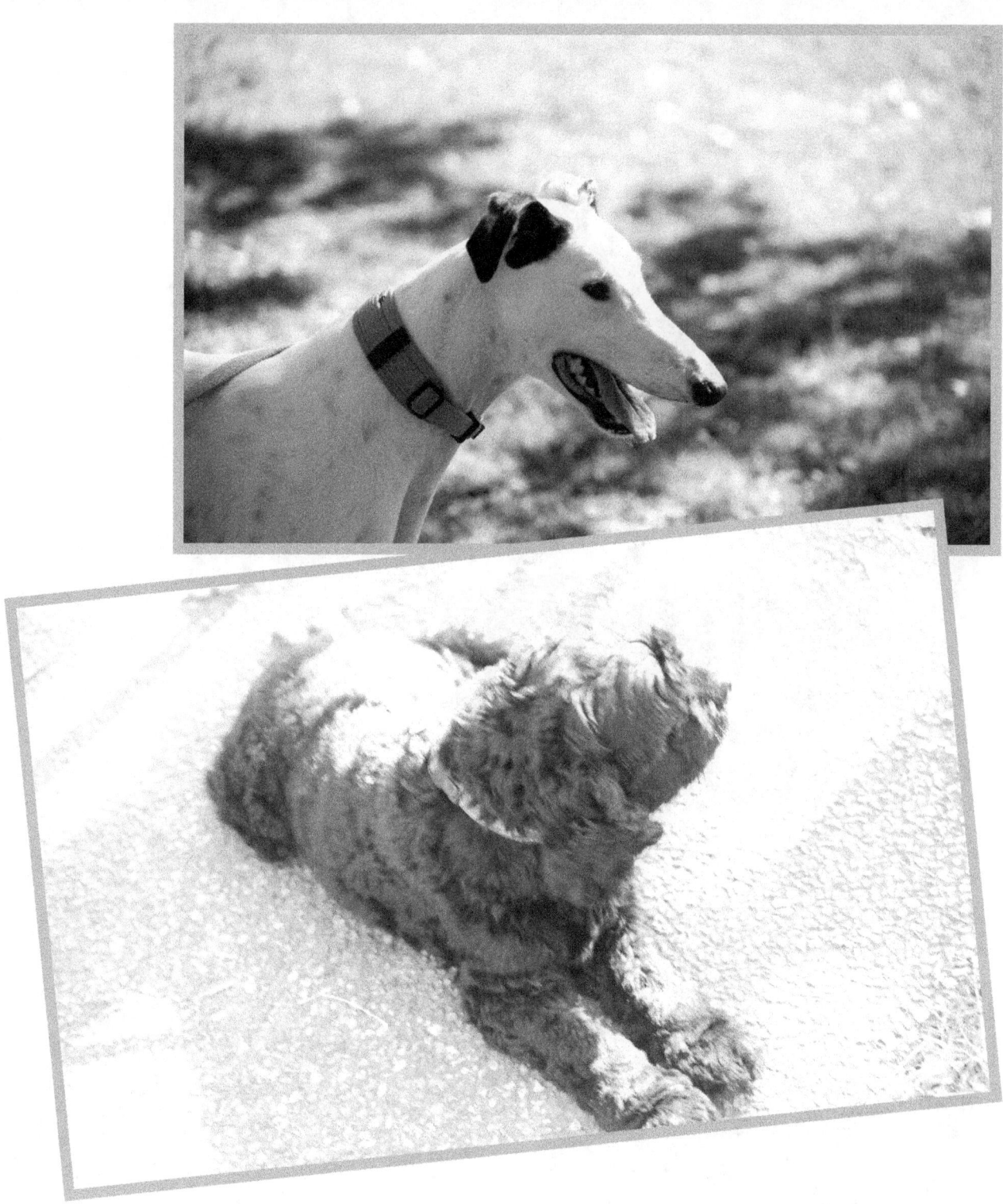

page 83

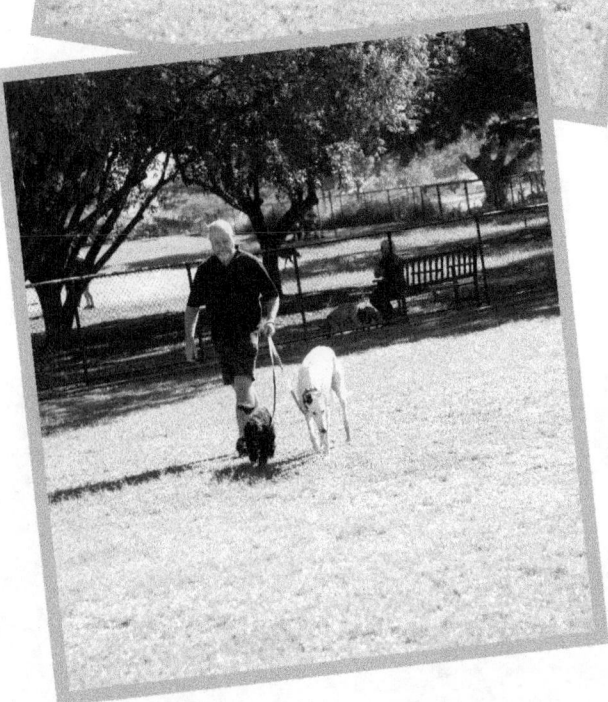
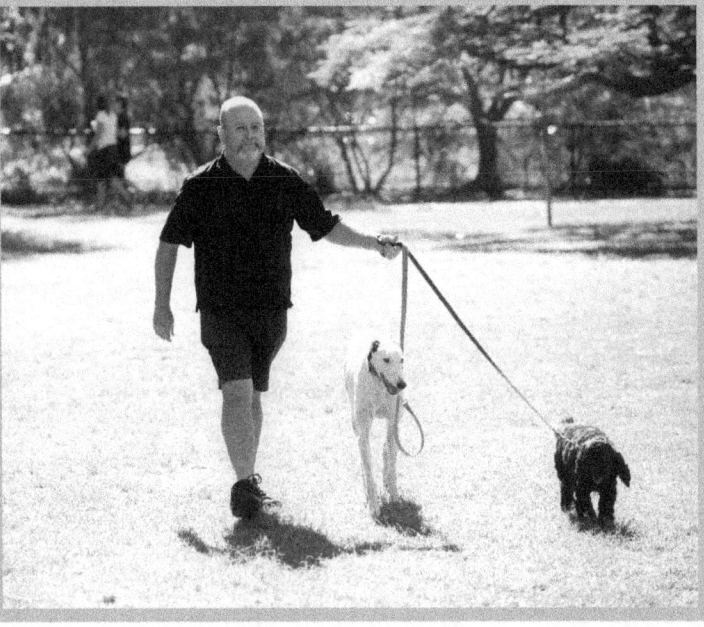

page 84

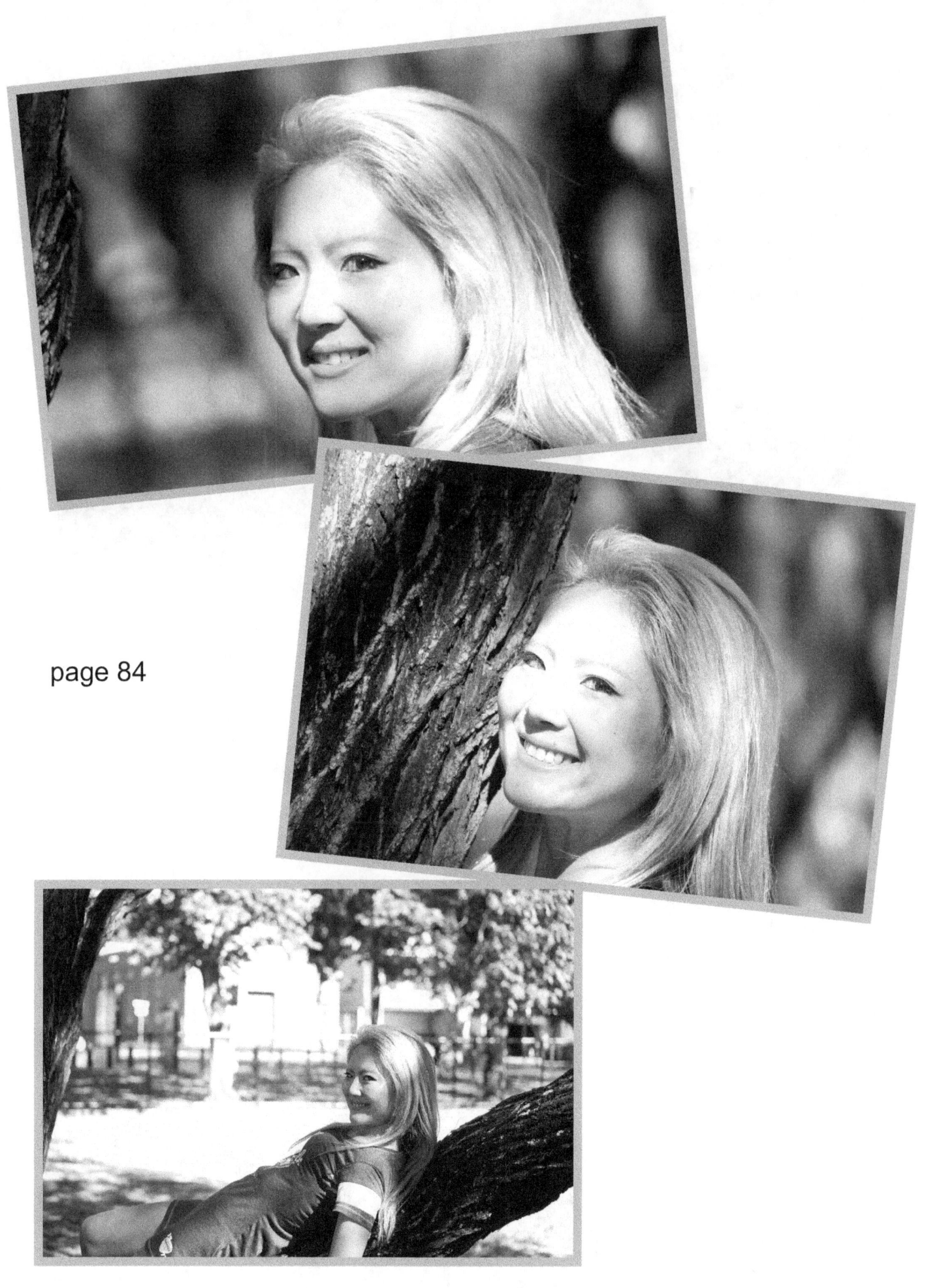

page 85

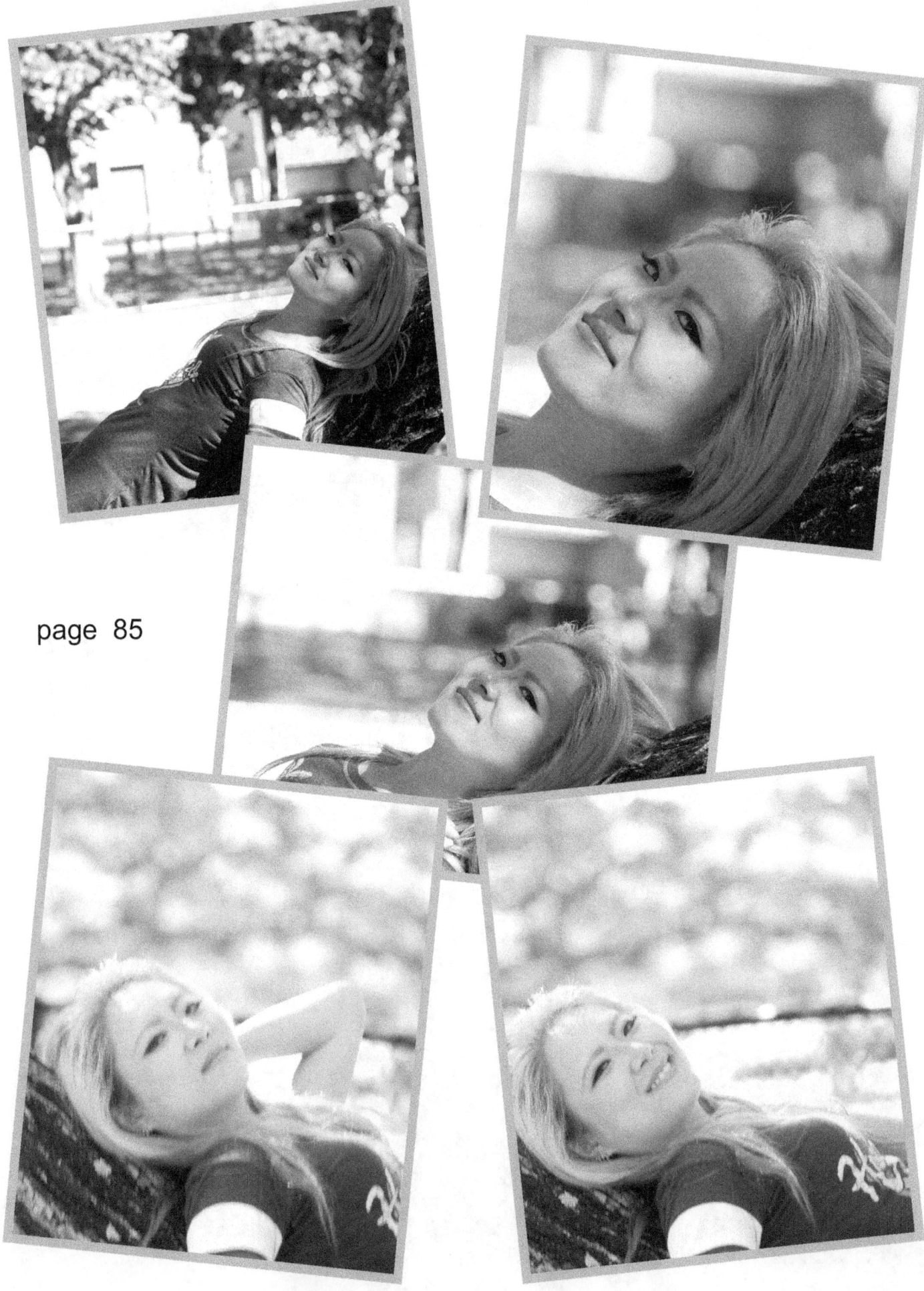

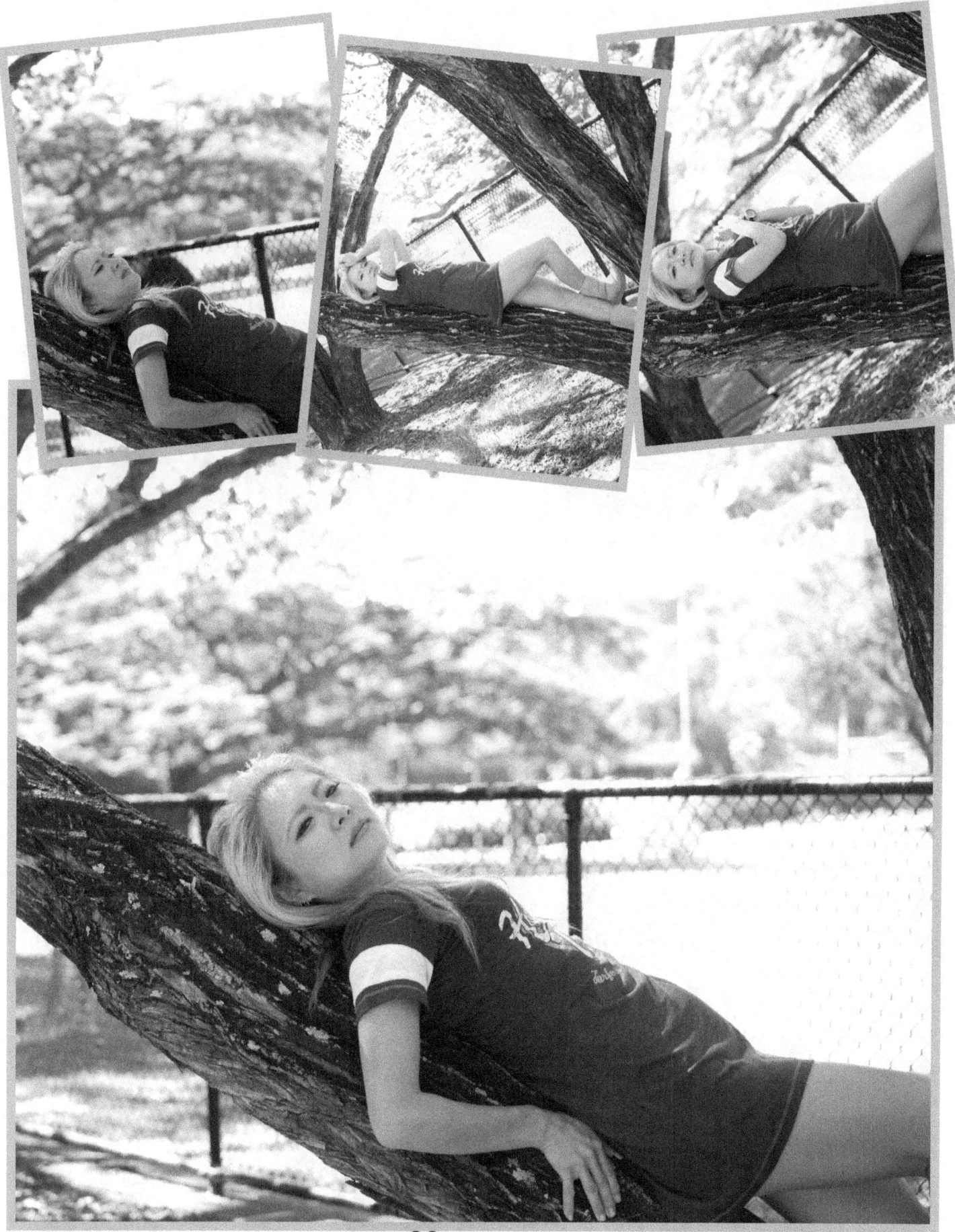

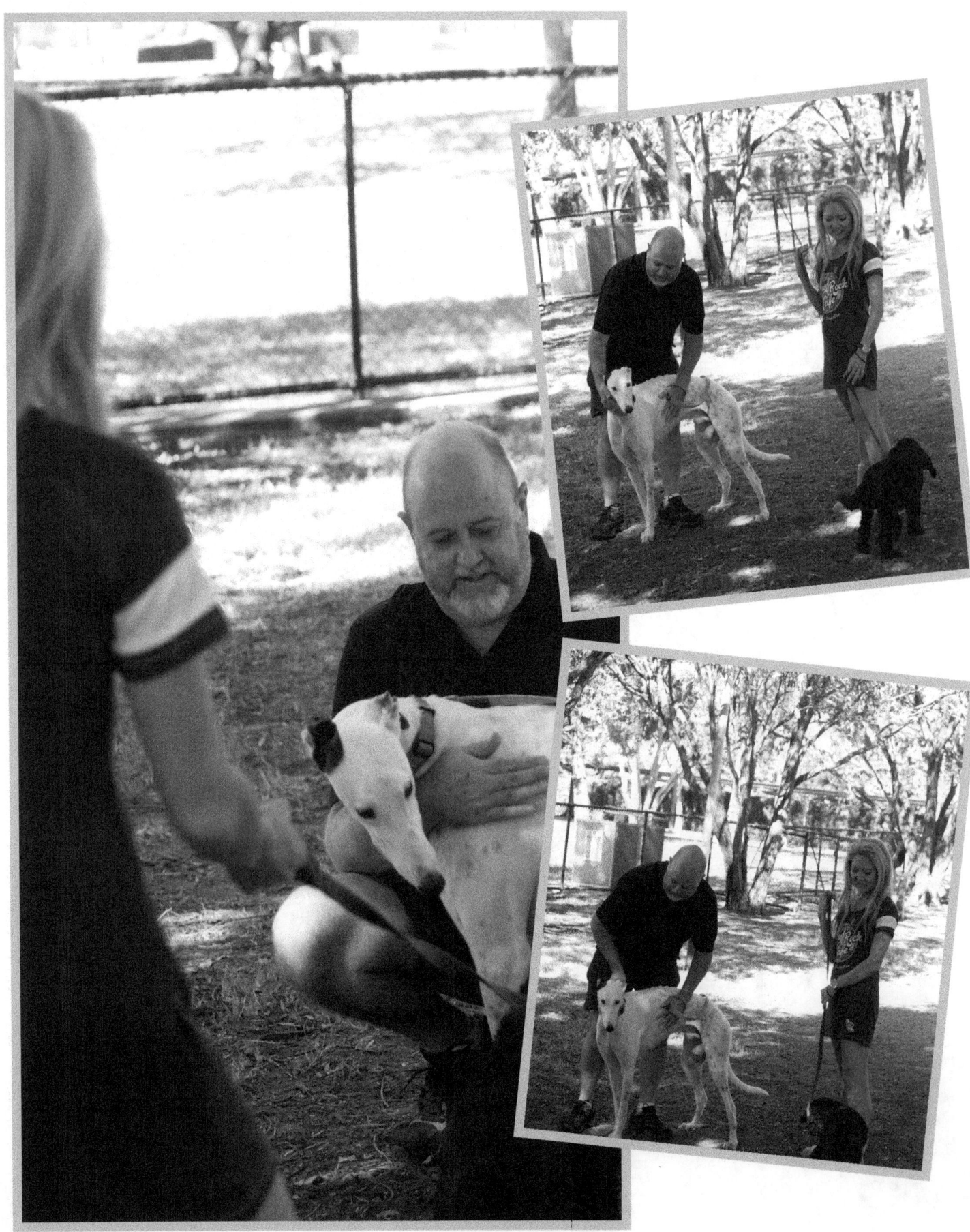

page 87

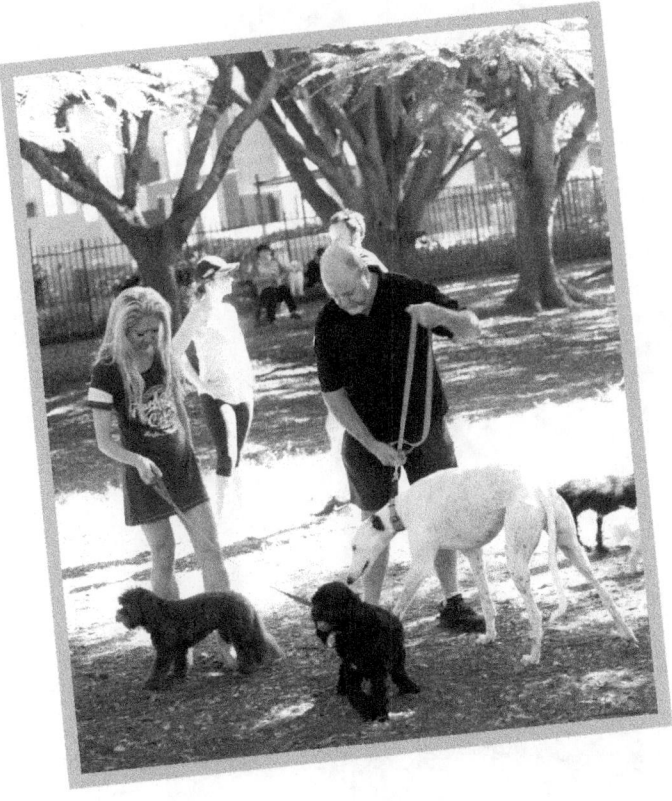
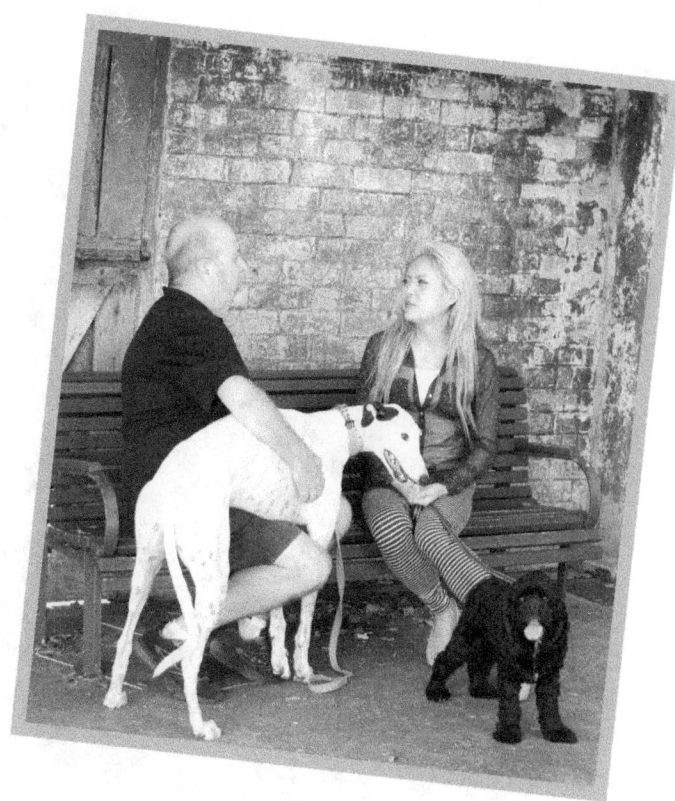

page 88

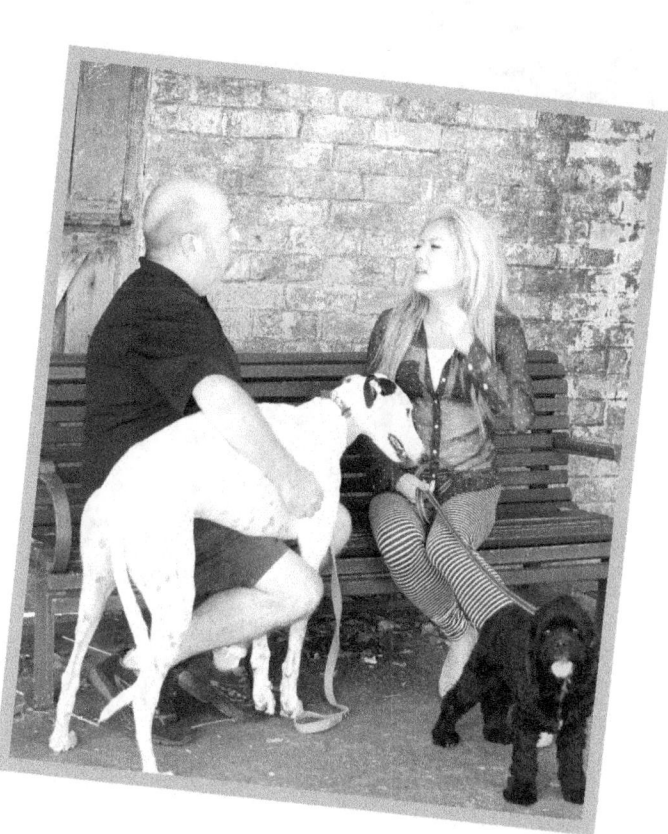
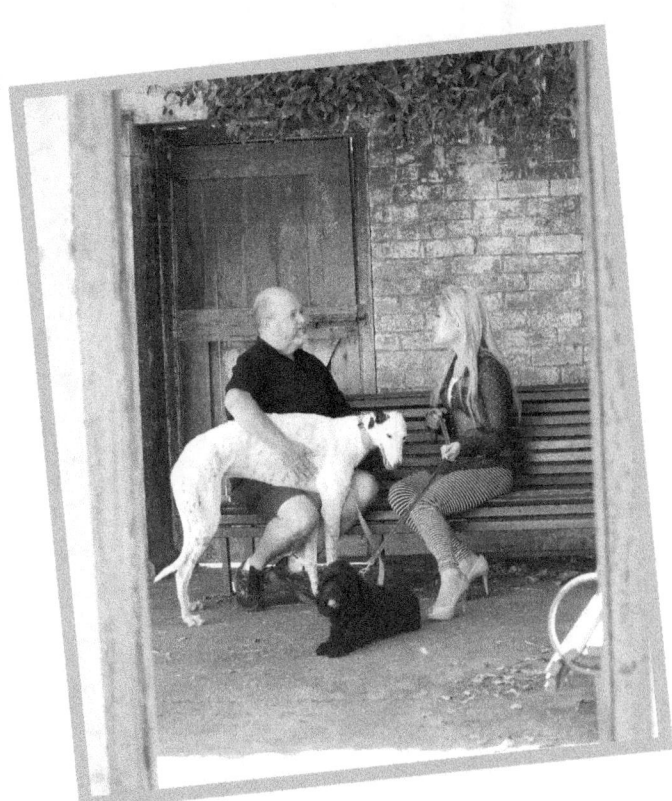

page 89

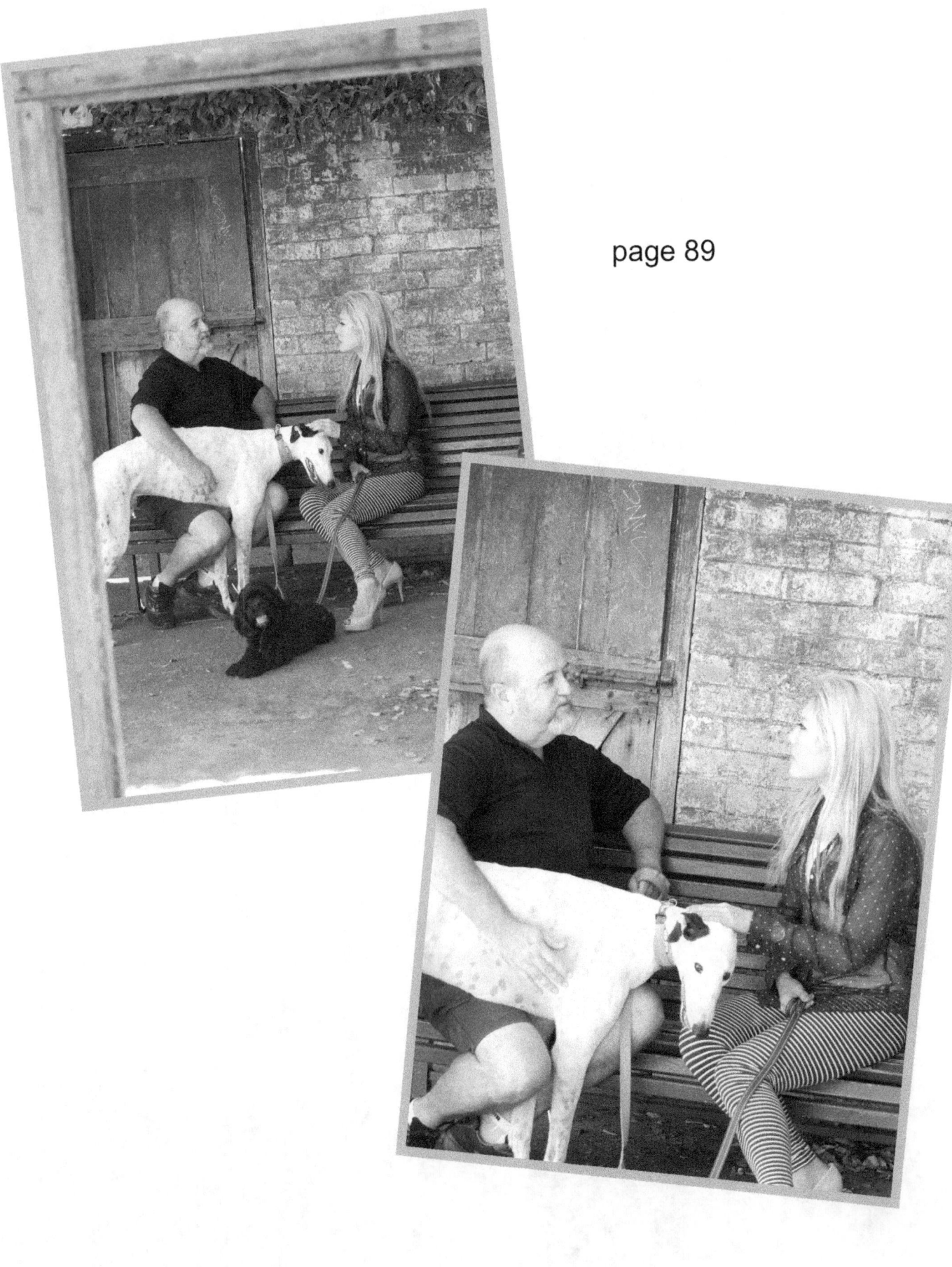

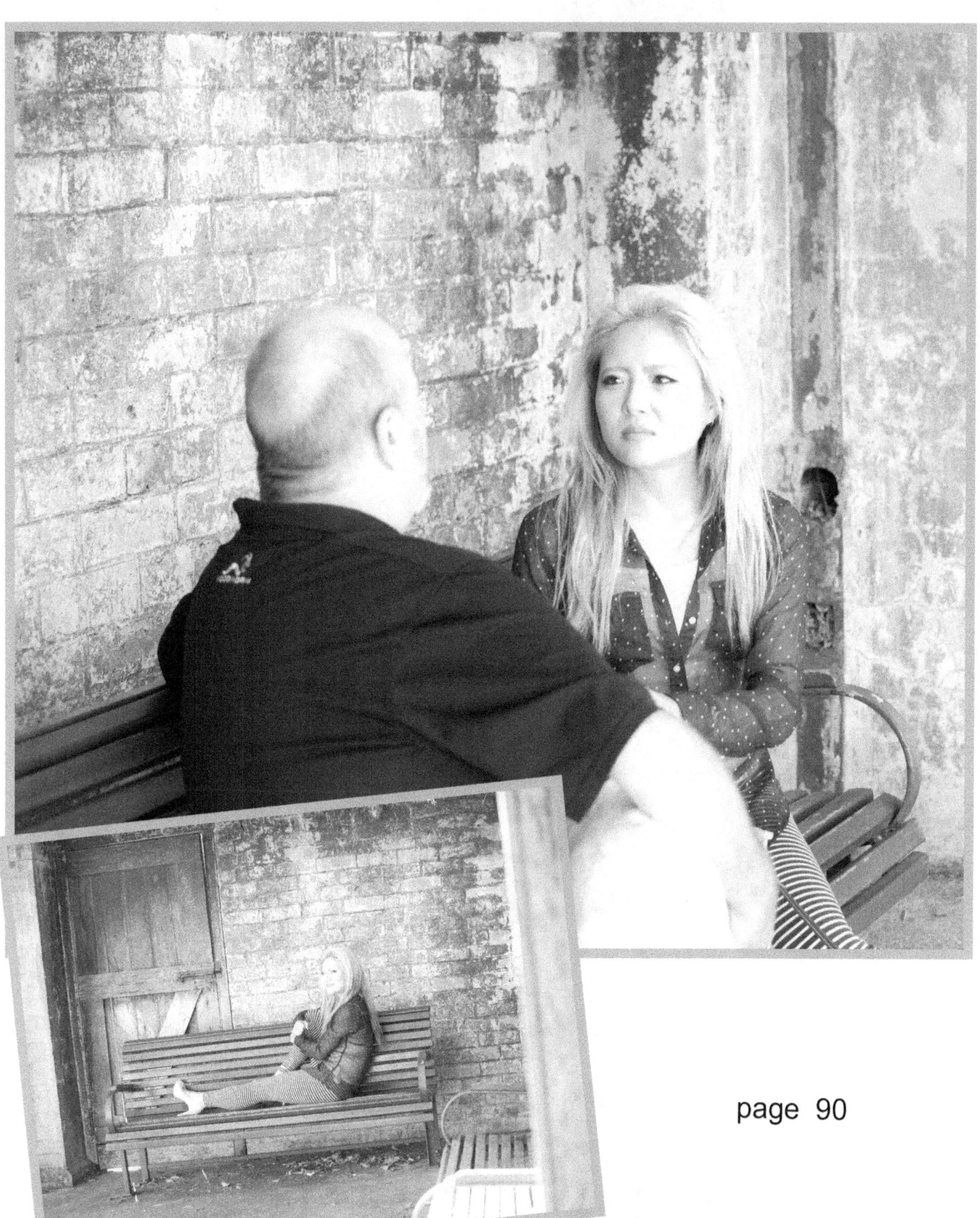

page 90

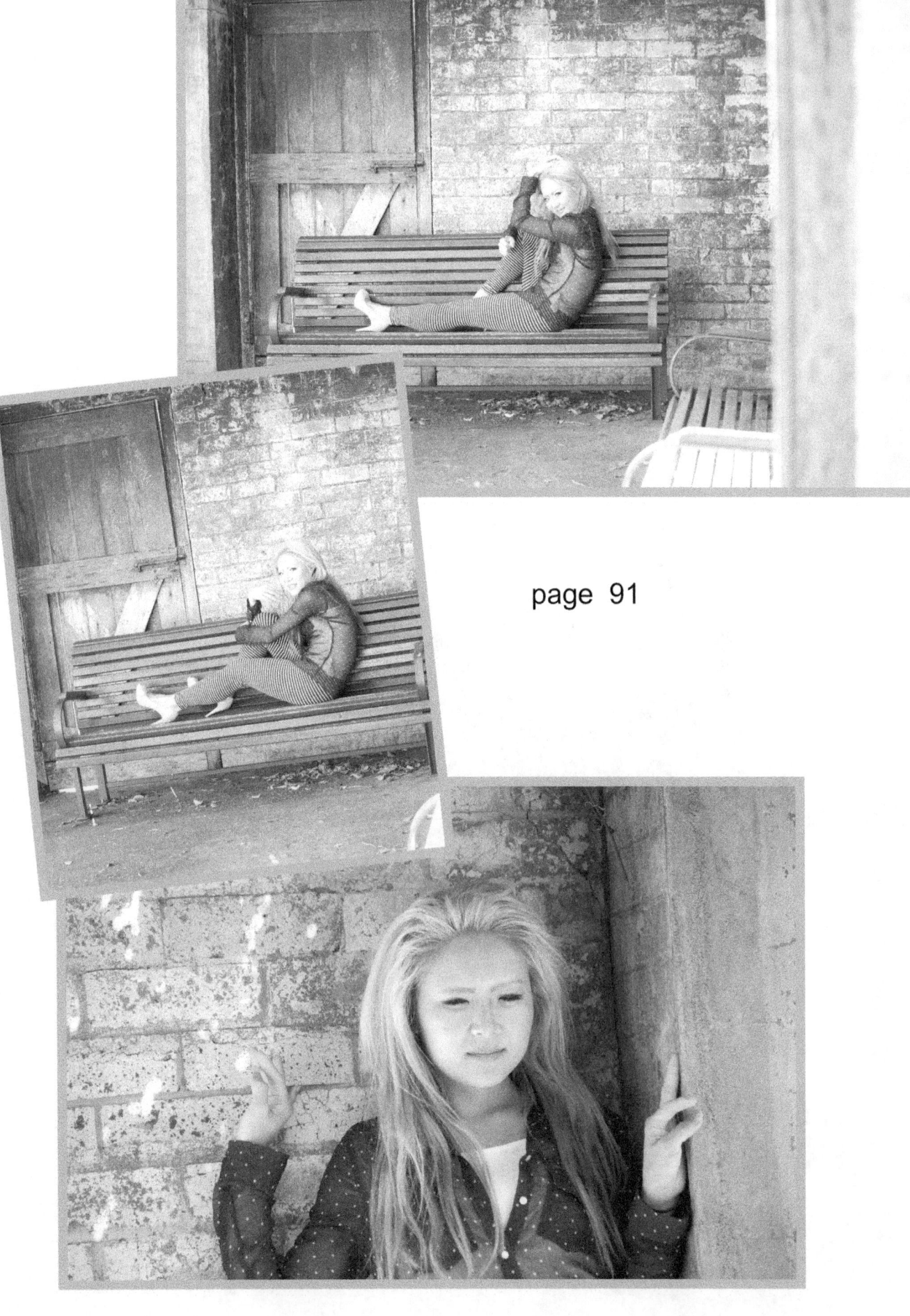

page 91

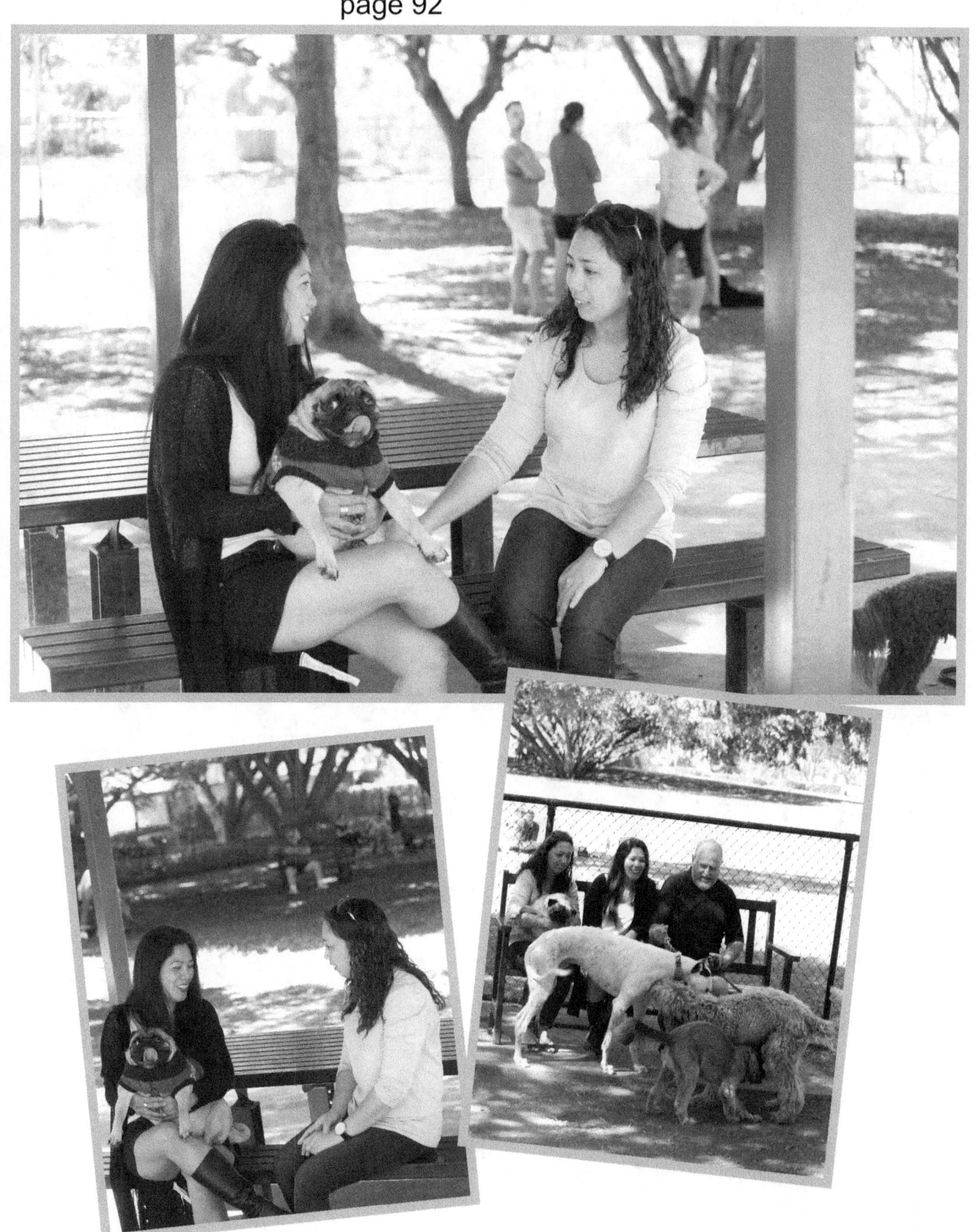

page 93

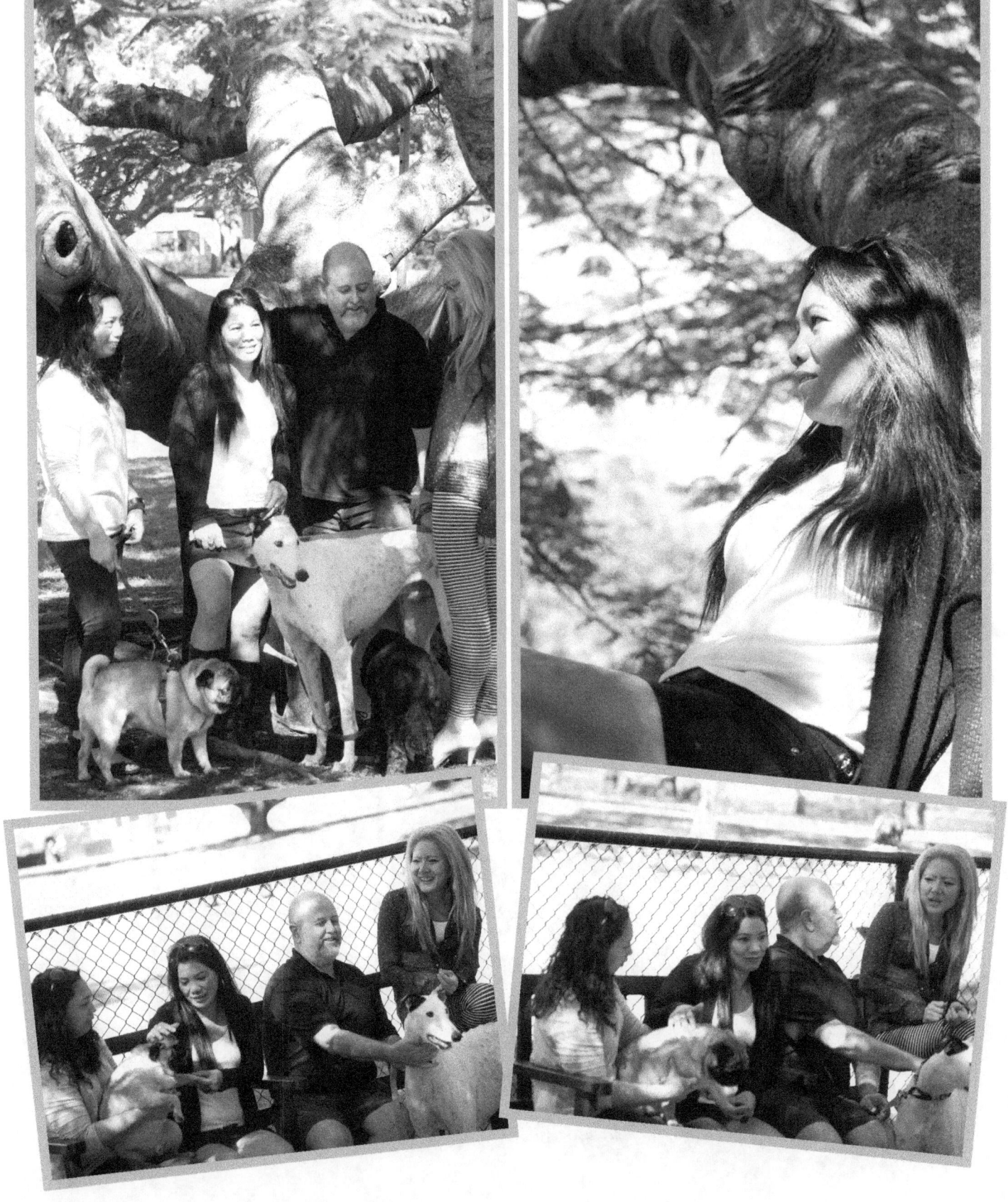

page 94

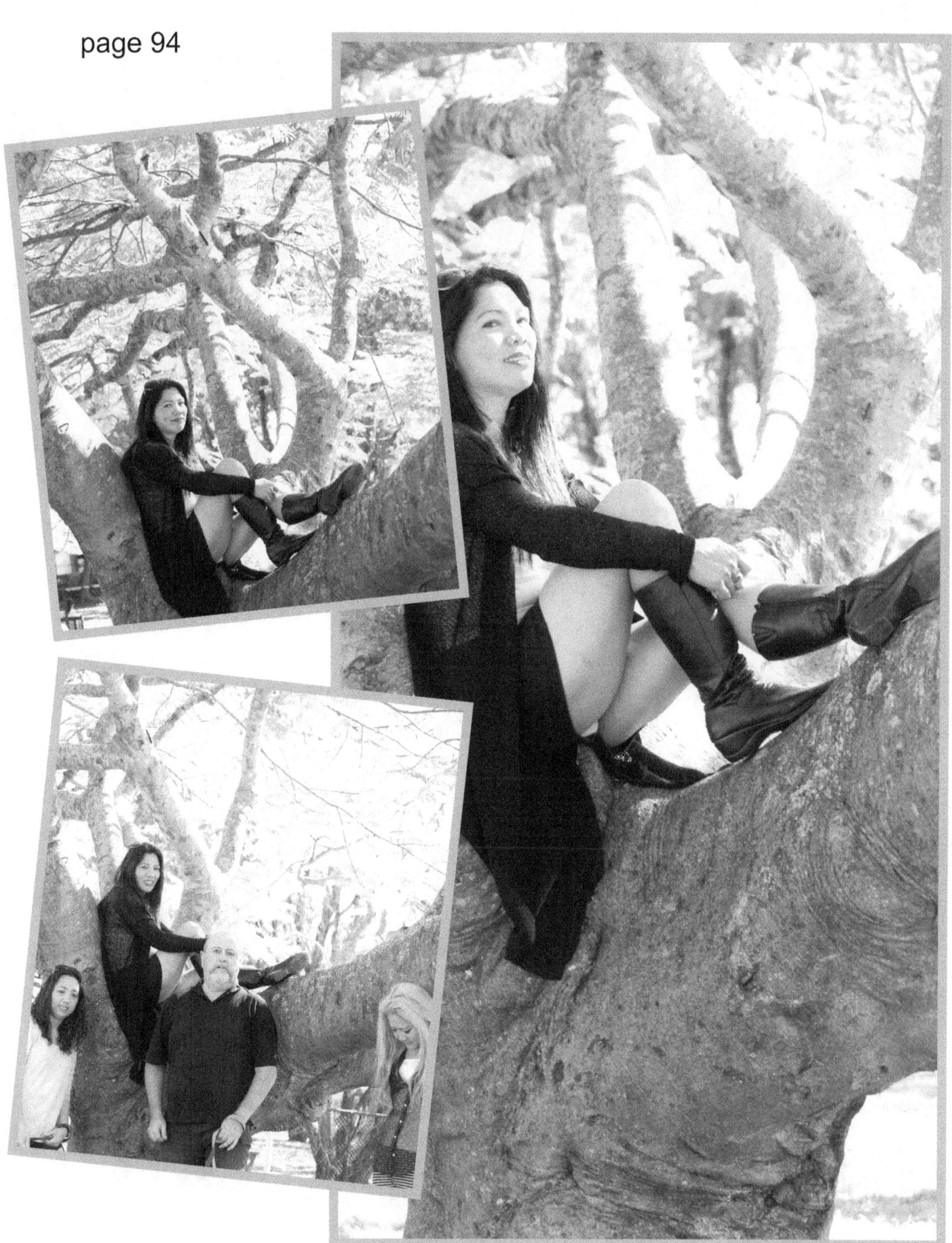

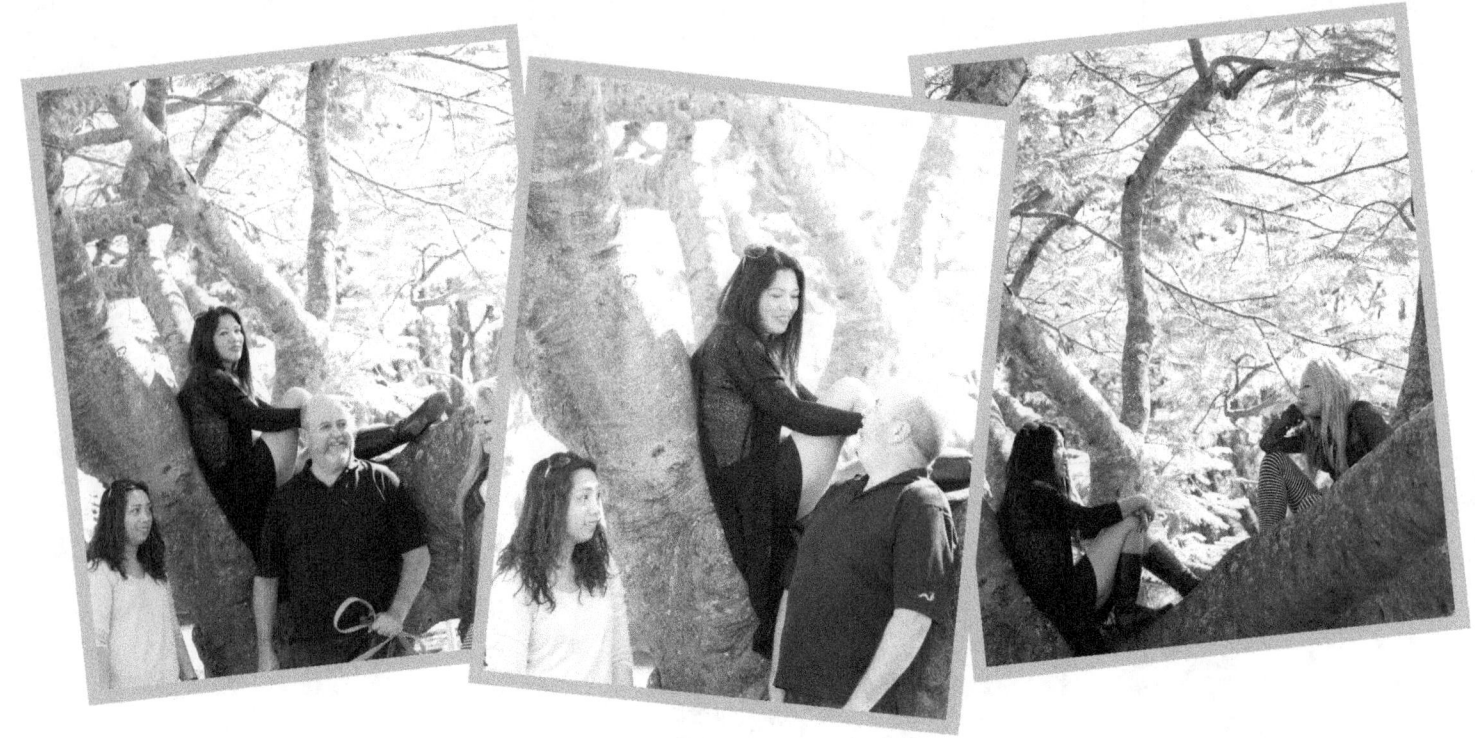

page 95

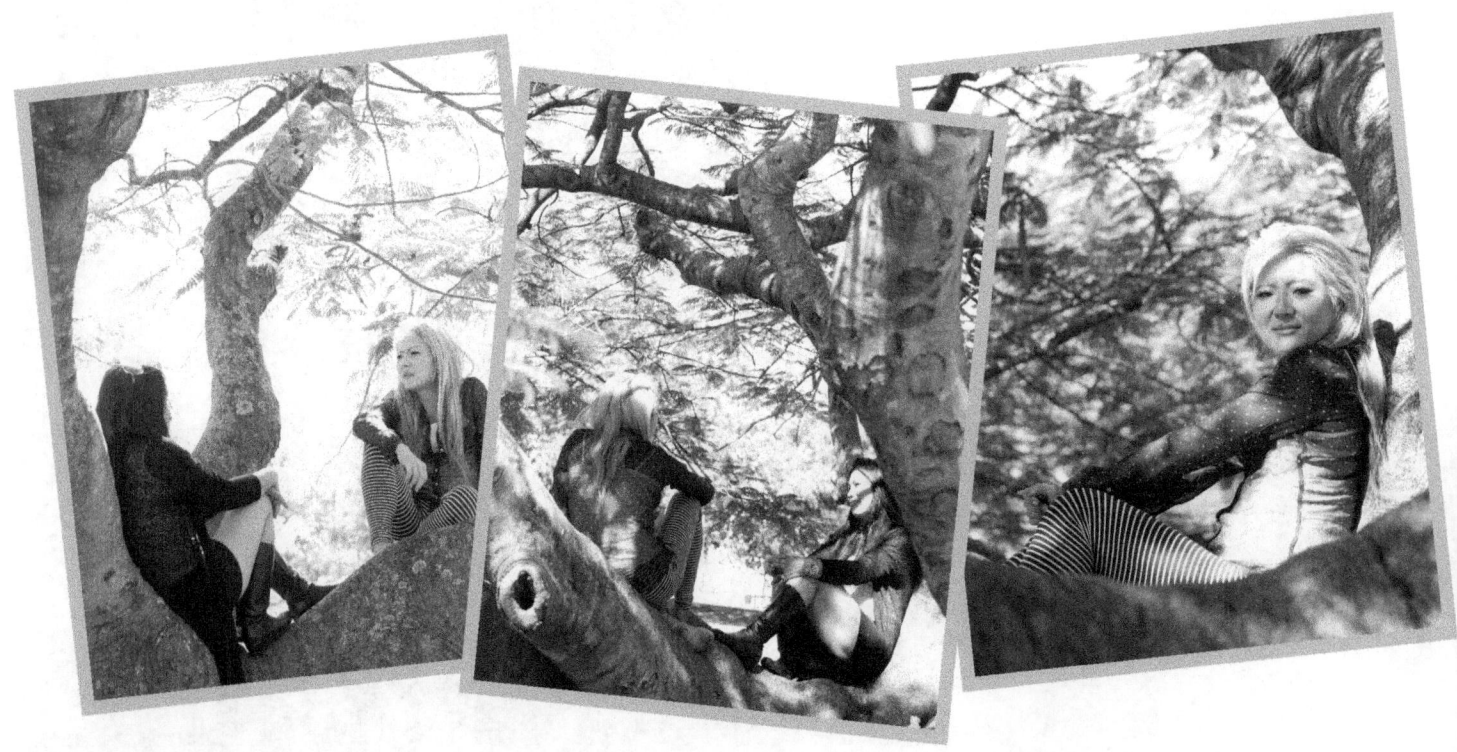

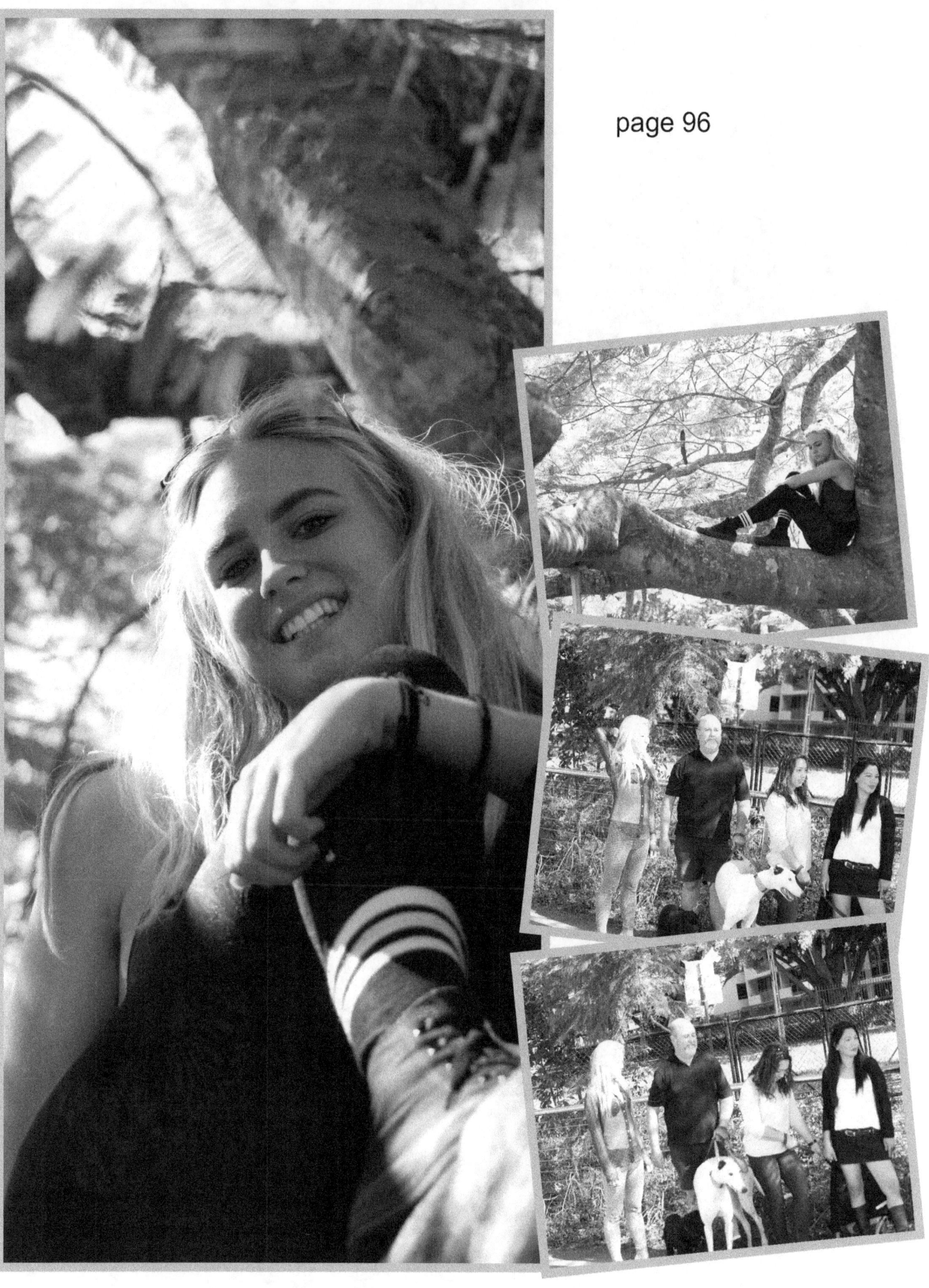

page 96

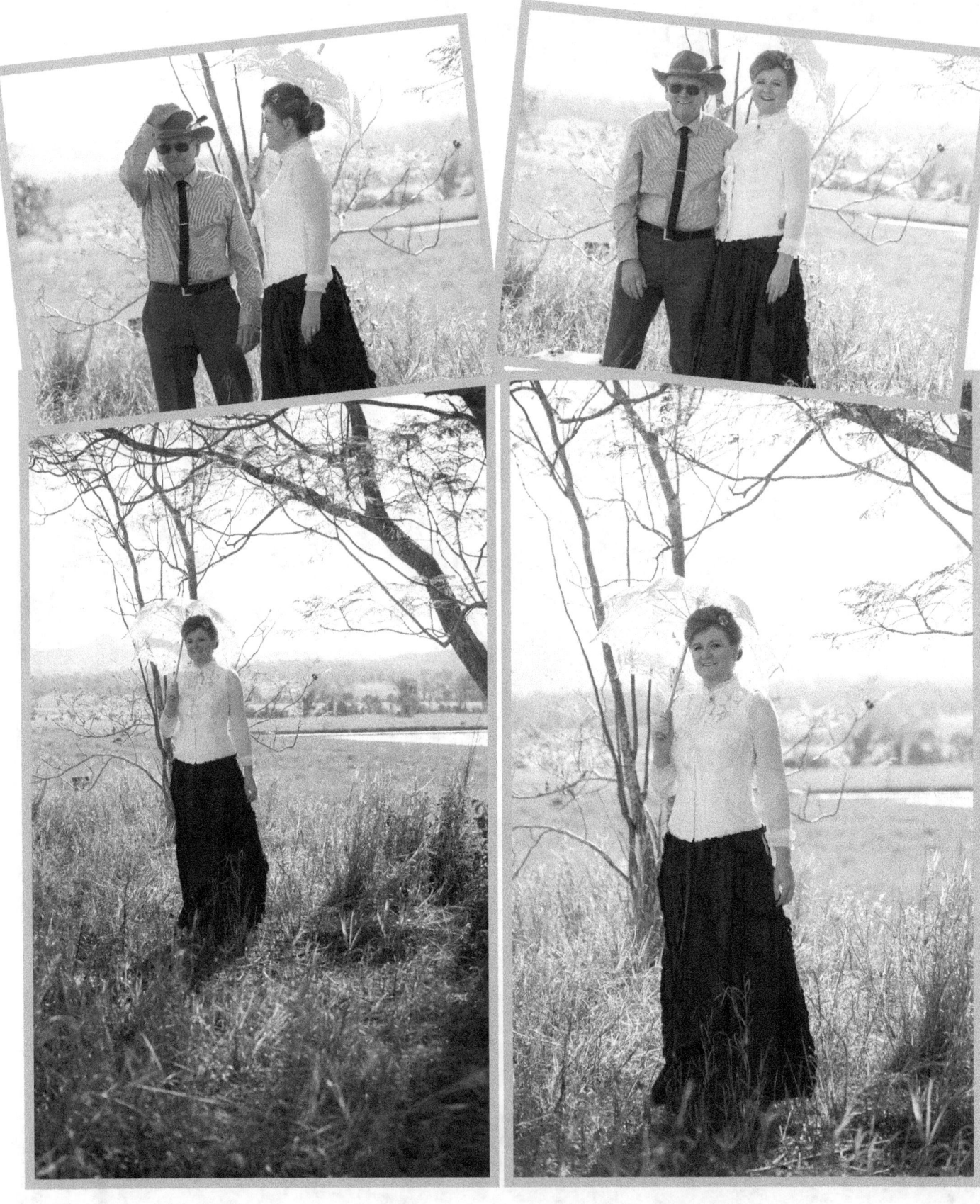

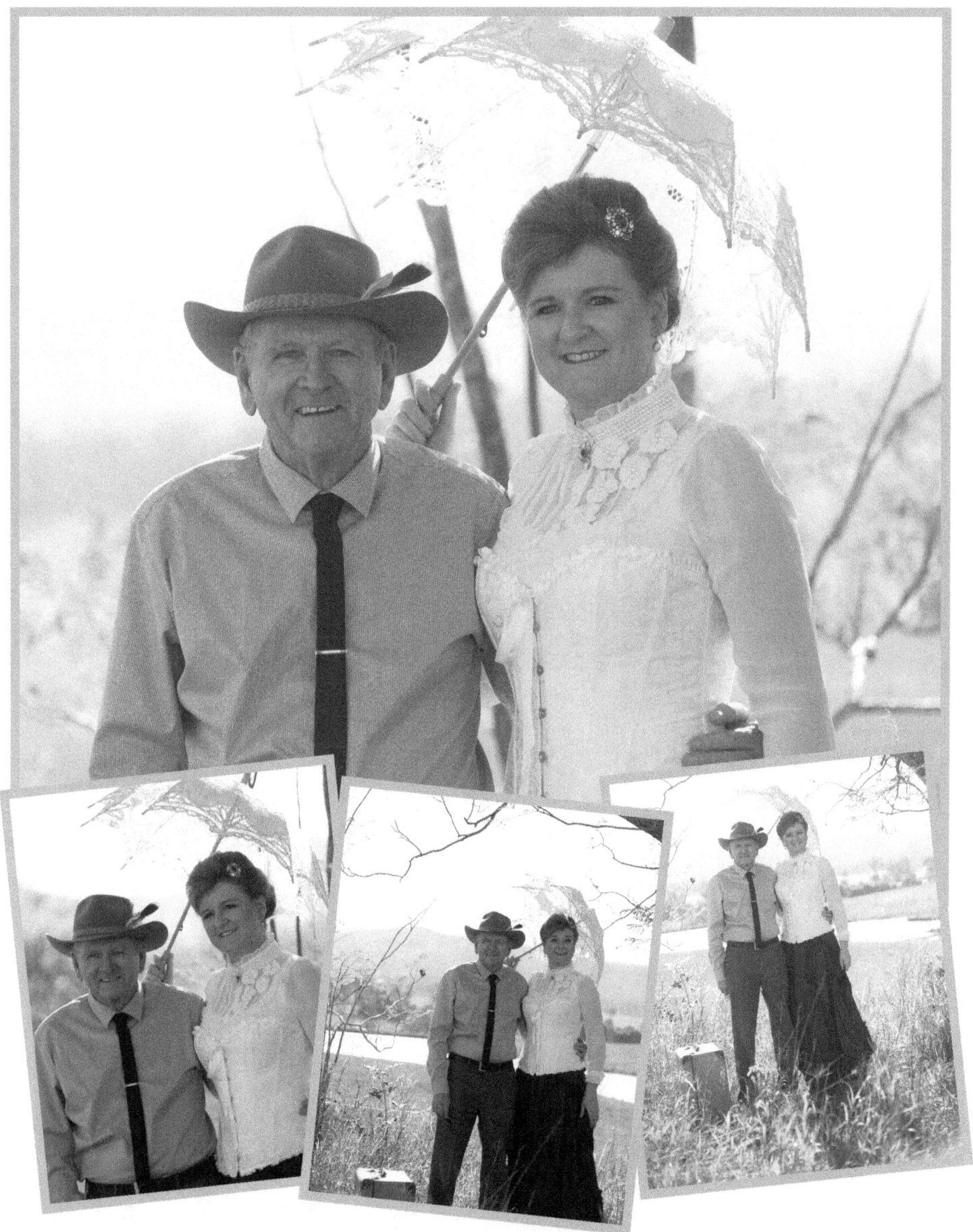

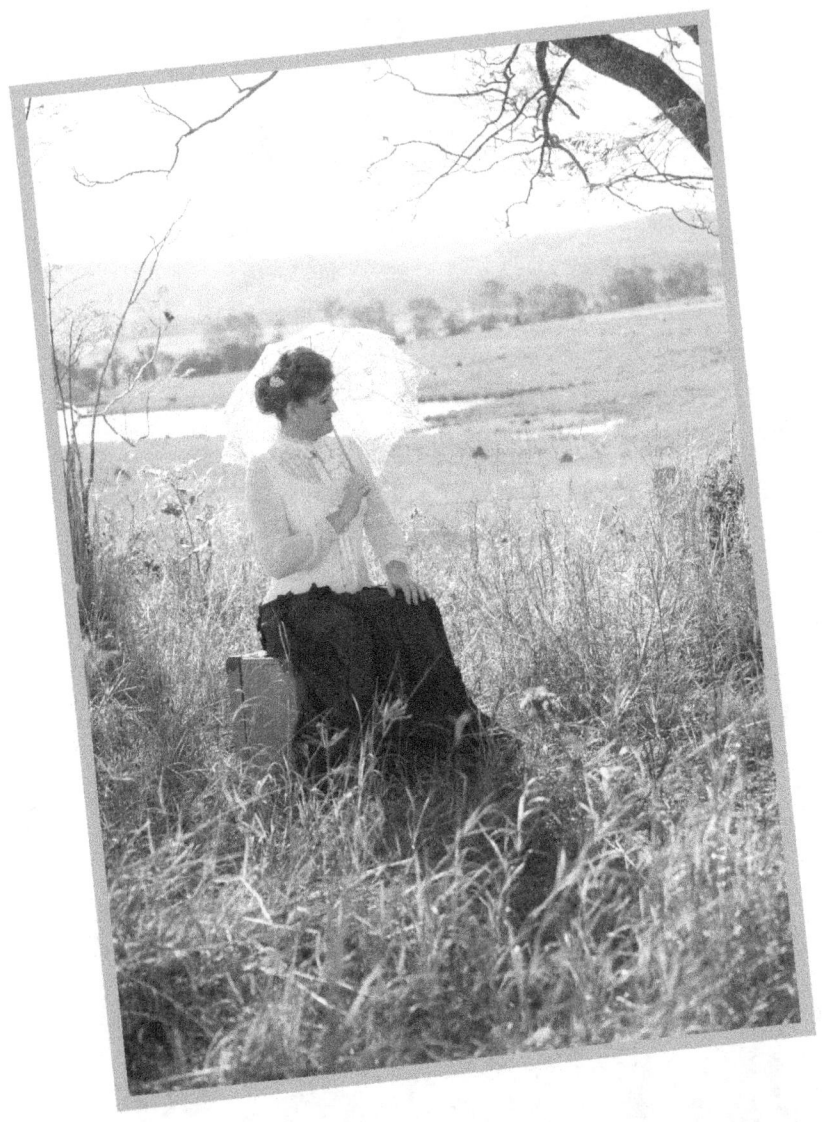
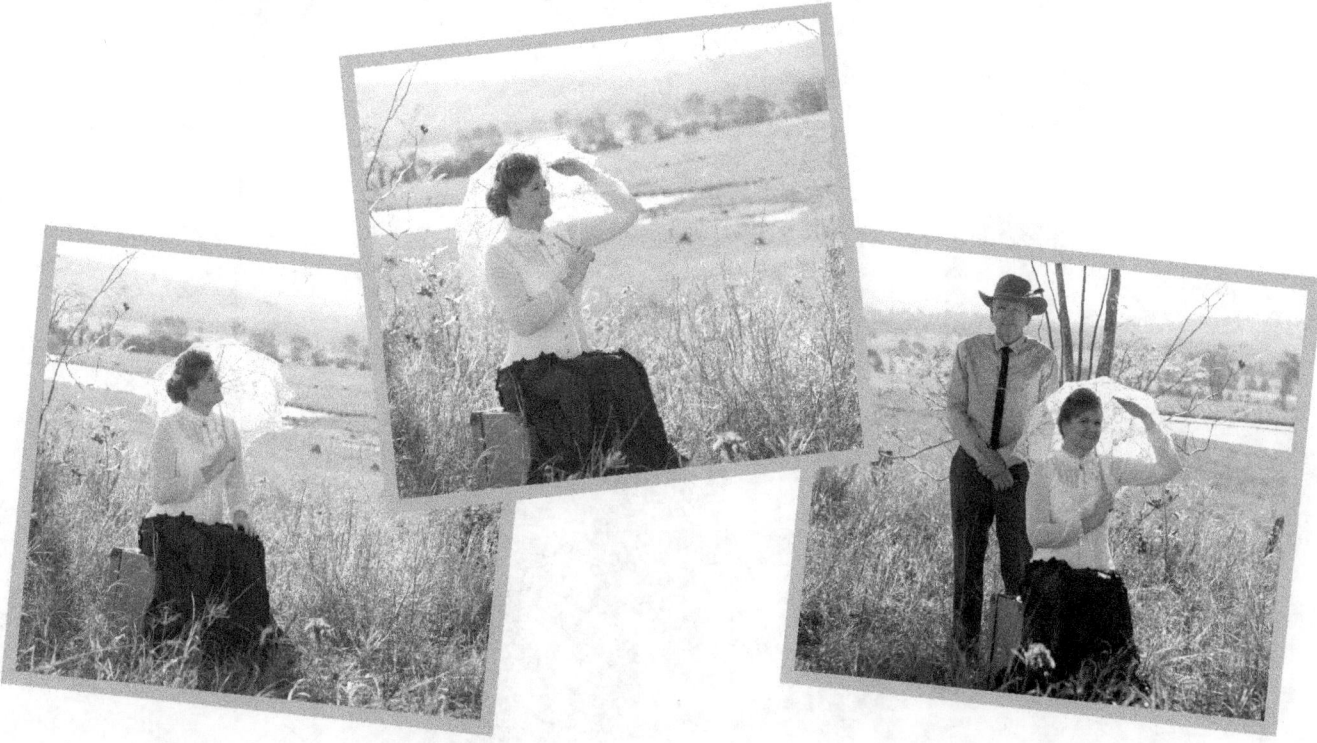

page 100

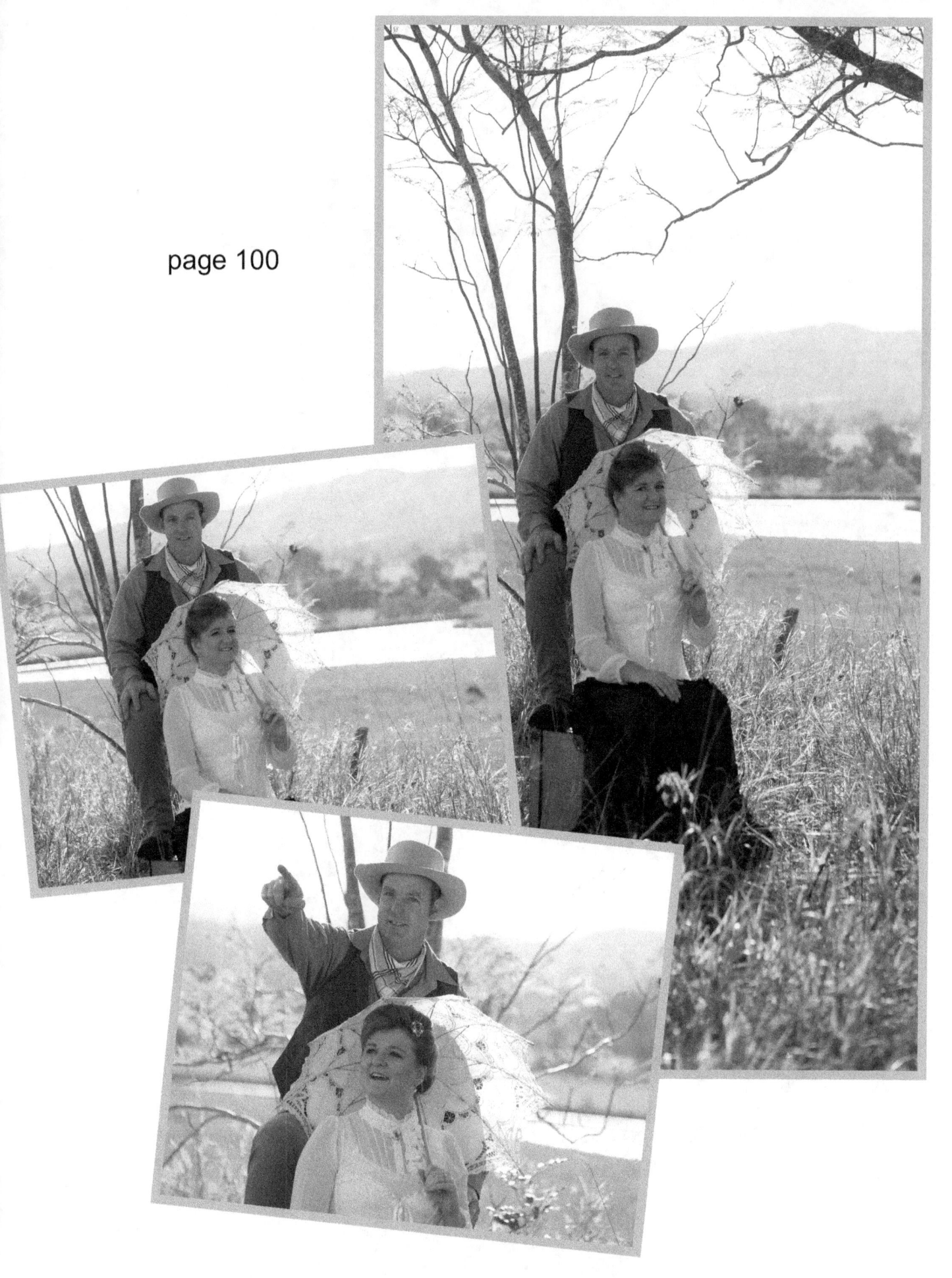

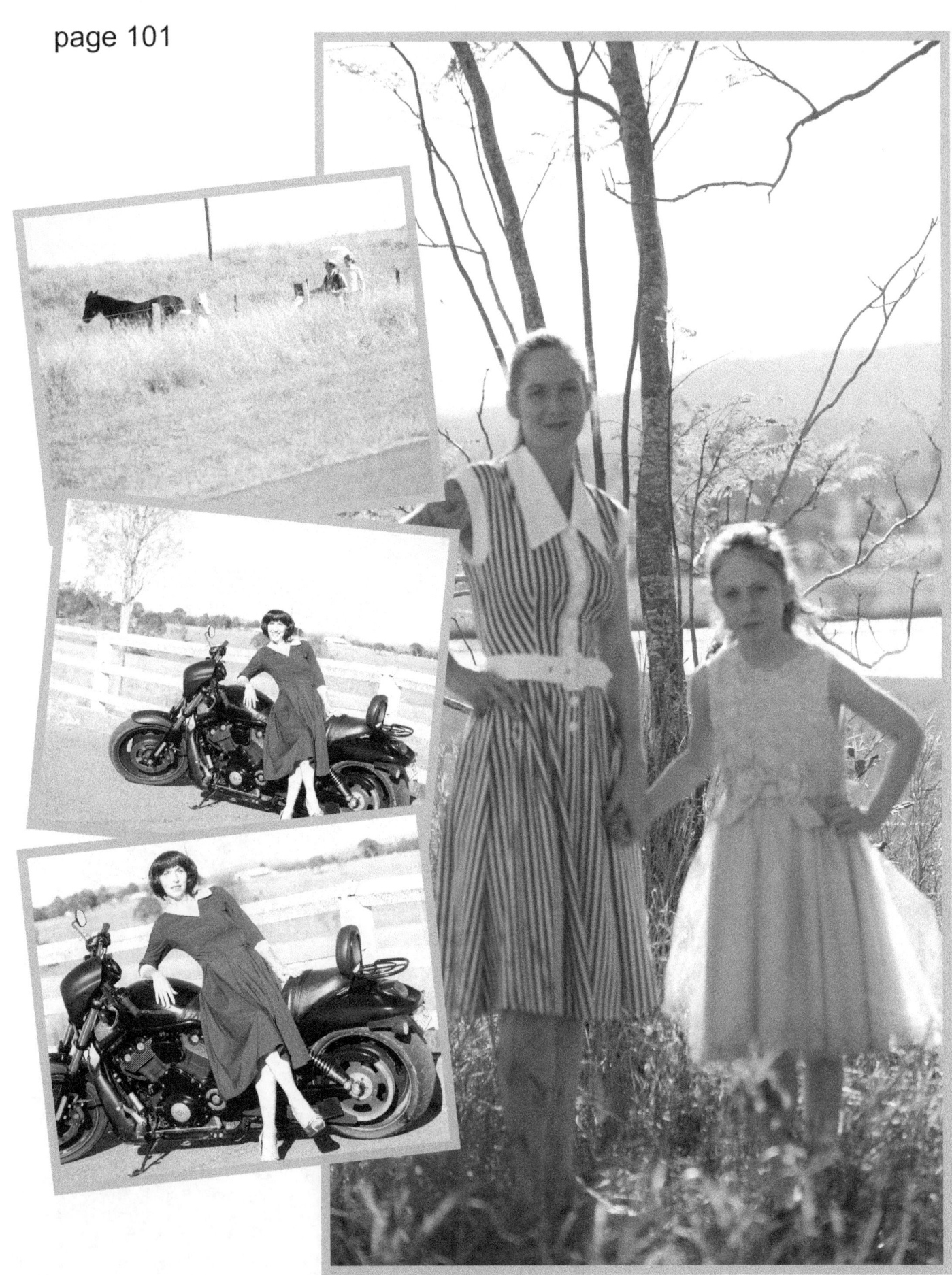

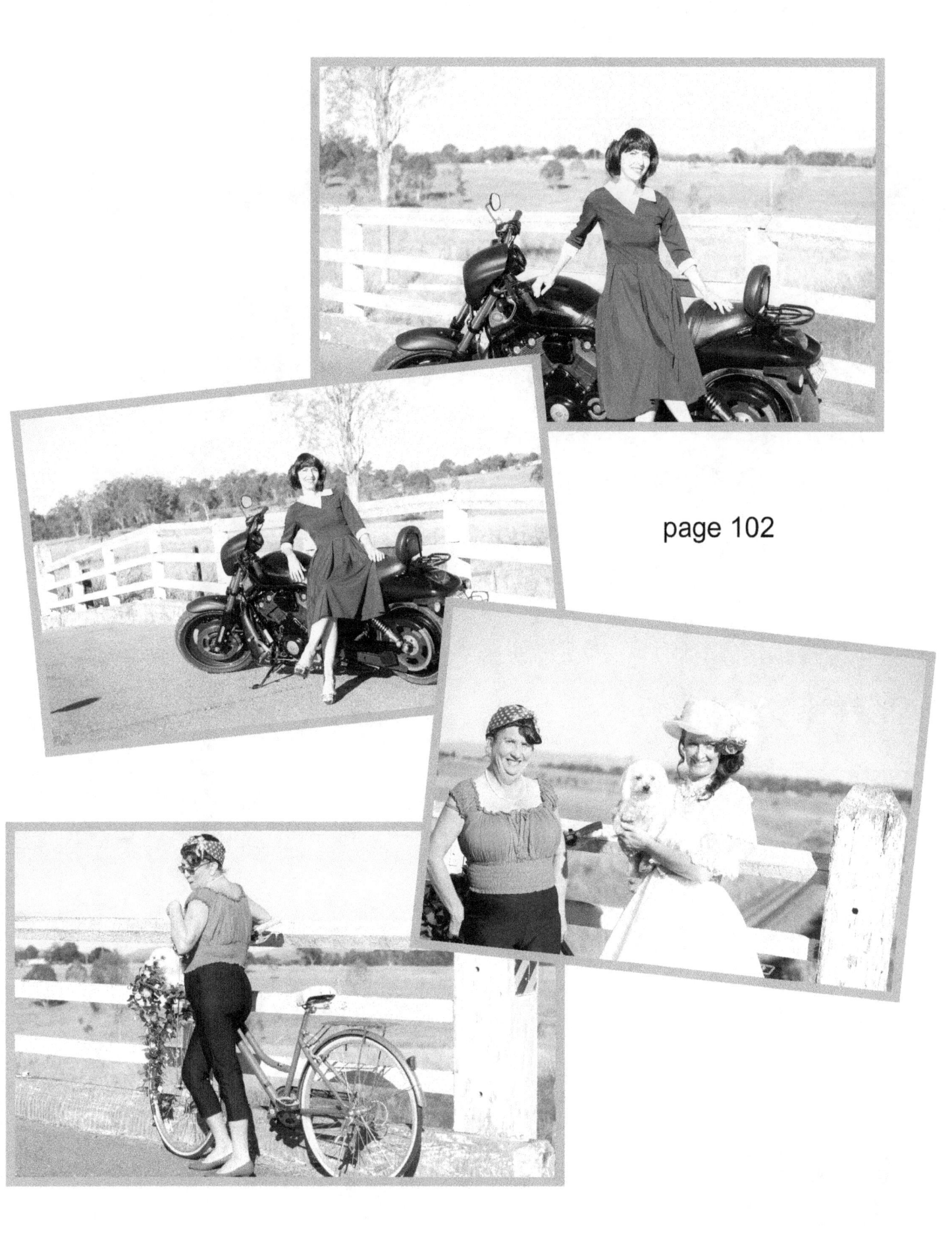

page 102

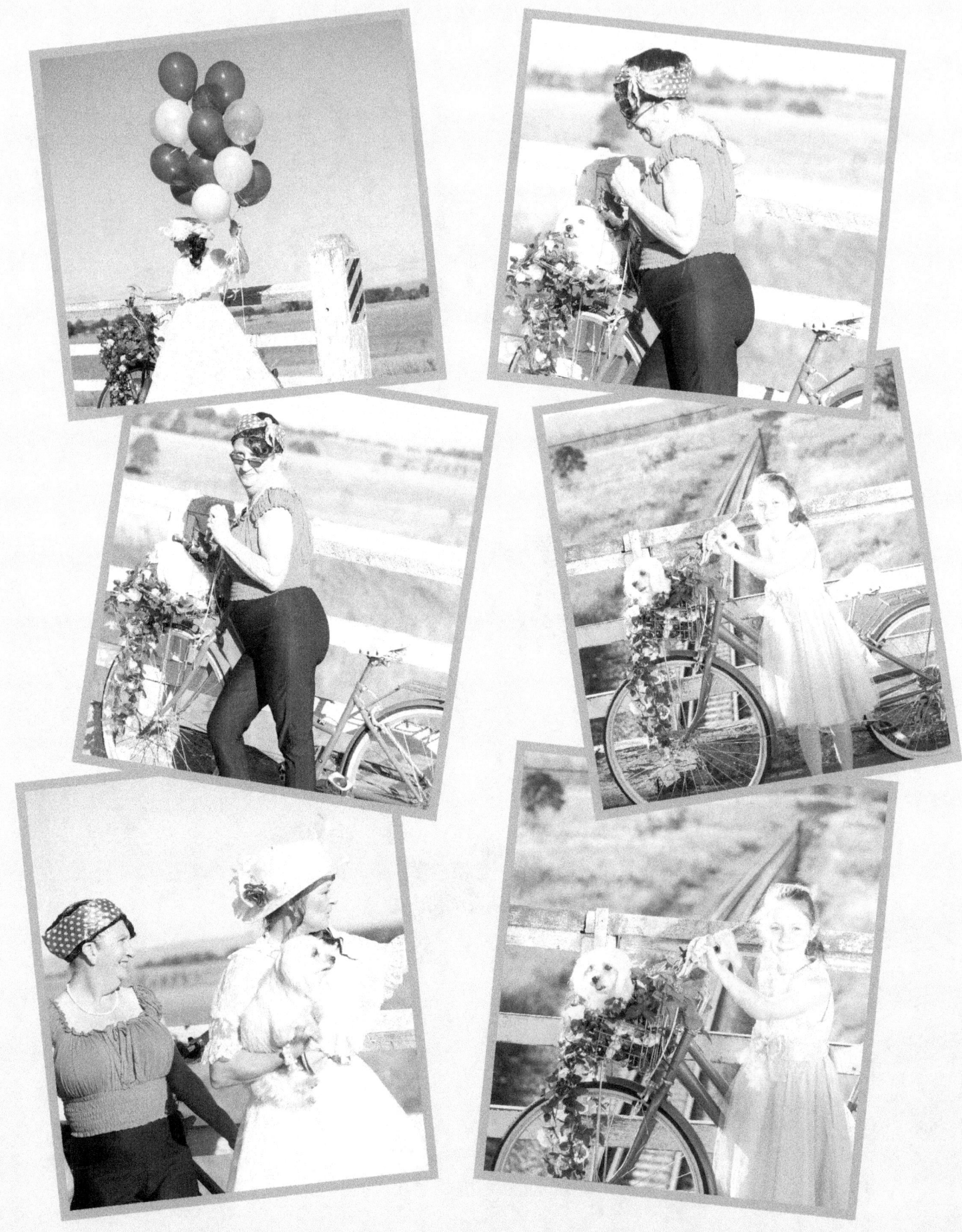

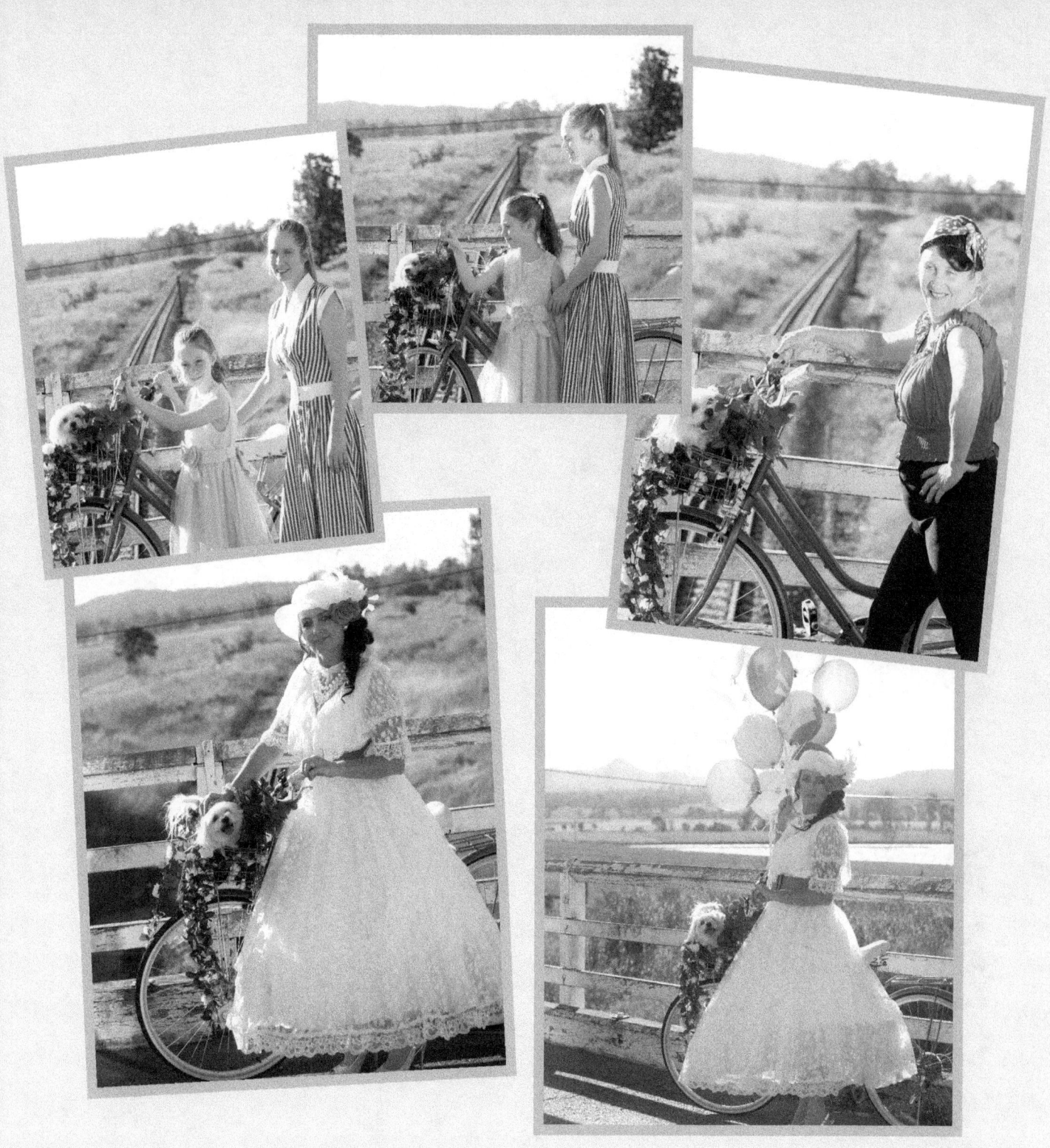

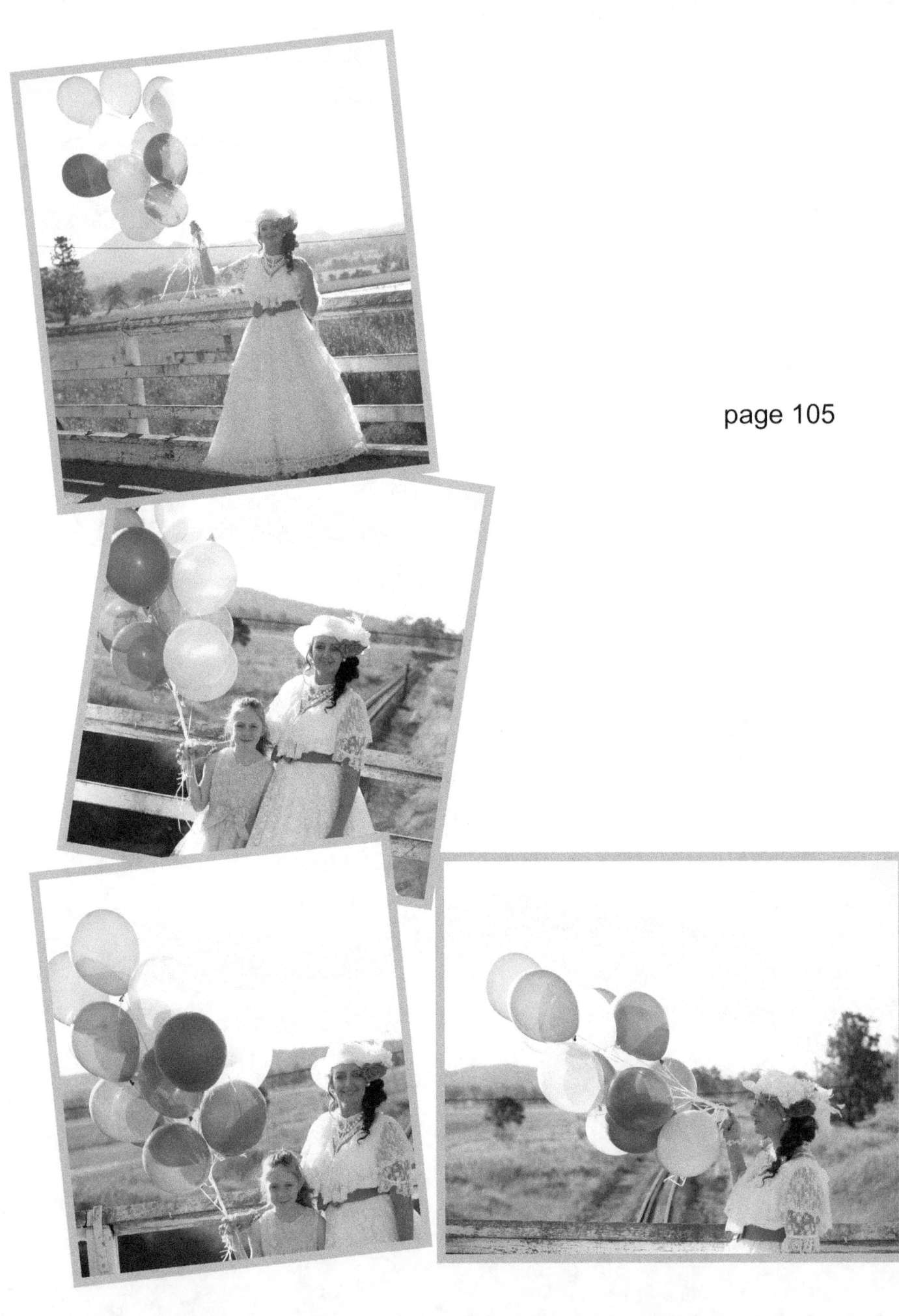

page 105

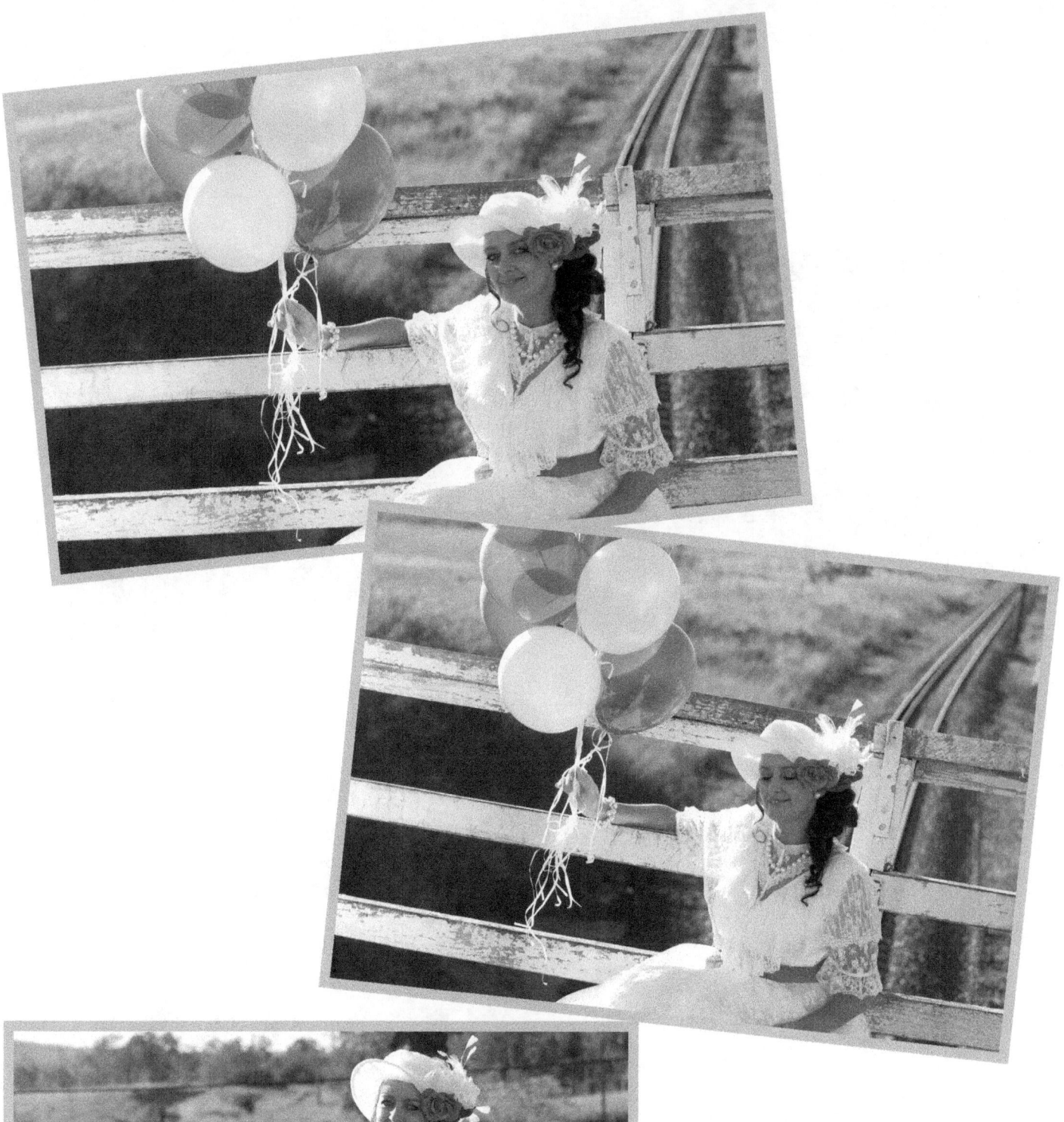

page 107

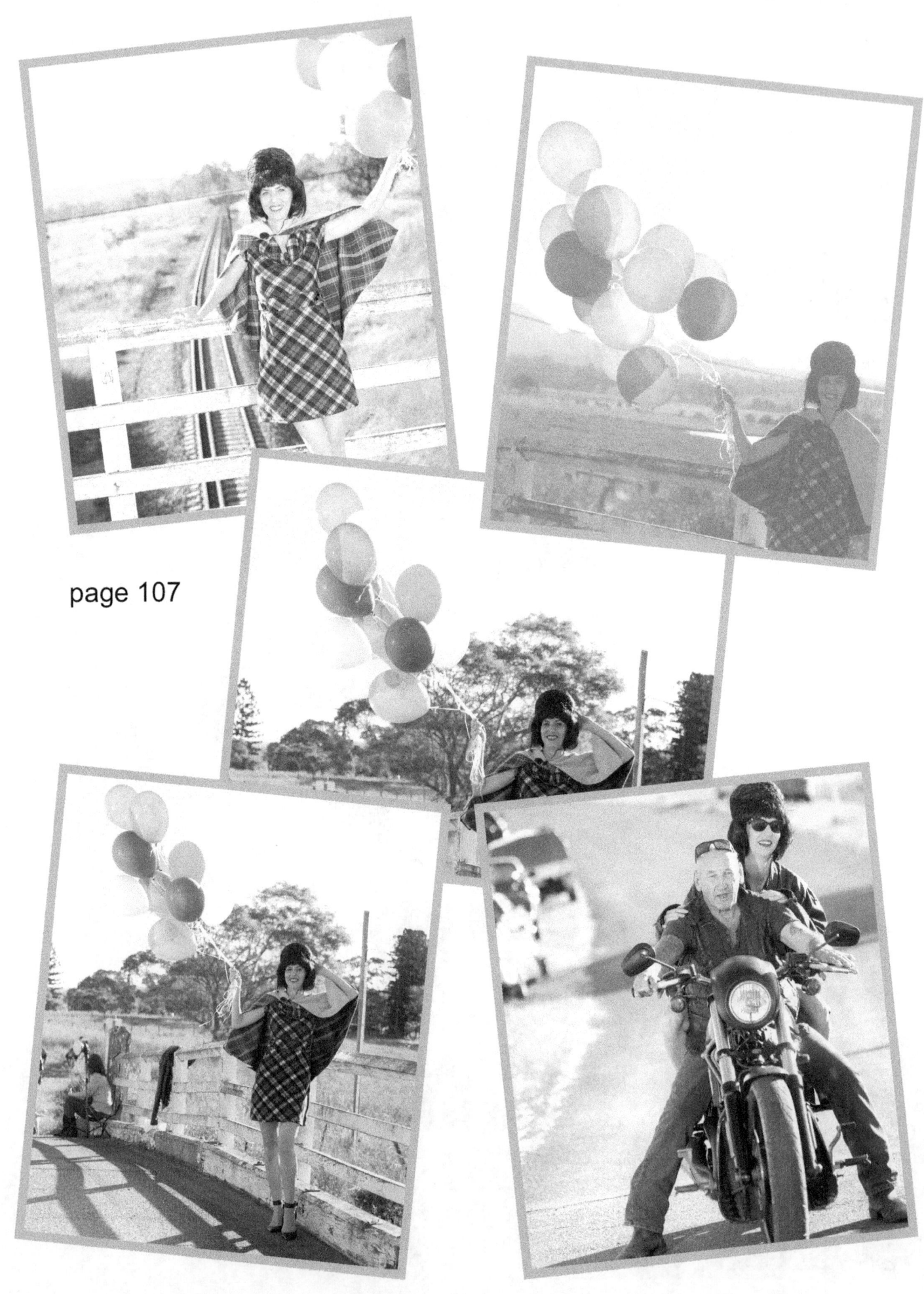

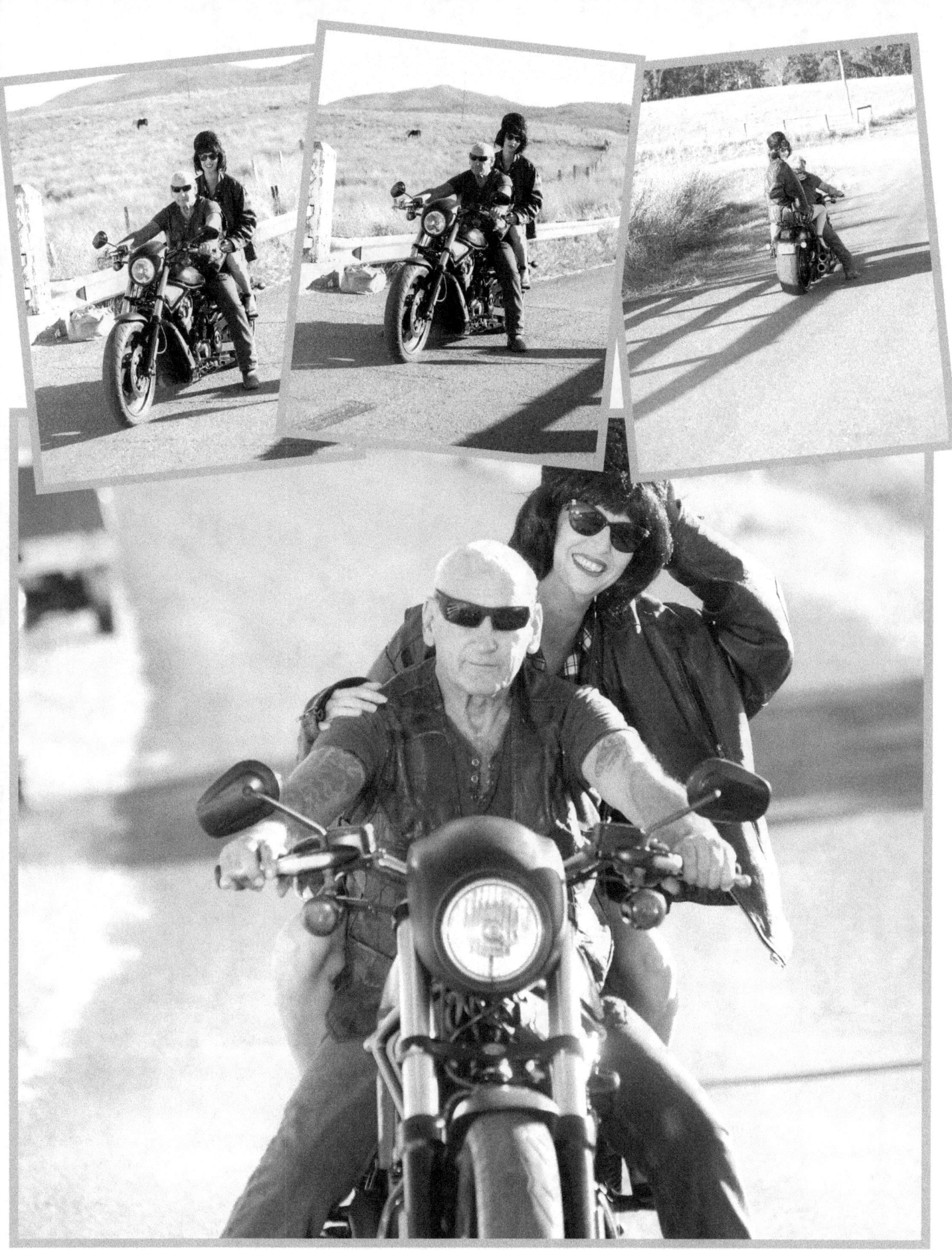

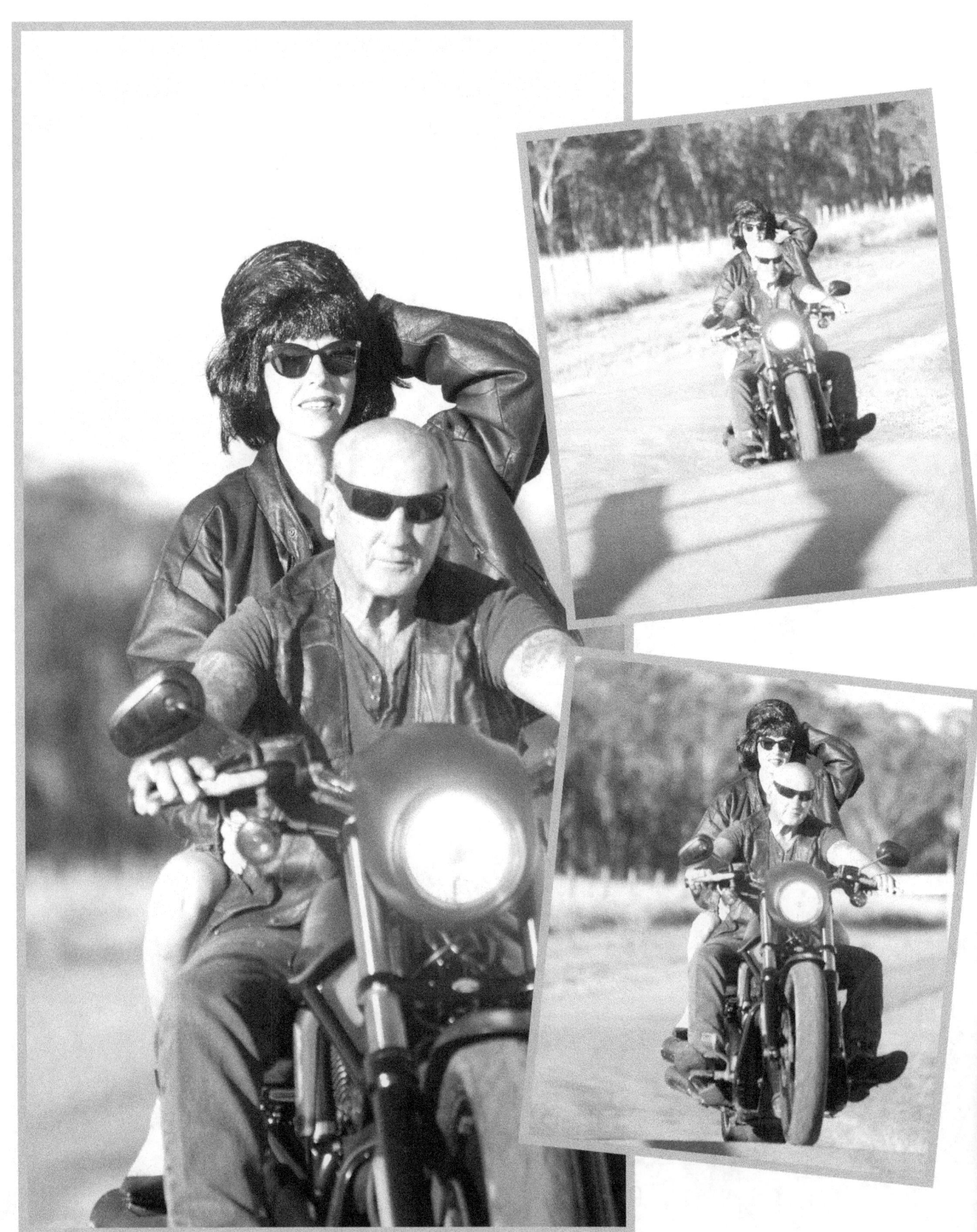

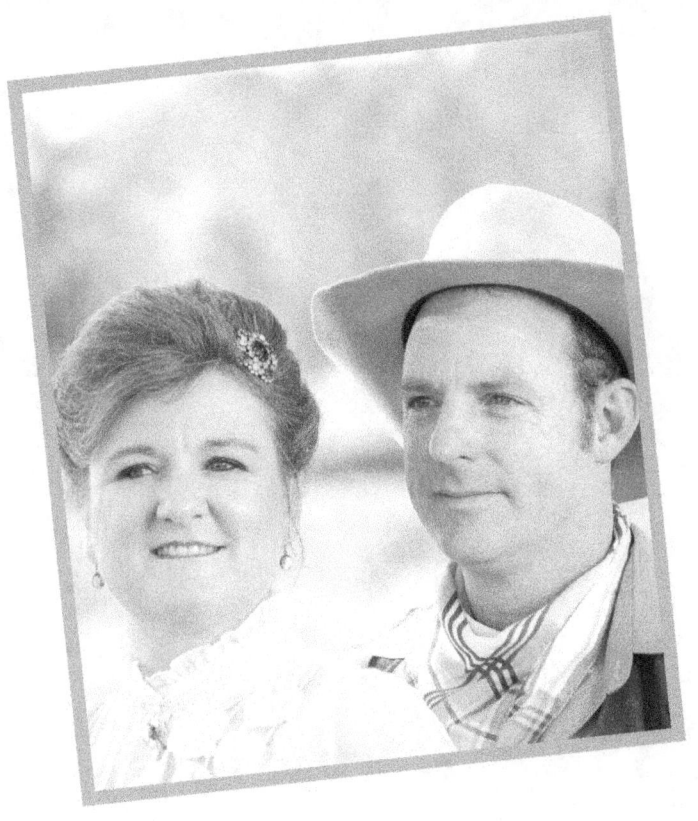

page 110

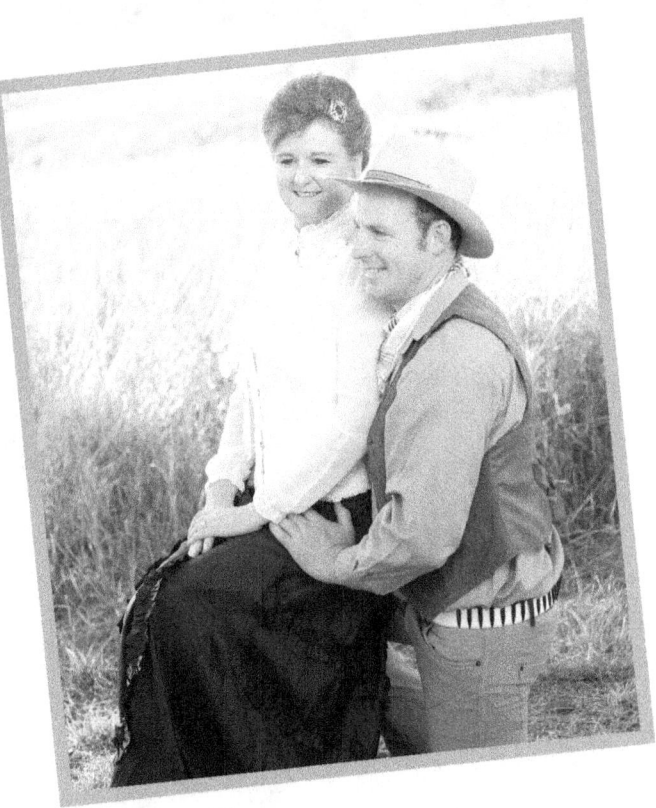

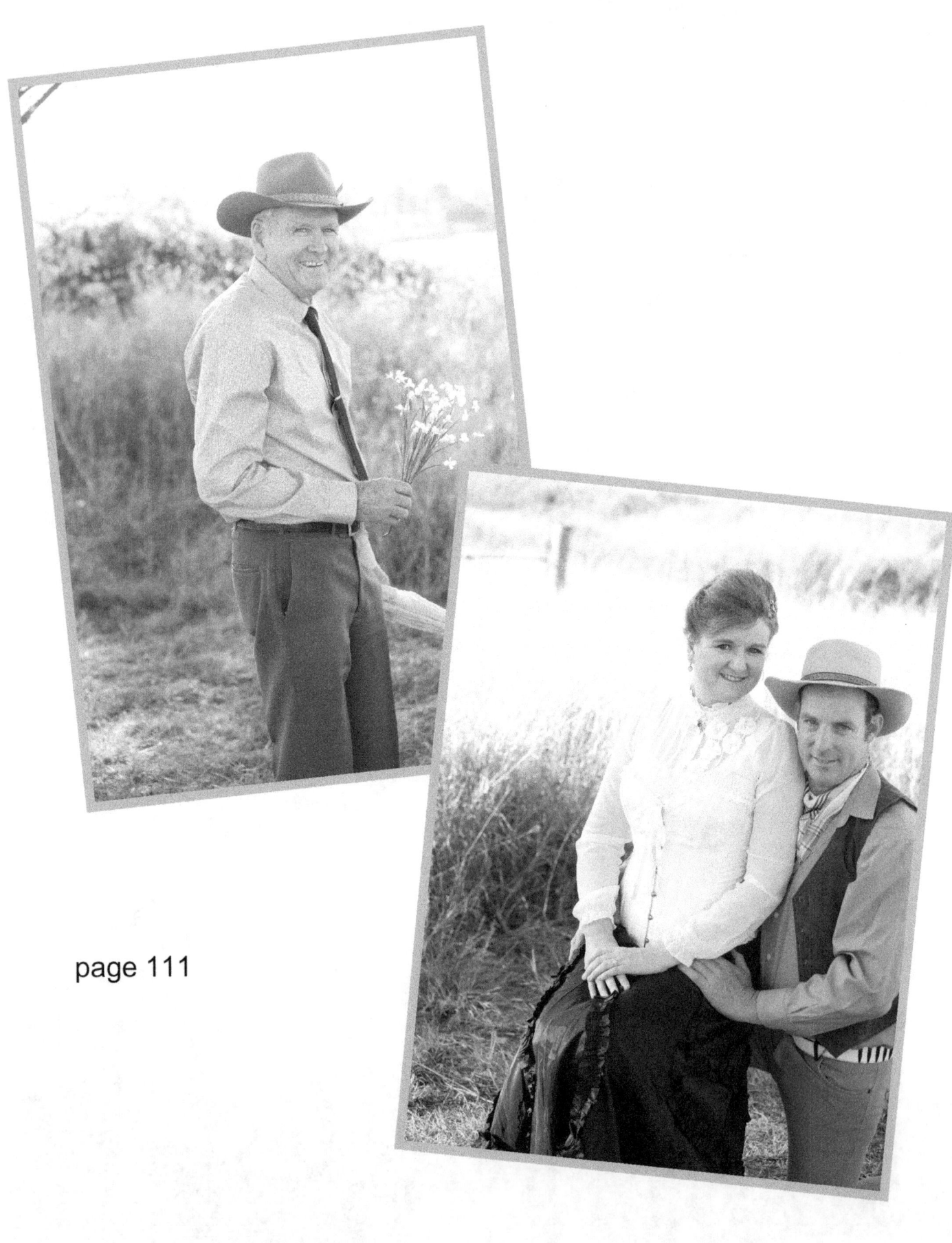

page 111

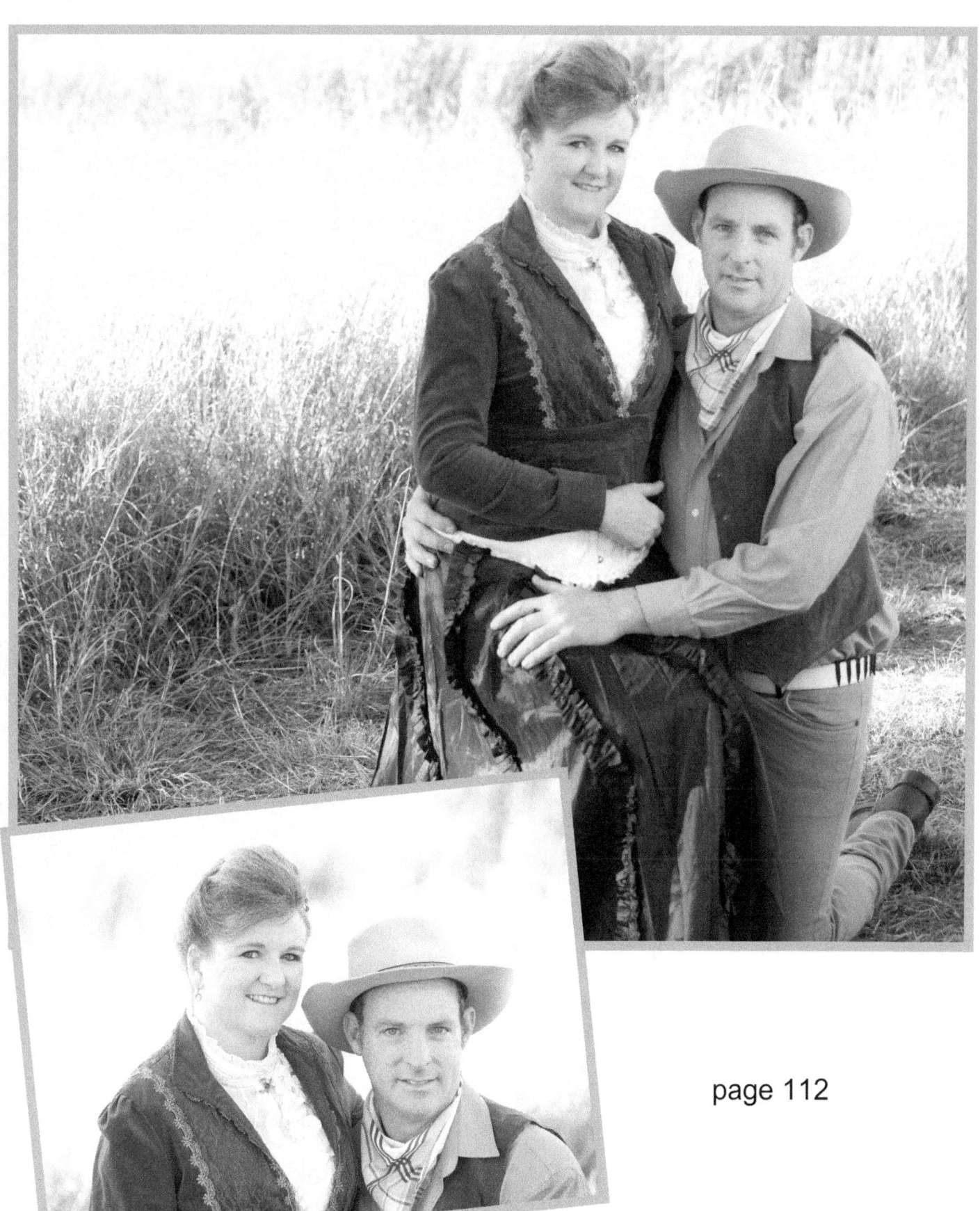

page 112

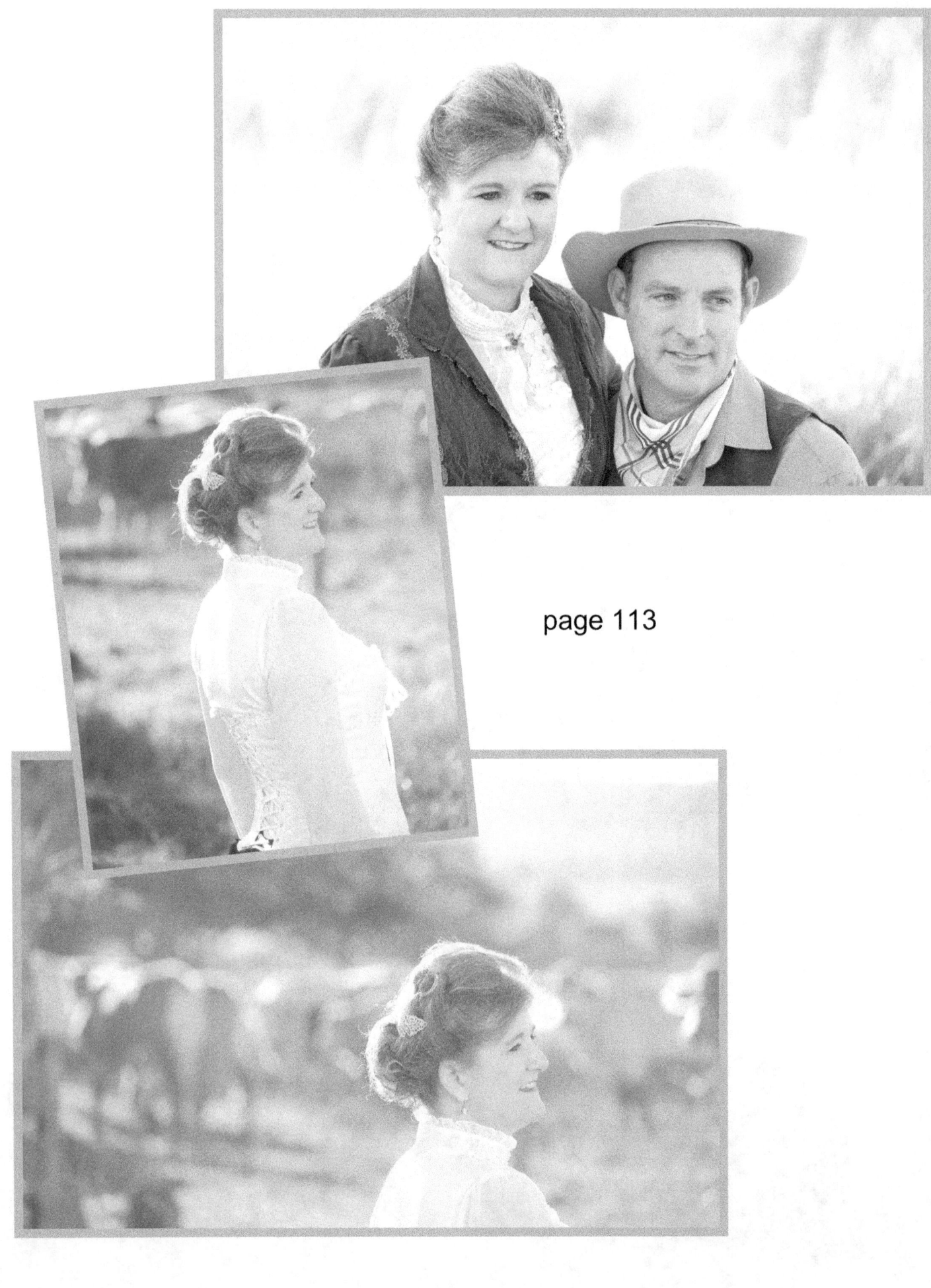

page 113

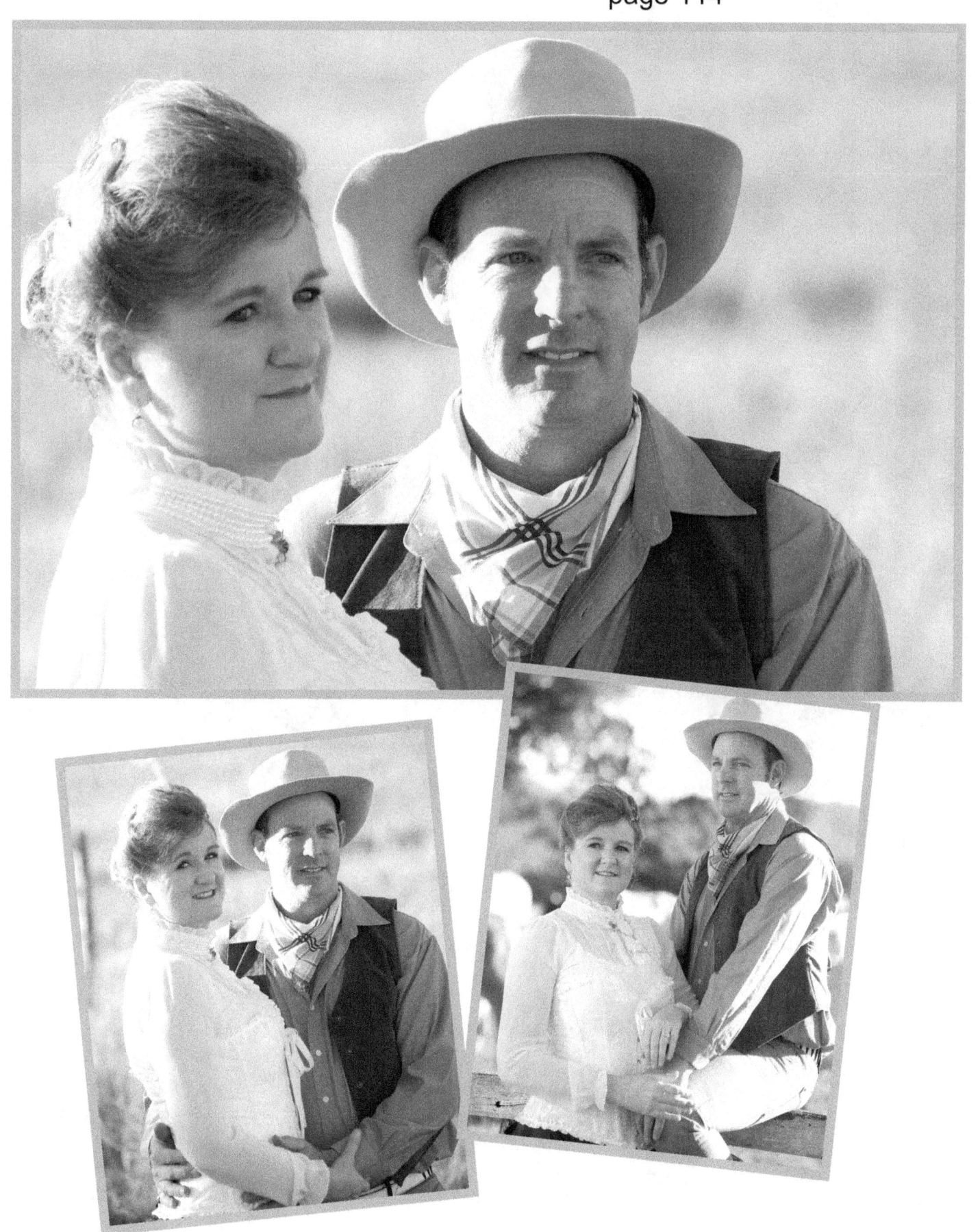

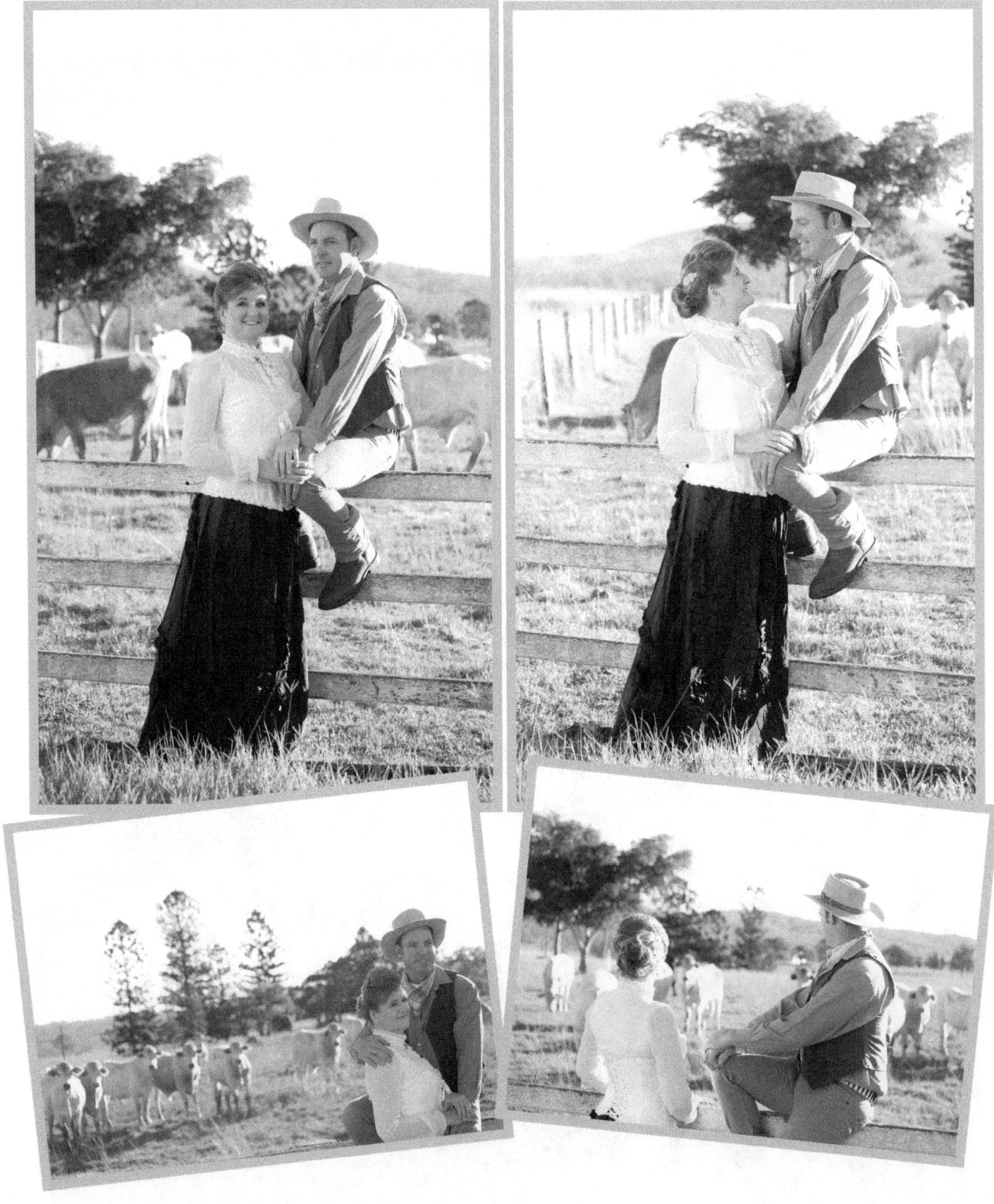

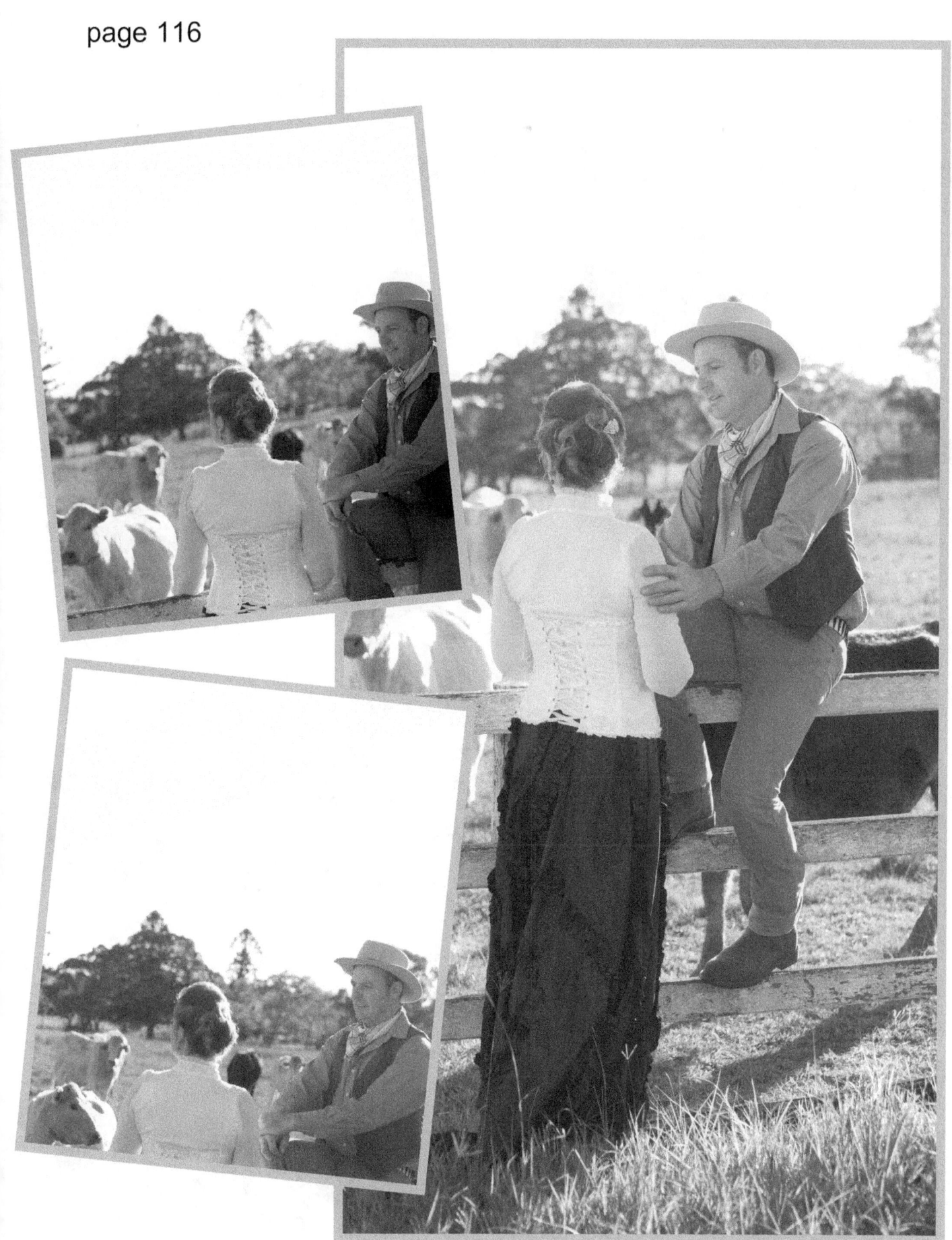

page 117

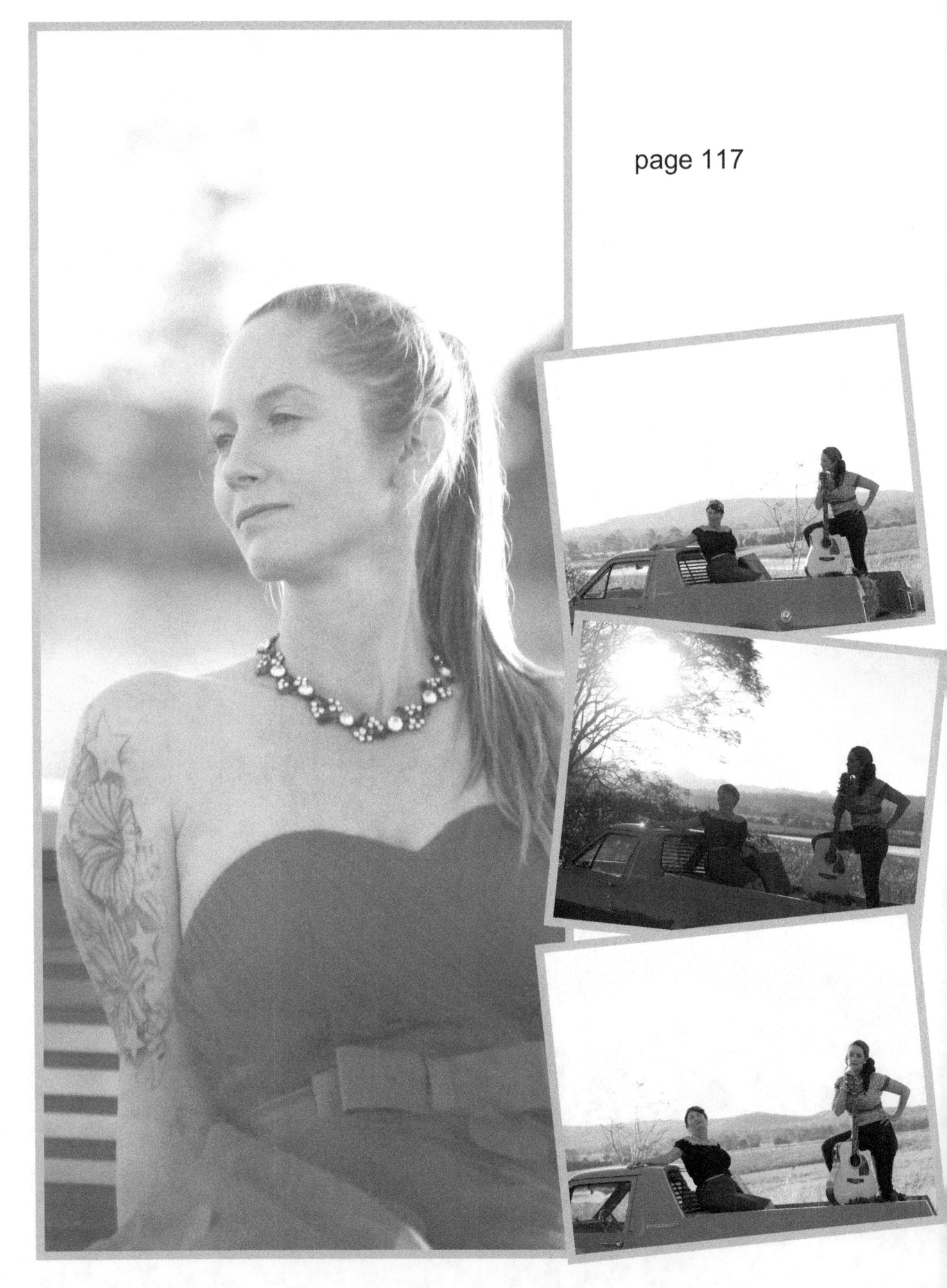

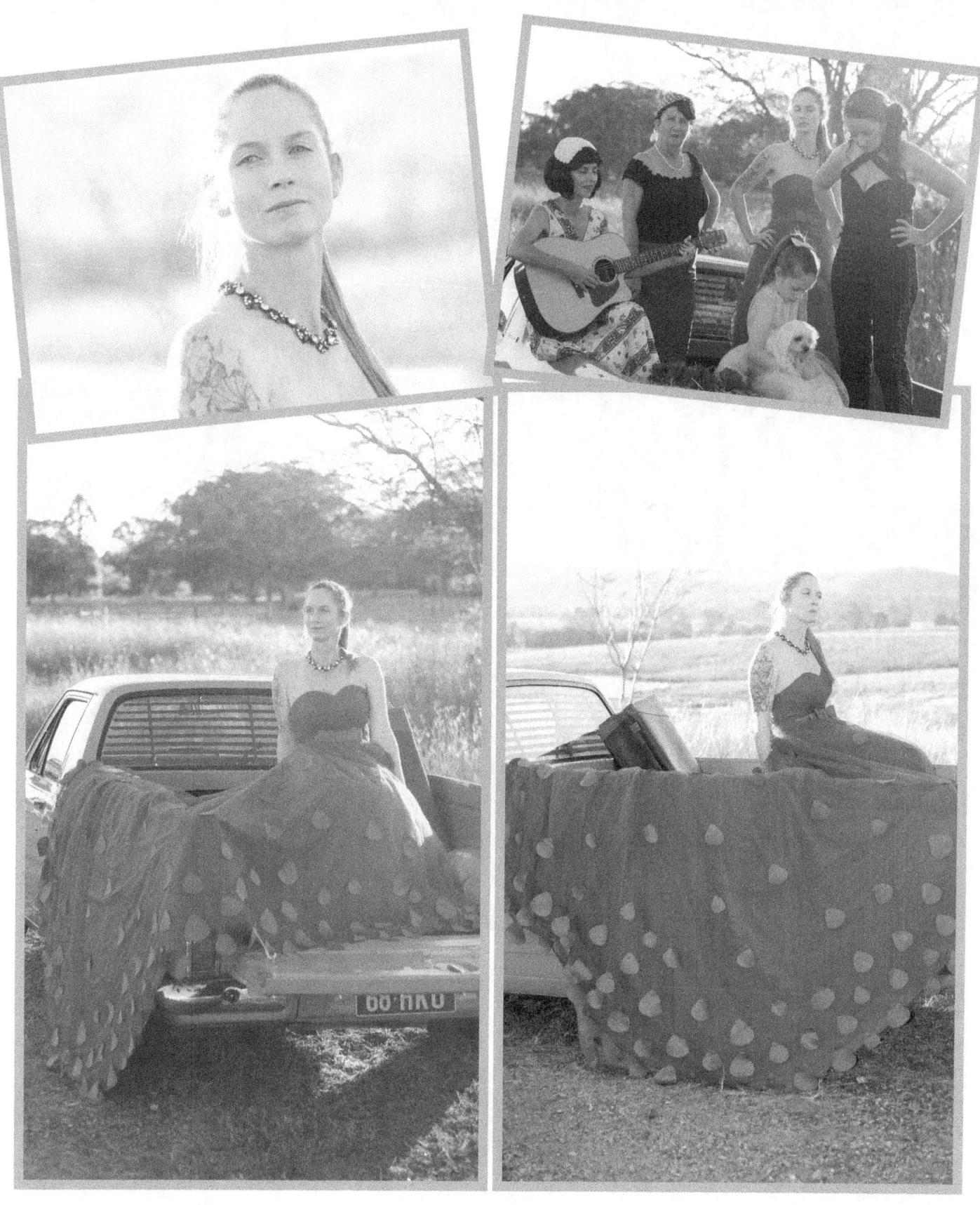

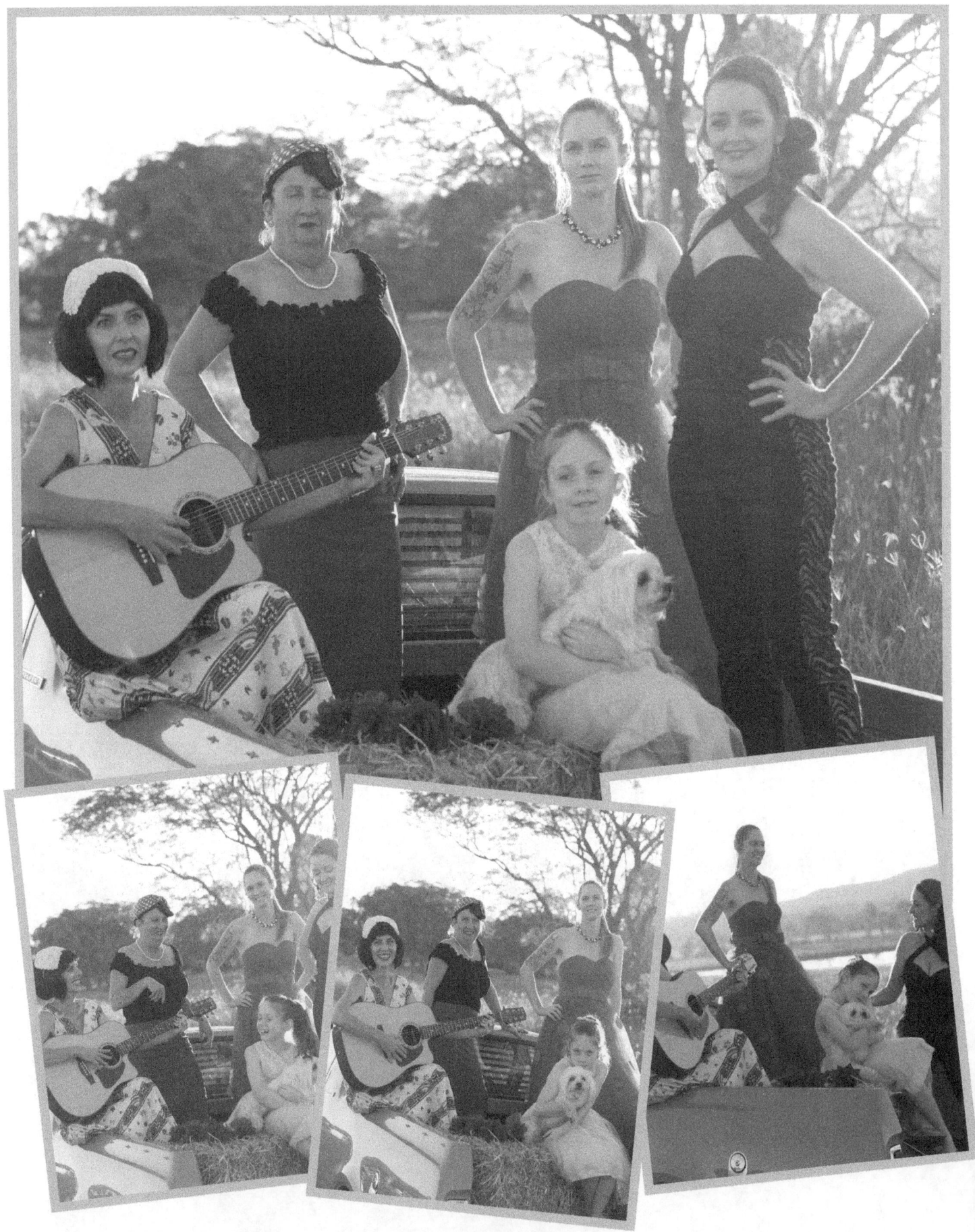

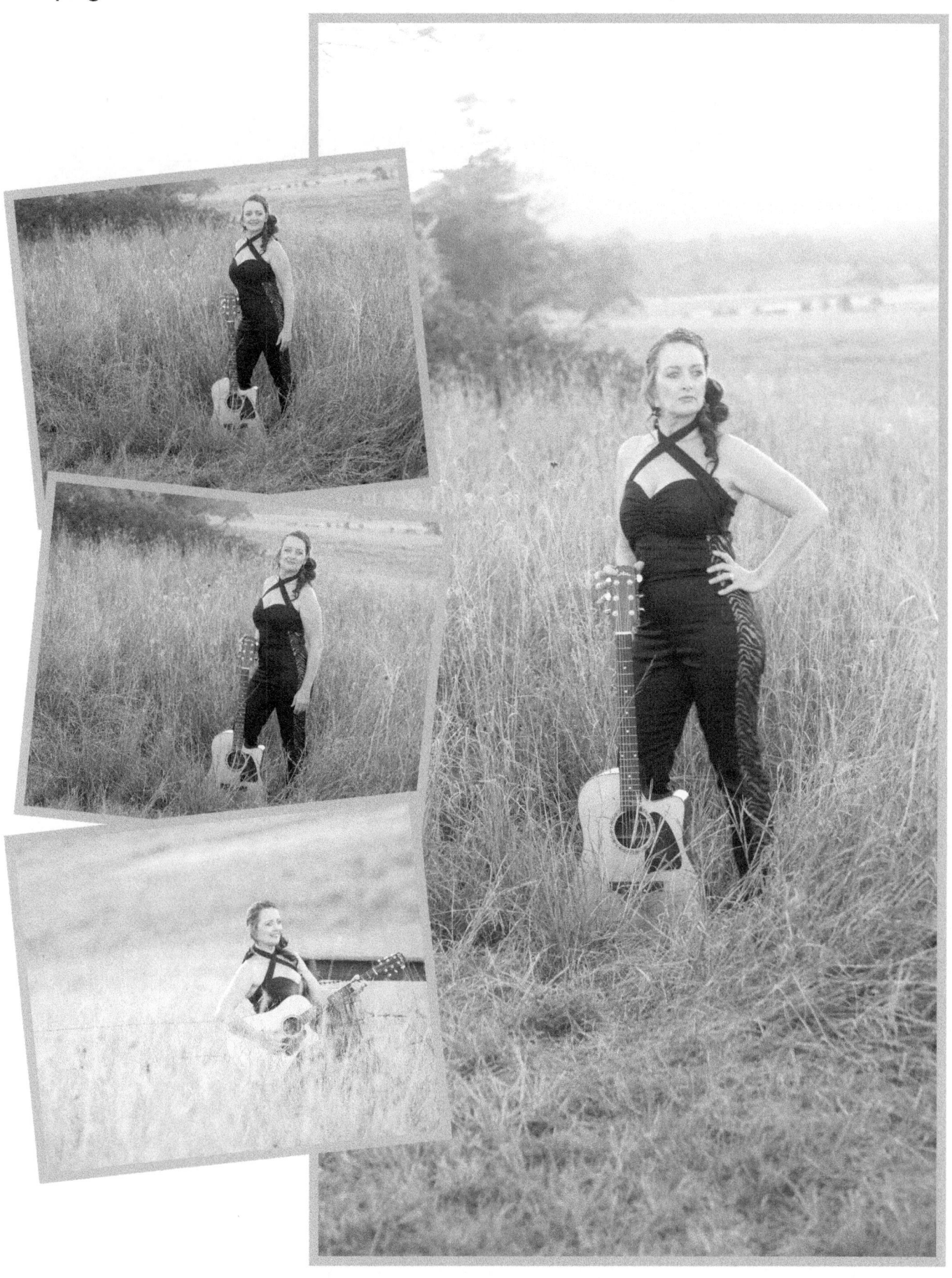